Video Shooter

Storytelling with DV, HD and HDV Cameras

Barry Braverman

DV
Digital Video
EXPERT SERIES

CMP**Books**
San Francisco, CA

To my father, the ultimate pack rat,
who taught me to see the romance in technical things.

Published by CMP Books
an imprint of CMP Media LLC
600 Harrison Street, San Francisco, CA 94107 USA
Tel: 415-947-6615; Fax: 415-947-6015

www.cmpbooks.com
email: books@cmp.com

Managing editor: Gail Saari
Interior design and composition: Leigh McLellan Design
Cover design: Noel Ekart

Distributed to the book trade in the U.S. by:

Publishers Group West
1700 Fourth Street
Berkeley, CA 94710
1-800-788-3123

Distributed in Canada by:

Jaguar Book Group
100 Armstrong Avenue
Georgetown, Ontario M6K 3E7 Canada
905-877-4483

For individual orders and for information on special
discounts for quantity orders, please contact: CMP Books
Distribution Center, 6600 Silacci Way, Gilroy, CA 95020
Tel: 1-800-500-6875 or 408-848-3854; fax: 408-848-5784
Email: cmp@rushorder.com; Web: www.cmpbooks.com

Library of Congress Cataloging-in-Publication Data

Braverman, Barry.
 Video shooter : storytelling with DV, HD, and HDV
cameras / Barry Braverman.
 p. cm.—(Digital video expert series)
 ISBN-13: 978-1-57820-289-8 (alk. paper)
 ISBN-10: 1-57820-289-2 (alk. paper)
 1. Video recordings--Production and direction. 2. Digi-
tal cinematography.
 I. Title. II. Series: DV expert series.
 PN1992.94.B73 2005
 384.55'8—dc22 2005033308

Printed in the United States of America

05 06 07 08 09 5 4 3 2 1

CMP**Books**

Contents

Introduction

I'LL BE HONEST WITH YOU. I hate DV. I hate everything about it. And that goes for HDV and the new inexpensive HD cameras as well.

I hate all of it for one very good reason: Not long ago I was a revered craftsman of privilege and status, a special person with unfettered access to the world's best and priciest storytelling tools. If you needed something shot and shot well in the Arctic, Turkey, or the Amazon, I was your Shooter. You could look up to me, hail me with accolades, and buy me lavish gifts. Then I just might agree to tell your visual story, if you approved, that is, my rather exorbitant day rate.

Today, I'm no longer that special person as almost anyone can afford a decent camera and be a Video Shooter. The tools have become so easy to use and so commonplace, it is no longer much of an issue who possesses the means to tell captivating stories—we all do. The issue now is who owns the storytelling *craft*—and *that* is a much tougher commodity to come by. It takes years of discipline, learning to see the world in a new uncluttered way. Understanding the nuts and bolts of effective framing, composition and camera angles, all play a part, but so does adopting the proper philosophy and point of view. That's why I chose to write this book, in one of my more magnanimous moments, to offer you, the aspiring video shooter, a new perspective and reasonable hand up in acquiring the skills to tell truly compelling visual stories.

The means of storytelling have taken many forms over the centuries. In years past, we might have etched our stories into stone, used smoke signals or simply made them part of our oral tradition. Today, the video camera has evolved into a dominant storytelling tool, as critical to communicating in

the 21st century as paint and paintbrush were to Michelangelo and Leonardo da Vinci during the Renaissance.

Thanks to DV, we're all shooters now, and as I look around at the video storyteller today, I can see that many fundamental skills no longer come with the territory. Blame it on the technology advancing at a dizzying clip, or the seductive power of the latest digital *tchotchke* or gimmick. The film medium, for all its relative crudeness and expense, imposed its own kind of discipline that must now be self-imposed by the video shooter.

And so in this struggle to develop one's craft, let us not forget the storyteller's obligation to have something meaningful to say. Like the ancient Egyptians who carved their stories into stone, if we want our work to survive the ravages of time, we have to tell stories that people care about.

So while I hate DV, I do love a good story.

Acknowledgments

My students at Video Symphony in Burbank who are a continuous source of inspiration and good stories; Jeff Giordano at 16x9, Inc. who knows the camera accessory business better than anyone and who is a great person to whine to; Dorothy Cox at CMP Books who threatened to come after me with a hatchet but never did despite me being more than a few months late in delivering this book; Jan Crittenden and Doug Leighton at Panasonic who provided endless insights and favors; Tom Di Nome at Sony who perhaps supported me more than was wise or prudent; Michael Wiegand at DSC Laboratories for use of his superb reference charts used in my tests; Amy Rascarin of Red Giant Software who never questioned what the heck I was up to; Wayne Schulman from Bogen who bent over backwards to fulfill my oddest requests; Amnon Band and his fabulous crew at Band Pro who provided workshop space and support for my umpteen evaluations; Fujifilm's Craig Anderson and Text 100's Shannon Walsh who are likely sick to death of me asking technical questions about recording media; Lee Bobker of Vision Associates who gave me my first assignment shooting soybean fields 25 years ago; Ira Tiffen whose vast knowledge, enthusiasm and love for photography I tried to emulate; Sid Platt, my friend and mentor at National Geographic who inspired me as a young man and sent me to weird places; Ben and Zoe, my fabulous son and daughter, who so graciously posed for dozens of pictures and illustrations; and my wife, Debbie, who in her own way encouraged me to write this book.

The DV Point of View

IN THE 1980s, while on assignment for *National Geographic* in Poland, I learned a profound lesson about the power of television. On May 2, 1988, in the dying days of one of the world's most absurd regimes, a thousand soldiers and tanks massed at the gates at the Lenin Shipyards in Gdansk to crush a strike by workers belonging to the outlawed Solidarity union. I happened to be shooting in Gdansk when these events were unfolding and despite it not being part of my "official" assignment, I ventured over to the vicinity of the shipyard anyway, in light of the intense world attention being focused there, and the compelling human drama unfolding inside.

Out of sight of my government "minder," I understood the risks involved. I could've been shot, beaten up, or, at the very least, deported, but I felt compelled to take the chance as I was convinced that history was in the making. The night before, a similar military force had stormed a coal mine in southern Poland and brutally beat and killed many strikers as they slept. Not a single photograph or frame of video emerged to tell the tale, but word spread quickly anyway through non-government channels. The shipyard workers figured they were in for the same treatment and I very much wanted to record some piece of it.

Considering the Communists' total control of the press and TV, it came as no surprise that the Polish Press Office would deny me and my Arriflex access to the shipyard. But that didn't stop my two local friends—with less obvious equipment—from sneaking inside.

Capturing the unfurling drama on 8mm video equipment donated by the AFL-CIO, Solidarity activists Piotr Bikont and Leszek Dziumowicz had already been secretly shooting and editing Solidarity newsreels in a Gdansk

church loft. Circumventing the regime's chokehold on the media, Piotr and Leszek shot and edited their own programs, then distributed them via a network of church-run schools, enlisting the help of eager schoolchildren who ferried the precious cassettes home in their backpacks. On this night, Piotr and Leszek slipped into the shipyard in the back of a delivery van, and swore to stay with the strikers to the end, to tell the story of the assault and ensuing carnage from their point of view. Their physical beings didn't matter, they kept telling me. In fact, they looked forward to being beaten—provided of course they could get the material out of the shipyard to me and the watchful world.

But that night, the attack didn't come. Indeed, for the next two weeks, Piotr and Leszek simply held their ground, capturing the range of the strikers' emotions, from the euphoria of the strike's first days to spirit-sapping exhaustion as the action dragged on. No one doubted that an attack would come. The only question was when. In scenes reminiscent of the American Alamo, 75 men and women facing almost certain annihilation stood steadfast in the face of army tanks and provocateurs who'd occasionally feign an attack in order to probe the strikers' defenses.

It was then that Piotr and Leszek made a startling discovery—that their 8mm video camera could be a potent weapon against the military forces amassing at the shipyard gate. On the night of what was surely to be the final assault, the strikers sent out an urgent plea over the shipyard loudspeakers: "Camera to the gate! Camera to the gate!" The strikers were begging Piotr and Leszek to point the camera at the soldiers as their last best line of defense. It was pitch black around the shipyard at 2:00 AM and the camera couldn't see much of anything. But it didn't matter. When the sol-

Figure 1.1 *The Little Camera That Could: The Sony model CCD-V110 that changed the world in the late 1980s.*

diers saw the camera, they pulled back. They were terrified of having their faces recorded!

As the days dragged on, the 8mm camcorder became an increasingly potent weapon against the regime. In an act of desperation, a government agent posing as a worker ripped the camera from Piotr's arms and raced off. The agent in his frenzy ducked into a building housing other undercover officers, not realizing, incredibly, that the camera was still running. Inside the makeshift police headquarters, no one thought to shut the camera off as the Sony dutifully recorded a gaggle of nervous agents conspiring to smuggle the camera *out* of the shipyard. The point of view from inside a brown paper bag didn't reveal much as the camera was shuffled from one set of agents' arms to another, but it *was* nonetheless Solidarity's point of view—

| THEY'RE AFTER US! RUN! | CAMERA GRABBED! | INTO THE CAR! | AT POLICE STATION | CAMERA ON TABLE | CAMERA IN BAG |

a point of view that would ultimately prove devastating to the totalitarian regime.

In the struggle for the camera, the regime and strikers both recognized the power of the camcorder as a potent weapon. Indeed, the government had tried on several occasions to bring its *own* camera and reporter into the shipyard, but Solidarity leader Lech Welesa refused to let the government's camera in. "We despise what you're doing in TV," he told the state's reporter trying to push his way past the strikers. "You see that?" Lech gestured to Piotr's camera, its red tally light blinking. "*We* now have television, too. And when this thing is over, all of your faces will have been recorded and we'll know who you are."

Several days after this pointed exchange in a shipyard guard station, the government lifted the siege and agreed to round-table talks. Solidarity was legalized, and 18 months later the Berlin Wall came crashing down. And in my opinion, it all began in the shipyard with the point of view afforded by Piotr's camera in the brown paper bag.

Of course, with the advent of DV, technology has improved many fold since the analog Sony that Bikont used to transform the world in the Gdansk shipyards. Today, the DV shooter/storyteller wields many times more power. You can use this power for nefarious or unsavory ends (as some storytellers have done in the adult entertainment industry or you can use your camera to transform the world and create works of lasting beauty for the betterment of mankind.

It all depends on your point of view—and the stories you wish to tell. The DV camera gives you the power. Now the question becomes how to use it wisely, creatively, and effectively.

Figure 1.2 Late in the strike, the camera was ripped from Piotr's hands by government agents and hauled off, still running, to police headquarters. Despite the shaky camera and cryptic images, the visual storytelling is riveting from the inside of a brown paper bag. If the context is right, you don't need much to tell a compelling story. [See accompanying DVD for excerpt from "Ballad of a Strike".]

Wearing Many Hats

Today's DV and HDV cameras offer vastly improved performance over previous analog 8mm or VHS models: better screen resolution, superior color fidelity, greatly reduced video artifacts. The rapid advances in technology have been remarkable, even dizzying, and the fact that camera manufacturers have done so with such economy is even more astounding. Considering the DV revolution of the 1990s, it is easy to see the positive impact on the world: the democratization of the medium, the empowerment of the masses, the incarnation of a new motivated generation of young visual storytellers. You could also cite a litany of successful feature films shot on DV: *Murderball*, *Copenhagen*, and *The Buena Vista Social Club*, to name a few.

But DV has a dark side as well, and it has nothing to do with its relatively high 5:1 compression, reduced color gamut, or often flimsy camera gear. No, my disdain for DV stems from one dispiriting realization, that this cheap technology enables—indeed, encourages!—an appalling lack of discipline in the shooter. Simply stated, given the low or no cost of shooting DV, there is simply insufficient financial penalty for exercising bad craft.

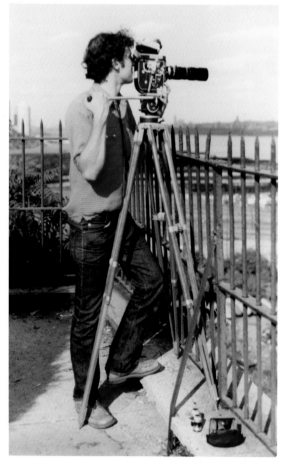

Figure 1.3 *The author with his Bolex 16mm camera on assignment in 1980.*

It used to be if a shooter knew the Five Cs of Cinematography[1] (camera angles, continuity, cutting, close-ups, and composition) that knowledge alone would be enough to assure a reasonably successful career in the film and television industry. For decades, shooters pawed over Joseph V. Mascelli's masterwork, which explained in exhaustive detail the five essential disciplines of the shooter's craft.

When shooting film was our only option, the stock and laboratory costs were high, so the discipline of when to start and stop the camera came with the territory. Shooters and directors *had* to consider their storytelling options before rolling the camera or face severe, even crippling, financial pain.

I can remember in 1976 trying to line up the resources to shoot a PBS documentary on 16mm film. After a long and arduous struggle, I finally landed a small grant for several thousand dollars, and can still recall the gnawing anxiety of running actual film through the camera. Every foot (about

1. The Five C's of Cinematography by Joseph V. Mascelli. Copyright 1965. Silman-James Press. First edition still in print.

a second and a half) meant 42 cents out of my pocket—a figure forever etched into my consciousness. And as if to reinforce the sound of dissipating wealth, my spring-wound Bolex would fittingly sound a mindful chime every second en route to its maximum 16.5-foot run.

So it was the camera and technology of the time that imposed the required discipline and limitations on the shooter. Every shot *by necessity* had to tell a story with a beginning, middle, and end. Every choice of lens, lighting treatment, and background had to be duly considered. A skilled cameraman able to manage the technology and craft was somebody to be respected—and appropriately remunerated.

Figure 1.4 *The Bolex 16mm camera imposed a discipline and love of craft not easily realized in today's low/no-cost auto-everything DV environment.*

Times Have Changed

The five Cs are still relevant, of course, maybe even more so. But look at who is exercising the cinematographic principles now. It's not just shooters. It's anybody with a hand in the digital process: editors, directors, 3D artists, DVD menu designers. Anyone with a late-model Macintosh or fast PC. And that covers just about everyone.

Truth is, the traditional cameraman's role has been eroding rapidly since the advent of the DV revolution. It used to be I was a revered artist whose knowledge of film emulsions and pull-down claws was derived from a lifetime of learning. Shooting film required an understanding of f-stops and shutter angles, A-wind versus B-wind emulsions, incident versus reflected light meter readings. There was a basic expertise required to shoot *anything*.

Now, for a few hundred dollars and little or no training, anyone can produce decent pictures on DV. Which makes for some pretty ugly competition for shooters no matter how talented or inspired we may think we are. For the DV shooter to prosper in the current environment, he or she must become a twenty-first century Da Vinci. There is a definite movement in the industry toward craftspeople who can do it all. Editors, camera people, Photoshop artists—these days, increasingly, we're talking about the same person.

No More Chasing Rainbows

After completion of principal photography for *The Phantom Menace*, George Lucas is said to have digitally rearranged his actors in scenes, re-composed landscapes, even removed unwanted eye blinks from his stars' performances. Alas! No one is safe on this runaway digital bus, not even the actors!

I look upon the current digital onslaught as analogous to life. Just as strands of DNA comprise life's basic building blocks, so do zeros and ones constitute the core of every digital device and software program. Today's shooter now understands this new reality applies to *everyone*. Whether you're an actor, sound recordist, Photoshop artist, or music arranger, it doesn't matter. Fundamentally, it's all the same. We're all manipulating the same zeros and ones.

A few years ago on the island of Maui, I spent an entire afternoon chasing a rainbow from one end of the island to the other, looking for just the right combination of background and foreground elements to frame the elusive burst of color. It was in many ways a typical assignment for *National Geographic*.

Today, I don't think many producers (including the *Geographic*) would pay my exorbitant day rate for a Wild Rainbow Chase. Why? Because producers today, versed in the DV point of view, are much more likely to buy a stock shot of the Hawaiian landscape (or create their own in Bryce), and then generate the rainbow in Boris Red.

These producers, many of whom have migrated from the Web, have learned to harness the digital beast, layering sometimes dozens of elements to compose their scenes. And whereas shooters in the past were responsible for creating well-composed finished frames, today's image makers are much more likely to furnish the elements inside the frame—elements to be rearranged, relit, or completely eliminated later by a multitude of editors, special effects folks, DVD menu designers, and control-freak directors.

Ersatz image creators from across the industry spectrum are receiving visual storytelling training at a feverish pace. And what are they learning? To create the backgrounds that never existed in real life. To shift the color balance and mood of scenes. To crop, diffuse, and manipulate objects in three-dimensional space. In short, to do the shooter's job.

Quel horreur, this DV point of view!

Everybody Is a Shooter Now

If everyone can afford a DV camera capable of producing high quality images, then who needs the shooter specialist at all? And that's what's happening. Producers are increasingly acquiring cameras and related gear

to shoot the projects themselves. If you're an editor, you're in no better shape. Producers have access to the same inexpensive desktop nonlinear editors (NLEs) that you do. Same story for musicians in this godless DV world, with desktop music composers that sound almost as good as having your own 26-piece orchestra at your disposal.

Whoa. No craftsman is safe in this wild converged environment. But alas, the DV shooter may have it worst of all. A few years ago, I was asked to shoot an episode for the History Channel's *Sworn to Secrecy* series. My assignment was straightforward: to fly with a "crew" to Spokane and interview Air Force fighter pilots undergoing wilderness survival training. I was warned that the producers didn't have much money, a *de rigueur* disclaimer on most cable documentaries these days, and that we would of course be shooting DV.

Now, you've got to remember, we were shooting interviews for broadcast, so good quality audio was essential. Thus on the airplane leaving Los Angeles, I couldn't help but notice that the promised "crew" seemed to be quite small—in fact, only the director and myself. I expressed astonishment to my 22-year-old crewmate who broke into a broad smile.

I couldn't help but glare at him incredulously. "What are you so happy about? We've got no soundman!"

"Yes, but I've got a *cameraman*!" he replied with joyous ebullience.

It was then I realized the truth of it all—and the DV point of view. This tyro director, motivated as he was fresh out of film school, was hired to write, direct, shoot, and edit a one-hour show for a respected television series. And what was he receiving for this ordeal of ordeals? $150 per day!

I'm feeling ill as I write this. Maybe I'll just commit hara-kiri and be done with it. But before I do, I might as well offer you a valuable tip. In this brave new world of DV, you *cannot* compete on price. As a shooter, whatever rate you quote, no matter how low, I can assure you that someone else will always offer to do the project for less. If you say you'll shoot a project for $100 per day, someone else with the same DV camera will bid $50. And if you bid $50, someone will do it for $25, and so forth—until some poor loser grateful for the opportunity offers to do the project for "credit."

So forget about undercutting the competition. It's hopeless. We're all shooters now, and we have to deal with it.

Still a Penalty for Being a Rotten Shooter

In the days when film cameras were all we had, the penalty for inefficiency and lack of competent storytelling skills was severe, so the "posers" lurking among us were quickly weeded out and returned to their day jobs. Today, no thanks to the technology, such weeding out seldom occurs. The

posers with their thousand-dollar Sonys or JVCs simply blast away, cassette after cassette, one case of tape after another, until fatigue or boredom finally cuts them down.

Does it matter if they're not getting anything interesting or useful? Of course not. Tape is cheap, they'll tell you over and over, as if that's the issue.

But there is still a penalty for a shooter's lack of discipline, perhaps more than ever. Burning through a truckload of tape will not save you if you're not providing what you or your editor needs to tell a compelling visual story. This means providing adequate coverage, the *range* of shots necessary in order to assemble the finished show in the NLE workstation. In the cable documentary genre especially, you simply don't have time for the novice's shotgun approach to shooting. In DV—*especially* in DV—a successful shooter is consciously editing as he is shooting, watching (and listening) for cut points that will make or break the show in post.

Consider also the effect of returning home to your Final Cut Pro workstation with 50 or 100 one-hour cassettes. Somebody (maybe you) has to go through that morass of material, log it, and then capture it. This can be a costly and colossal waste of time, truly God's payback for not learning good camera craft in the first place.

We're All Plumbers Now

If you're good—really good—at shooting DV, you can still do rather well despite the competition, if you exercise the proper discipline. This discipline merges traditional principles and techniques with the skillful exploitation of DV's real and perceived limitations. It is this ability to make DV *not* look like DV that is today's pro shooter's stock and trade.

I've often thought that my job as a shooter is analogous to a plumber. I know I need different length pipes to complete my task: some straight, some curved, just like I need long shots and close-ups plus a variety of fittings to link them all altogether. These are the slow reveals, the in-and-out of focus zooms, the variety of reaction shots that enable the master plumber—the director—to put it all together.

To survive in the DV world, shooters must learn to attack their subjects with an almost voracious zeal. This means getting very close to your subject or very far away, far above your subject or way below. Medium shots at eye level are just plain boring and are to be avoided like airline food in coach. Indeed, the one thing I've observed in all good shooters is the willingness to get his or her pant knees dirty.

At the end of the day, make sure yours are plenty grubby.

The DV Storyteller

TODAY IS A GREAT TIME for the DV storyteller. Owing to the proliferation of cable outlets, web video opportunities and DVD, the demand for adept DV shooters is enormous, with experienced shooters regularly pursuing an array of interesting and engaging projects. Given the reality of today's fragmented marketplace, however, the DV storyteller must do a lot with relatively little—and that's the focus of this chapter.

Today, the typical low (or nonexistent) production budget for DV programming means that shooters must adopt a highly disciplined methodical approach to the craft. Because the format's low cost tends to work against such discipline, the effective DV storyteller must impose the required discipline on himself—a major challenge to most folks and the DV shooter's greatest peril.

My First Taste

I got my first taste of the DV monster in 1999 while working on a documentary series for the Discovery Channel. The inaugural show, focusing on the world's largest shopping mall in Edmonton, Alberta, was to be part of the network series, *On the Inside*, which examined a range of lifestyle subjects. Until this time, my documentary work had been mostly for the major networks or *National Geographic*, for whom I had shot many educational films and TV specials on 16mm film. This time the exotic "wildlife" I was stalking wasn't the usual gnus and bald eagles but obstreperous

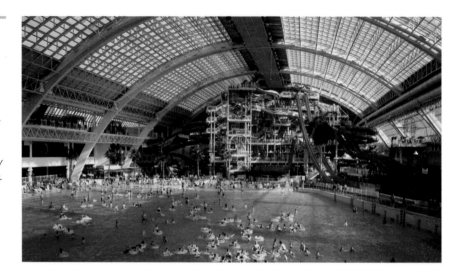

Figure 2.1 *The DV format has opened up a huge demand for documentary programs that can be produced quickly and cheaply. Here the world's largest shopping mall in Edmonton, Alberta, makes the perfect subject for a cable network looking to fill and constantly refill its prime-time schedule. Looking around at the broadcast industry today, the appetite for human-interest "reality" shows appears insatiable. (Photo courtesy of West Edmonton Mall)*

mallrats, overzealous security guards, and flaked-out shoppers who haunt the sprawling mall's corridors and food courts.

From the outset, it was clear this was not just another assignment. Covering 200 acres, the mall housed 500 stores, 20 penguins, a full-sized replica of Columbus's Santa Maria, a tropical water park with a ten-story bungee jump, and the world's largest indoor roller coaster.

Changing Times and Budgets

In the not too distant past, the budget for a one-hour nonfiction program might have been half a million dollars or more and would have been almost certainly shot on BetacamSP or 16mm. The shooter lucky enough to land such a project would have been treated like royalty, assigned anything and everything he could possibly want to make the production run smoothly, including an affable soundman, full lighting crew, and a five-ton grip truck.

Today, the DV shooter can forget most of that. With the advent of cable and much smaller audiences, hard-pressed producers are cranking out programs for a tenth of what they used to. Production budgets as low as $30,000 per program hour are not unheard of in the cable industry, and that amount continues to drift downward as the DV juggernaut picks up steam.

The squeeze affects every aspect of program production. In preproduction, scouting and planning trips have been cut back or eliminated. In post-production, most producers have dispensed with online finishing sessions, opting to output video *and* audio directly from the Avid or Final Cut Pro workstation. To older shooters with years of experience, the changes have

Figure 2.2 *High-priced documentaries of past years like this one shot on 16mm film have largely disappeared. In their place has emerged a flood of low and no-budget projects that challenge the DV storyteller's fundamental understanding of his or her craft.*

been particularly vexing as producers turn to low-end prosumer cameras to capture the bulk of their footage.

From the shooter's perspective, the trick is to maintain a professional look in a medium and business that has gone decidedly downscale. Indeed, for all the scrimping and cutting corners, most viewers still demand

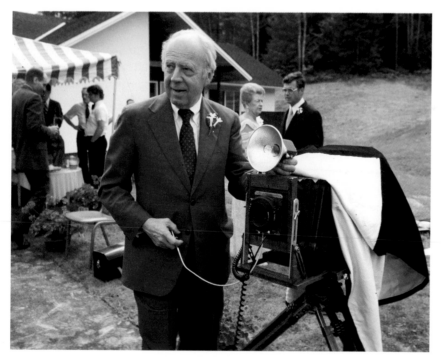

Figure 2.3 *The antithesis of DV. Great American photographer and documentary filmmaker Willard Van Dyke prepares to shoot with an 8 × 10 view camera in 1979. To the great shooters of the past, every shot had to count. Composition, lighting, camera angle—it all had to work and work well. The economics of the medium demanded good craft and good storytelling.*

broadcast-quality glitz whether they're watching *Who Wants to Be a Millionaire?*, a news show, or a neighbor's bar mitzvah. As a shooter who likes to work, and work often, I feel obligated to somehow meet that expectation regardless of monetary and other considerations.

But as the French say, the more things change, the more they stay the same. Craft is and will always be the crucial factor. Not which camera you use, which brand tape stock you prefer, or what tripod you hoist over your shoulder. Craft is the most intangible of all commodities, that elusive quality that places you head and tripod above the next guy who just happens to have the same mass-produced camera with all the same bells and useless digital effects.

Telling a Good Story

As a high school sophomore competing in the 1970 New York City Science Fair, I constructed a bizarre project that garnered considerable media attention. Concocted from an old tube radio, recycled coffee can, photocell, and a hodgepodge of home-ground lenses and prisms, the Rube Goldberg device dubbed *The Sound of Color* aimed to associate specific colors with sounds. In the era of Apollo missions and men walking, driving, and playing golf on the moon, my creation purporting to hear colors did not seem *that* out of this world. Sure, the concept made eyes roll for more than a few hard-core physicists and engineers. But *The Sound of Color* as a riveting story was a huge success, eventually taking top honors at the fair and a commendation from the U.S. Army.

Of course the Army knew that one could not really hear color. But the storytelling was compelling—and isn't that what filmmaking and science fairs are all about? Telling a good story? Just as in any good book or piece of folklore, there are compelling characters, in my case the cool assemblage of discarded junk: the Chase & Sanborn coffee tin turned makeshift heat sink, the pitched squeal of a tube amplifier, and the romance and thrill of a universe populated by fringe patterns and amorphous splashes of color. To most folks, including the Army brass, *The Sound of Color* seemed plausible and relatable—the two criteria that also happen to lie at the heart of every good movie or television show.

Go Ahead! You Can Exceed 108 Percent

In stories that are otherwise riveting, the DV shooter needs not be overly concerned with minor technical anomalies such as the occasional artifact or hue shift, as such (usually) subtle defects are not likely to threaten the integrity of the underlying storytelling. More obvious defects, however,

such as severe clipping of highlights or unintelligible audio, are another matter entirely because such defects may undermine one's ultimate storytelling goals.

Four decades ago, the Army recognized *The Sound of Color* not for its engineering prowess (which was dubious at best) but for its seductive storytelling. In other words, the scientist judges were responding to a *feeling*. And if the United States Army can respond that way, there must be hope for the technically obsessed among us languishing behind their waveforms.

These engineers will tell us that for various technical reasons only 108 percent of a video signal can be recorded to tape before *clipping* and loss of detail occurs. But what does this mean in the context of telling stories with a DV camera? Do we refrain from shooting a gripping and emotional scene because the waveform is peaking at 110 percent? Is someone going

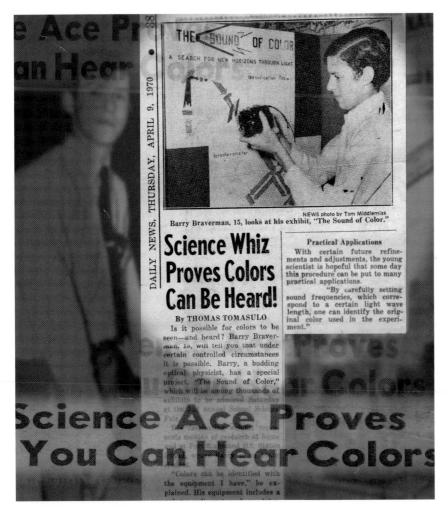

Figure 2.4 *The melding of art and science. As a DV shooter and craftsman, your viewer demands a good story! Make sure you tell a good visual one.*

to track us down like a rabid beast and clobber us over the head with our panhandles?

In the ideal world, engineers provide the tools, not the rules, for effective storytelling. In my 25 years as a shooter, I encountered more than a few irksome engineers who've complained bitterly over what they see as my disregard for sacred scientific scripture.

And that's your challenge: to wed your knowledge of science and the technical to your ultimate goal as a great storyteller. Yes, you need the tools at your disposal—the camera, VCR, DVD encoder, and all the rest—and you should have a decent understanding of all of them. But let's not forget the ultimate goal here: to tell compelling *visual* stories with your DV camera.

Breaking the technical "rules" ought to be a part of every shooter's playbook. As potent storytellers, some deviation from engineers' dictates would appear to be in order, at least occasionally. My intent in this book is not to advance the cause of a know-nothing or launch a pogrom against guileless engineers. Nor is it my aim to prepare you for a life as a formula-crunching physicist. It is rather to offer the shooter-craftsman some insight into a technical universe that is inherently full of compromises. Of course the competent shooter must be knowledgeable of the engineer's world, but the shooter must also recognize that the engineer's mission is not necessarily his own. The skilled DV storyteller knows that compelling stories do not begin and end with the shifting shadows of the waveform.

So go ahead, exceed 108 percent. Blow past it with alacrity. You may lose detail in the highlights, but where's the harm if you move your audience to laugh or cry, smile or grimace? Only make sure those pesky engineers don't see what you're doing. We don't want them having a coronary. After all, we need them to design and build our next-generation 14-bit cameras, decks, and DVD players.

Put a Frame Around the World

Go ahead. Try it. What do you see?

In the 1970s, in lieu of a social life, I used to run around the Dartmouth campus flaunting a white index card with a small rectangle cut out of it. Holding it to my eye, I'd frame the world: a bunch of trees, a dumpster of trash, fellow students mocking me. It sounds silly in retrospect, but the simple exercise forced me to think about what makes a subject interesting, and oddly it often had little to do with the subject itself.

Indeed, I found almost *any* subject could be made visually interesting given the proper framing and point of view. What mattered most in how I framed the world was paradoxically not what I put in the frame but

what I left out—what I was choosing *not* to include in my compositions. To a young shooter learning the ropes this was a major revelation!

If you like the index card idea, you can go all out by adding a second card. Holding the two cards to your eye and altering the distance between them simulates the variable field view of a zoom lens. Expensive equipment manufacturers might not appreciate this (almost) no-cost gimmick, but it can be invaluable to the new shooter developing his eye.

Exclude, Exclude, Exclude

This is the motivating force behind every skilled shooter: every element in a composition is there for a reason. Like every light has a function, every movement of the camera must similarly advance the story.

As we go about our daily lives, the exclusion of irrelevant story elements is subconsciously done for us, as the human eye is adept at framing the world and focusing only on what

Figure 2.6 *Frame your shot carefully! The most valuable skill that a shooter can develop is the ability to exclude what is not helpful or essential in the frame. Telling effective stories with a DV camera demands that you rigorously control your frame's boundaries, like the Old Masters and photographers of old.*

is integral. In our minds, we frame an establishing scene every time we enter a new locale, such as when entering a coffee shop. Our eye is drawn to a friend seated at a table, and as we move closer, we see (in close up) the relevant story details in her face—maybe a tear, a runny nose, or bloody lip. We see these details and try to decipher their meaning, but we don't notice the many distracting elements behind, around, and in front of her. The

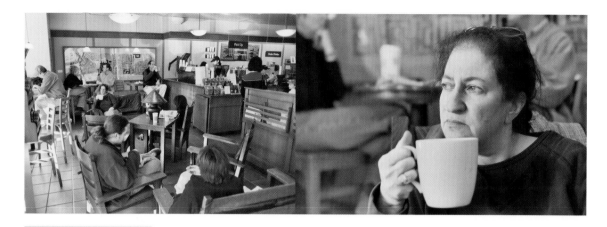

Figure 2.7 *The movie in our mind. Without giving it a thought, our eye frames the scene at right, excluding what is irrelevant to the story. Your DV camera has no such inherent storytelling capability.*

processor in our brains works constantly to reframe and maintain proper focus. And so without realizing it, we are creating a movie in our mind, composing, exposing, and placing in focus only those elements that are essential to our story.

The brain as a signal processor is very efficient. Feel blessed you're not the great comic book artist Robert Crumb, who was reportedly so tormented by urban visual clutter that it eventually drove him mad. Indeed, most of us living in large cities are only able to do so because we've learned to exclude the visual and aural chaos that constantly bombards us. Just as we don't notice the roar of a nearby freeway after a while, we also come to ignore the morass of utility lines crisscrossing the urban sky. The DV camera placed in front of our eye has no automatic ability to ignore the sickening mess.

Backgrounds Tell the Real Story

It may come as a revelation to some folks that backgrounds often communicate more to viewers than the subject itself. This is because audiences by nature are a suspicious lot, constantly scanning the edges of the frame for story clues. As a shooter and storyteller, you're providing your audience a unique window on the world. Is this window opening on a comedy or drama, a sappy love story or gripping war epic? Is the earnest-sounding politician on screen credible or does he come across as an abject liar?

Poor control of background elements may undermine your story and communicate the exact opposite of what you intend. I recall a radical soundman friend in the 1970s who invested every dollar he earned in pro-Soviet propaganda films. His latest *chef d'oeuvre* sought to equate 1970s America with Nazi Germany, and so he hoped to open up the minds of Westerners to the *enlightened* Soviet system. The world has of course

Figure 2.8a,b *Like the clatter of a city subway, visual noise can be just as deafening, as evident in the cluttered LA streetscape above. In framing a scene, the DV shooter must first identify, then exclude the extraneous elements that can undermine clear and effective storytelling.*

changed since then, and few folks would make this kind of movie today, but at the time intellectuals ate this stuff up.

Now, you have to remember this guy was a soundman, so it's understandable that his focus should be on what people say. Indeed, the film was little more than a series of talking heads, consisting mostly of out-of-touch university professors and fellow radicals. In one scene in front of an auto plant in the Midwest, a union foreman roundly lamented his low wages: "Capitalism is all about f—-ing the working man!" he proclaimed.

Not surprisingly, the message and film played well in the Soviet Union where officials were eager to broadcast it on state television. The show when it finally aired drew a large appreciative audience much to the delight of government apparatchiks and the filmmaker, but not for the reason they imagined.

In the scene featuring the union foreman, the labor leader came across as compelling in his tone and choice of words. His remarks *sounded* sincere. But Soviet TV audiences were focused on something else. Something visual.

In the background of this scene filmed at the entrance to the auto plant, Soviet viewers could glimpse a section of the parking lot where the workers' cars were parked. This was unfathomable to Soviet viewers at the time—that workers at a car plant could actually own the cars they assembled. To Russian audiences, the workers' parking lot in the background, full of late model vehicles, told the *real* story—in direct contradiction to what the union foreman was so eloquently articulating.

Figure 2.9 *Don't get stabbed in the back! Rigorous control of background elements is essential if viewers are to focus on what's important in the frame—the story you intend to tell. In every scene you must ask yourself if a background is working for or against you.*

Thus the DV shooter can learn a critical lesson: that audiences believe what they see, not what they hear. An inappropriate or conflicting background can immediately undermine the credibility of a subject regardless of who he is or the pearls of wisdom streaming from his mouth. As my activist friend discovered, the most innocuous background, if not duly considered, can have a devastating effect on the story you're trying to tell.

When you take control of your frame, you take control of your story!

Box-Girder Bridges Anyone?

Compelling compositions can play a pivotal role in communicating the correct visual message. Just as in the construction of the Great Pyramids and box-girder bridges, the triangle can be the source of great strength, lying at the heart of our most engaging and seductive frames.

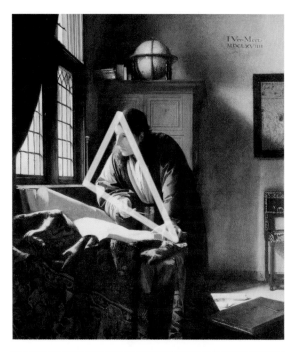

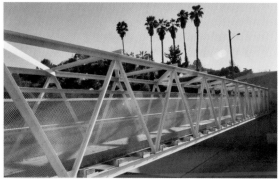

Figure 2.10 *The triangle as a source of compositional strength was widely exploited by the Old Masters, as in "The Geographer" (1668) by Vermeer.*

Figure 2.11a,b,c, d *Like the steel girder bridge, strong compositions often rely on the triangle for maximum strength. Whether realized or not, seeing the world as a series of triangles is a core capability of every competent DV shooter-storyteller.*

The essence of developing a shooter's eye is in effect learning to see the triangles in the world around us. Framing the environment in a series of triangles enhances your visual storytelling skills by helping the viewer identify key elements in your story. In DV/HDV, owing to the limitations of a tiny CCD and often dubious quality optics, we have an impaired ability to resolve fine detail or focus selectively in clearly defined planes This doesn't mean we can't compose strategically, however. The DV shooter, like a builder of steel bridges, derives strength from strong compositions built on the power of the triangle.

The Law of Thirds

For centuries, the power of the triangle has been recognized by artists and engineers who've attempted to codify the overriding compositional principle. *The Law of Thirds,* as it came to be called, divides the frame into roughly three equal parts horizontally and vertically, the artist typically

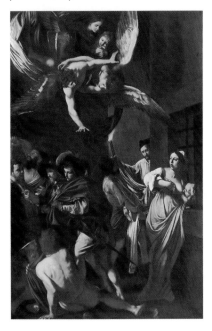

Figure 2.12 *Caravaggio's "Seven Acts of Mercy," painted in 1607. The Old Masters seldom placed the center of interest in the middle of the canvas. You can take advantage of the Law of Thirds as well to achieve powerful compositions.*

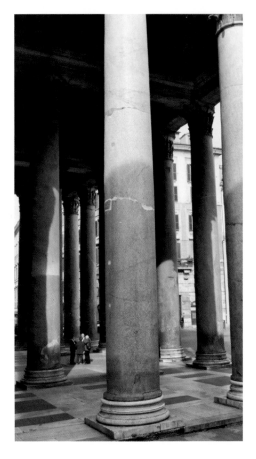

Figure 2.13a *The colossal columns of the Pantheon dwarf the human figures placed at the lower third of the frame. Television's horizontal perspective precludes these kinds of compositions.*

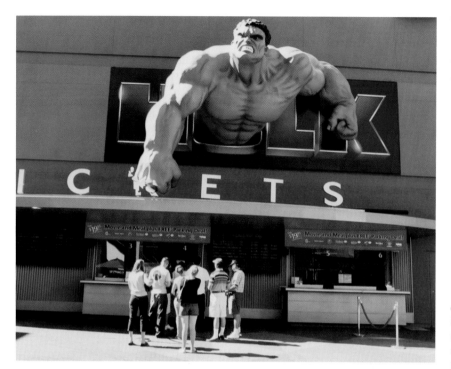

Figure 2.13b *Here the character in the upper two-thirds of frame dominates the ticket buyers below.*

Figure 2.13c *Linear perspective reinforces the strong compositional triangle in the lower third of frame.*

Figure 2.13d *The couple kissing in front of the La Comédie Française occupies a favored position at the right third of the frame.*

Figure 2.13e *An Indian salt gatherer ekes out a living on a salt flat in the Guajira Desert of northern Colombia. The empty two-thirds of the frame above the subject increases her apparent isolation in the desert expanse.*

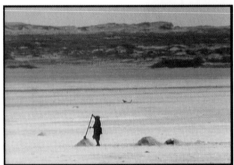

Figure 2.14 *Ouch! Cropping through sensitive areas of the body can cause pain in your viewer. You dig?*

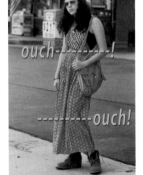

placing the center of interest on one of these boundaries. A composition built on the Law of Thirds can be considered the *de facto* standard for most shooters.

Evoking Pain

But suppose your goal is *not* to make the viewer feel comfortable. Tilting the camera in a so-called *Dutch angle* connotes emotional instability or disorientation. Cropping the head off your subject makes that person seem less human. Running the frame line through a subject's knees or elbows evokes pain in the viewer. Maybe this is what you want. Maybe it isn't.

Proper composition and framing is not about following a prescribed set of rules but communicating a point of view unique to your story. As a skilled shooter, you are obligated to communicate a point of view in *every* shot. This perspective may be one you're being paid to present, but it is a point of view nonetheless—and it *is* your story, at least visually. So go ahead. Express your view of the world. Express it with gusto. Make Jean-Paul Sartre proud!

You Have to Suffer

Consider what your viewer *really* wants when seeing your images zip by on screen. Most of all he wants to be shown the world in a way he has

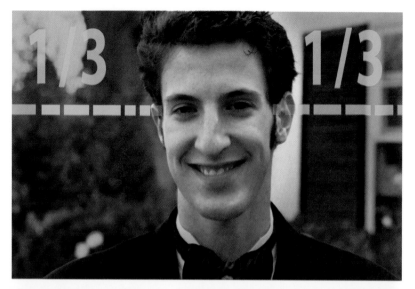

Figure 2.15 *When shooting close-ups, the upper third of frame normally passes through the subject's eyes. Most viewers comfortably accept this composition as correct.*

Figure 2.16a *Knowing when to break the rules is an essential skill for the DV storyteller. I wasn't present for the massive earthquake that struck Mexico City in 1985 but that didn't stop me from recreating the experience in a series of rocky "poorly" composed scenes for National Geographic.*

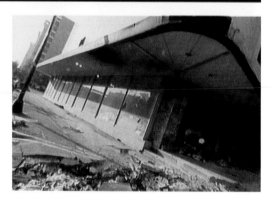

Figure 2.16b *A wrecked building after the 1985 earthquake. The lopsided Dutch angle helps tell the story.*

not seen it before and he is willing to work hard—very hard—to help you accomplish it.

Here's a key piece of advice: avoid like the plague medium shots at eye level. Such shots are boring. It's what we see every day walking past our local 7-Eleven or DMV office.

Figure 2.17 *Hey! Shooting the world in medium shot at eye level is a colossal yawn. This is how you see the world every day.*

Figure 2.18 *Interesting angles help build intimacy by drawing the viewer into your visual story. See? The world can be an interesting place after all!*

I recall interviewing the great photographer/curmudgeon Ralph Steiner at his home in Vermont in the early 1973. Ralph was one the twentieth century's greatest shooters, and his photographs, like his manner of

speaking, were anything but boring. One afternoon he bluntly clued me in to his secret:

"If you're just going to photograph a tree and do nothing more than walk outside, put the camera to your eye and press the shutter, what's the point of photographing the tree in the first place? You'd be better off just telling your viewer to go out and look at the tree!"

For the shooter, finding a unique perspective is not easy. It's painful. "You have to *suffer!*" Ralph bellowed, his voice shaking with passion. "Great photographers have to suffer! Running around with a camera can be fun once in a while, but mostly it's just a lot of suffering."

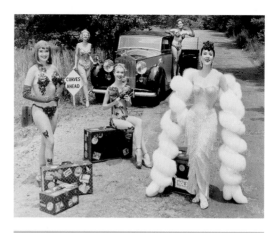

Figure 2.19 *"Curves Ahead" 1944 (Photo of Gypsy Rose Lee and Her Girls by Ralph Steiner)*

Figure 2.20a *Sometimes perspective and success go hand in hand as your career rises to new heights.*

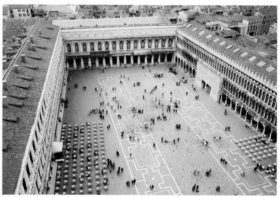

Figure 2.20b *A bird's eye view can offer the viewer a unique perspective. This view is of Venice's San Marco Square.*

Figure 2.20c *Sometimes you just have to lie low to get the shot.*

Figure 2.20d *Or get in the face of your subject and bear her wrath!*

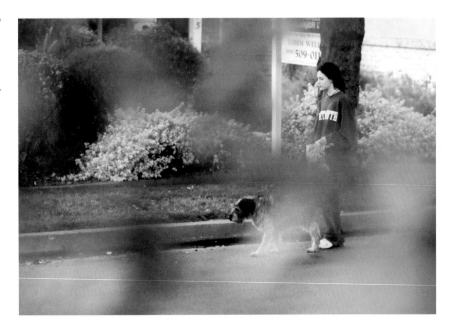

Figure 2.21 *Shooting through and around fore-ground objects can add a strong third dimensional sense and a touch of mystery to your compositions.*

Obscure, Hide, Conceal

The suffering notion is worth exploring because I truly believe the viewer truly wants to share our suffering. Here's what I mean.

If you look at great cinematographers' work, you'll notice that many like to shoot through, in, and around foreground objects. This helps direct the viewer's attention inside the frame, the out-of-focus foreground serving to increase the three-dimensional perspective while also guiding the eye to what's important in the visual story. The DV shooter looking to improve his craft should look for (or create) such opportunities wherever possible—to shoot through high brush or foliage, for example.

But what are we really doing by obscuring or completely concealing the subject at times, then revealing it, then maybe hiding it again? We're mak-

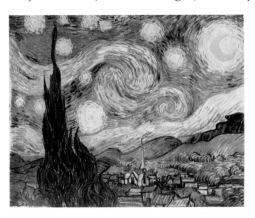

Figure 2.22 *The nineteenth century Impressionists didn't make it too easy for viewers either. Viewing a Van Gogh is an adventure. Try to instill a comparable challenge in your compositions.*

ing the viewer *suffer*. We're skillfully, deliciously *teasing* him, defying him to figure out what the heck we're up to. Yes, point your viewer in the right direction. Yes, give him clear visual clues. But make it a point to obscure what you have in mind. Smoke, deep shadow, or clever placement of foreground objects can all work to various degrees, but

Figure 2.23 *Selective focus can isolate what is important in the frame and help pull the viewer's eye into the scene.*

Figure 2.24 *Cropping of distracting elements protects the integrity of the frame. Be sure to exclude what isn't essential to your story.*

however you do it, the key is *not* to make your viewers' job too easy. Make him wonder what you're up to, make him *suffer*—and he'll love you for it.

Challenging Your Viewer

Making your viewer suffer is a noble and valid strategy, but too much suffering can be counterproductive. While some avant-garde shooters express cerebral justification for alienating the viewer, most of us cannot afford such an outcome given the demands of earning a living and the nature of clients we are normally required to serve.

Figure 2.25 *Use color and contrast to help focus your story.*

Figure 2.26 *A strong composition directs the viewer's attention by de-emphasizing what is not essential to your visual story. Here my son's pointing finger gains weight in the frame while his mom (partially obscured) is compositionally reduced in importance.*

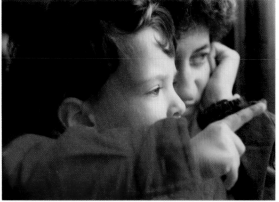

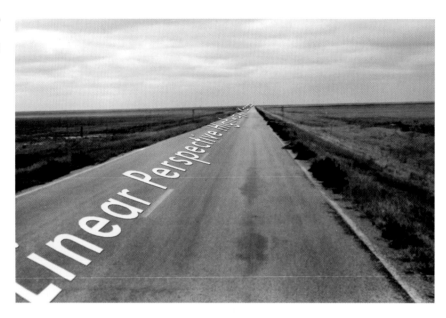

Figure 2.27 *Linear Perspective Highway, Kansas. In most cases, the shooter seeks to maximize the illusion of a third dimension. In this scene, photographed by the author while bicycling across the United States in 1971, the story of the journey is communicated by a highway that seems to have no end.*

The DV shooter must find effective ways to help direct the viewer's attention inside the frame. There are several ways a shooter might accomplish this vital storytelling goal by (1) placing less important objects out of focus, (2) cropping distracting elements out of frame, 3) attenuating the light falling on errant objects, and (4) deemphasizing the offending object compositionally.

Once again, it's a simple matter: exclude, exclude, exclude!

A Matter of Perspective

Figure 2.28 *Aerial perspective gained by looking through increasing layers of atmosphere is seldom used to advantage in DV but is common in classical art and photography.*

Whether working in the traditional fine arts or DV, the artist fights constantly to represent a three-dimensional world in two-dimensional space. One strategy that the DV shooter should always consider when framing a scene is maximizing perspective. The lonely highway converging to a point on the horizon is a classic example of *linear* perspective. *Aerial* perspective is realized from looking through distant layers of atmosphere common in many landscapes. The strategy is less useful in DV owing to the often high contrast and very fine detail.

Besides utilizing perspective to convey a heightened sense of three dimensions, the skilled shooter also usually strives to maximize texture. This can be achieved through supplemental lighting, or as in Figure 2.29, by exploiting the natural quality and direction of the sun and shadows.

Figure 2.29 *This backlit scene with prominent shadows strongly communicates a three-dimensional world.*

Figure 2.30 *The receding cobblestones of a Roman street help lift my daughter from the two-dimensional canvas.*

DV Means Lots of Close-Ups

Figure 2.31a *A tear running down a cheek. Why is she sad?*

Capturing compelling close-ups lies at the core every shooter worth his lens cap, so it is critical you capture your fair share. That close-ups play such a key role in the shooter's craft should not be surprising as television (owing to its small screen) is by nature a medium of close-ups. The relative inability of DV to capture fine detail in wide scenes like landscapes means that an even greater emphasis must be placed on close-ups in your visual storytelling. As a DV shooter, you're shooting close-ups 75 percent of the time!

Remember, close-ups tell your story!

Figure 2.31b *This is the story of a happy couple.*

Close-Ups and Coverage

In Chapter 1, I described the shooter's job as analogous to that of a plumber, he who understands that a total working system requires the appropriate fittings—some way to get in, some way to get out—plus the runs of longer pipe that do most of the work and assure functionality.

In 1987, I was on assignment in Lourdes, one of the most visited tourist destinations in the world. Millions of visitors flock to the grotto in southern France each year where the young Bernadette was said to have seen and conversed with the Virgin Mary in 1858. To the faithful legions, the water in the grotto offers the promise of a miracle, and indeed many pilgrims in various states of health come seeking exactly that.

From a shooter's perspective, the intensity etched into the pilgrims' faces tells the story, and if there were ever a reason to use abundant close-ups, this

Figure 2.31c *Precision machine.*

"*French Precision*" *circa 1952*

would be it. I figured one or two wide shots might be necessary, first to establish the geography of the grotto and the endless streams of pilgrims, and second, to reveal the abandoned pairs of crutches at the grotto exit, presumably by those who have been miraculously cured.

As a matter of course, I work my subjects from the outside in, meaning I do my reveals first in long shot then move gradually closer, exploring interesting angles as I uncover them. This way the viewer can share my own sense of discovery, as increasingly tighter close-ups reveal what's really important to the story.

The search for evocative close-ups can be exhilarating. In the grotto, I worked closer in a series of back and forth angles, the camera riding atop a lightweight tripod, my essential companion for shooting the most riveting close-ups possible.

The close-up story inside the grotto was gripping and emotional: the outstretched hands rubbing across the rock, the pilgrims in semi-silhouette kissing the time-smoothed walls, the intense faces of the believers, their hands clutching a well-worn crucifix or rosary.

Figure 2.32a *This grotto scene from a 1987 network documentary illustrates superb coverage. In the opening shot, we establish the grotto. We reverse and work closer in shot 2. Close-up shots 3, 4, and 5 do most of the work in the scene. The pilgrims crossing in front of the camera in shots 6 and 7 add an element of scope and a third dimension. Shot 8 is a transition close-up that enables shots 9 and 10—a tilt up to the crutches abandoned by pilgrims on the outside grotto wall.*

Figure 2.32b *The abandoned crutches of presumed miraculously cured pilgrims.*

Alas! We Are All Liars and Cheats

As honest and scrupulous as we try to be in our daily lives, the successful video shooter is frequently required to misrepresent reality. Skateboard shooters do this all the time, often relying on the extreme wide-angle lens to increase the apparent height and speed of their subjects' leaps and tail grinds.

In my own experience I recall shooting (what was supposed to be) a hyperactive trading floor at a commodities exchange in Portugal. I've shot in such locales before with traders clambering on their desks, shrieking quotes at the top of their lungs. This was not the case here, with a mere

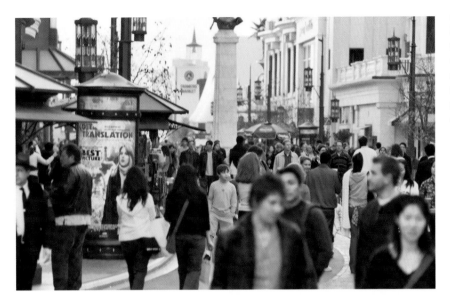

Figure 2.33 *Strategic use of a telephoto to compress space. The crowd at a Los Angeles shopping mall appears larger due to the foreshortened perspective offered by the long lens.*

seven very sedate traders sitting around, sipping espressos, and discussing a recent soccer match. Yet a paid assignment is a paid assignment, and I was obligated to tell the client's story, which included capturing in all its glory and nuance the wild excitement of a modern European trading floor.

So here is what was I thinking. First, forget the wide-angle coverage. Such a perspective would have only made the trading floor appear more deserted and devoid of activity. No, this was clearly the time for using the telephoto end of the camera zoom, to narrow and compress the floor area in order to best take advantage of the few inert bodies I had at my disposal.

Stacking one trader behind the other in frame, I instantly created the impression (albeit a false one) that the hall was teaming with brokers. Of course I still had to compel my laidback cadre to wave their arms and bark a few orders, but that was easy. The key was framing the close-ups filled with activity, the tight shots suggesting an unimaginable frenzy *out-side* the frame boundaries. The viewer understood from the frenetic close-ups that the whole floor must be packed with riotous traders when of course quite the reverse was true.

Overshooting: An Occupational Hazard

Providing adequate coverage is a core capability of every shooter-storyteller. On most assignments, I don't have time to adopt the novice's shotgun approach and shoot everything in sight. Indeed, I am constantly editing while rolling, watching, and listening for the appropriate cut points that can make for a unified and coherent show in the NLE.

One way that a shooter can increase his speed and efficiency is to set some parameters beforehand so he's not providing unnecessary coverage. A cameraperson should know, for example, how much screen time is required from each setup. There's no point shooting hours of tape when the director can only use a few seconds. In the case of the Edmonton Mall shoot for the Discovery Channel, I could have spent all day in the mall's Fantasyland. But how many gorgeous neon shots could the director really use?

The temptation to overshoot is an occupational hazard of the DV storyteller. One reason is the low price of tape media that fails to penalize sufficiently a shooter's lack of discipline. But there's another reason—insecure shooters and directors who lack a clear notion of what they want or need, and thus demand that the camera keep rolling no matter what. These people figure they must be getting *something* if the shooter is blowing through one tape cassette after another.

In the days when craft meant everything and the recording medium (film) was expensive, shooters might barely shoot two 8-minute magazines for a 30-second commercial. If you shot more, you risked being seen as wasteful or even incompetent. Now on some assignments, if you don't shoot a case of stock per day you may be accused of dogging it. "What am I paying you for?" I heard one young producer bitterly complain on a recent cable show.

C'mon. Shooting a *truckload* of tape will not save a production if the shooter fails to provide the appropriate coverage. Sure, tape is cheap. But that's not the whole story. Consider the poor devil (maybe you!) who has to review, log, and capture cassette after cassette of pointless drivel. Regardless of how cheap tape stock is, such an exercise is clearly not a wise use of time and money. As a shooter and ersatz plumber, you must provide the appropriate shots and pipe fittings that will enable your enterprise to come together as one.

It's worth repeating: *It's not how much tape you roll. It's how much coverage you provide.*

Excessive Depth of Field

Inspired framing can be a powerful tool for the DV storyteller, especially as most DV cameras lack clearly defined focal planes. An understanding of depth of field—that is, how much of the frame is in focus from near to far—has been applied for decades by photographers imaging on a range of film formats from 8 × 10 to 1970s-era Type 110 Instamatic. These formats with their much larger image areas have inherently reduced depth of field, a characteristic that facilitates effective storytelling by helping guide the eye to what's important, i.e., in focus, inside the frame.

Figure 2.34 *The tiny CCDs in DV cameras produce extreme depth of field that inhibits the shooter's ability to isolate key storytelling elements. When the entire frame is in focus, the visual story is less clear.*

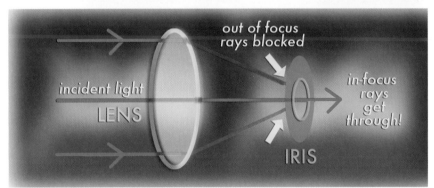

Figure 2.35 *At a narrow aperture, a proportionately larger number of in-focus rays reach the CCD target resulting in (usually) undesirable greater depth of field. For this reason, the DV shooter should take care to use as wide an iris setting as possible so as not to aggravate the small-format's already unfavorable depth-of-field condition.*

Figure 2.36 *Film's larger imaging area features reduced depth of field, thereby helping lift your subject from the canvas and enhancing the visual storytelling and three-dimensional effect.*

Figure 2.37 *The relative imaging area of a typical three-CCD DV camera vs. 35mm and 16mm film formats. Note the actual diameter of a one-third-inch CCD is 6mm; a two-thirds-inch CCD is 11mm.*

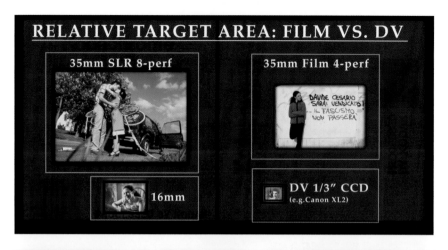

RELATIVE TARGET AREA: FILM VS. DV

35mm SLR 8-perf

35mm Film 4-perf

16mm

DV 1/3" CCD
(e.g.Canon XL2)

Figure 2.38 *Some DV models, such as the Sony DSR-500, use a two-thirds-inch chipset that provides increased resolution and reduced depth of field. Even in larger chipset cameras, the depth-of-field advantage enjoyed by film shooters cannot be approached in DV without specialized equipment like the P & S Technik mini35 adapter. [See Chapter 4.]*

DV shooters are at a natural disadvantage as most cameras feature miniscule chipsets as small as 3mm and thus produce far too much depth of field. It is a matter of physics that the smaller the image format and lens aperture, the greater the range of objects that will appear in focus. The savvy shooter understands this nagging depth of field dilemma, and attempts to find ways to address it.

Shooting Your First DV Feature

Shooting your first DV feature can be a humbling exercise. As audiences generally have loftier craft expectations for features than documentaries, the DV cinematographer must exercise utmost discipline in lighting, camera movement, composition, and lens choice.

Veteran shooters turning to DV for the first time learn quickly there is little inherent elegance in the economical format. Unlike film with its grace-

ful contrast range and softly modulated shadows, DV's punishing blacks offer no such reassurance. Truth is, the DV revolution has torpedoed the careers of many experienced cameramen who thought (falsely) they could simply transfer their age-old film sensibilities to the new medium. Owing in part to many cameras' inferior optics, poor mechanical function, hue shifts, and other anomalies, shooting a feature in DV is anything but a cakewalk, even for the most seasoned and diligent shooter.

Understanding the limitations of the format and equipment may ultimately impact the kinds of stories you choose to tell. In the end, the successful shooter of DV features and commercials embraces the shortcomings of the medium and learns to exploit them creatively.

For Different Reasons

Several years ago, my wife and I attended the premiere of *Titanic* at the Mann Chinese Theatre in Hollywood. The studio executives in attendance were clearly anxious as the $200 million epic unspooled in front of hundreds of clearly under-enthused industry insiders. The movie's trite dialog and banal love subplot elicited more than a few yawns and sighs from the jaded celebrity audience. Indeed, the polite applause at the film's end only served to underscore one inescapable fact: this movie was going to tank—and tank badly.

Of course, things didn't quite work out that way, and the movie went on to become the top-grossing movie of all time. Which only goes to confirm William Goldman's often cited observation about Hollywood, that no one knows anything. But to me, there was a more critical lesson to be learned: *Movies work for different reasons.*

Once released in the marketplace, audiences responded overwhelmingly to the epic tale of a doomed ocean liner. In the face of numerous well-staged action scenes, the world's viewers never questioned the plausibility of Kate Winslet in a sleeveless dress hanging from the ship's bow in the frigid North Atlantic. Clearly, other factors had to be at work for audiences to accept the scene and film, hook, line, and sinker.

For the DV shooter, the lesson is this: long-form programs, whether shot on DV, 35mm, or Fisher-Price Pixelvision[1], *can* be enormously successful if audiences can connect with them on some level. Of course it would be foolish to tell a story with the scope of *Titanic* on DV. On the other hand, a much smaller and more intimate tale could have worked just as well—or better. So when it comes to shooting a feature, commercial, or other project

1. Between the years 1986 and 1989, toy company Fisher-Price manufactured a 2-bit monochrome camera that recorded to a standard audiocassette. Pixelvision's cryptic images continue to attract a following today, as evidenced in the annual PXL THIS Film Festival in Venice, California.

on DV, it is really a matter of recognizing the entertainment value in your story, and taking your visual cues from there.

In 1985, shortly after the devastating earthquake in Mexico City, I interviewed a banker in Mexico's finance ministry. At the time, the country faced severe economic hardship with high inflation and declining GNP, two conditions made many times worse by the scope of the disaster. So I asked the minister what Mexico had to do to survive the crisis. He told me that Mexico had to look honestly at itself and recognize that it could not compete directly with the world's major industrial powers.

"The real issue for Mexico," he told me, "is recognizing its competitive advantages." In other words, what could Mexico do better than any other country in the world? There was no point trying to compete with Japan or Korea, and try to build a better car or TV set. But Mexico *did* have a large and eager labor force that could build the cars and TV sets for them.

Similarly, you the DV shooter must find the competitive advantage in the diminutive format, and then exploit its flexibility and economy in service to your story. In the world market, you will never be able to compete head-on with Hollywood on the level of *Titanic*. But that doesn't mean you can't compete. The DV shooter must simply recognize the strengths afforded by the low-cost medium—and then exploit the hell out of them.

In prominent DV features like Steven Soderbergh's *Full Frontal (2002)*, the diminished look afforded by consumer DV is intentionally made a part of the story. In a sense, the director is following my previously avowed mantra to exclude, exclude, exclude. In this case the filmmaker is choosing to exclude some visual polish in order to achieve a greater storytelling goal. Thus what some of us recognize as the DV Curse with all its harshness and lack of subtlety can also be seen as just another storytelling tool in your arsenal. The format's weakness can also be its strength, if you choose to look at it that way.

You've no doubt chosen DV for its economy and/or the relative inconspicuousness of the camera in sensitive locations. You've also come to accept whatever technical or aesthetic limitations there might be associated with the format. The issue now from a storytelling perspective is how to make peace with these limitations.

Limit Your Canvas

The first business when considering a DV/HDV feature or commercial is to review the script with an eye toward limiting the project's visual canvas. Owing to the format's often less than pristine performance especially in high detail scenes, DV features work best when their core entertainment value is derived from character rather than broad vistas or landscapes. Mediocre camera optics combined with excessive error correction can

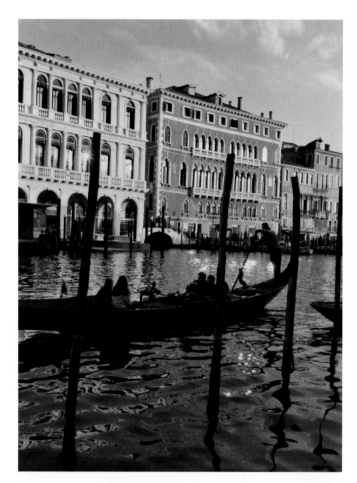

Figure 2.39 *The poor reproduction of fine detail in landscapes makes such scenes as this one on Venice's Grand Canal difficult to capture with DV and HDV cameras.*

Figure 2.40 *The modest images from most DV cameras were never intended for large-screen projection.*

make mincemeat of such scenes; the fine detail potentially falling inside the camera's CCD grid and producing a sea of fungus-like artifacts. These artifacts become hugely apparent when magnified on a 40-foot cinema screen.

Choosing Time of Day

Determining the proper time of day to shoot is a key responsibility of the DV shooter. It's no secret that DV looks really bad at noon but fantastic at dusk. So you and your director might be wise to adjust your story to suit.

Shooting exteriors at midday is an exercise especially fraught with peril. First, there is the risk of *clipping*, the loss of detail in hot, blown-out areas of the frame. The truncated highlights cannot be effectively restored

Figure 2.41a *High-contrast exteriors like this one can be particularly challenging for the DV shooter.*

Figure 2.41b *While the application of a silk can help many daylight exteriors, it may be easier or more economical to simply shift such scenes to early or late in the day. Script flexibility is a major advantage of low-cost DV production.*

in postproduction, so the DV shooter will want to minimize the clipping risk during shooting. Film and video cinematographers have traditionally used silks and butterflies to soften shadows and mitigate the harshness of the midday sun. The DV feature shooter will want to do the same to avert onerous artifacts that could detract substantially from the story. *(See Chapter 6 for more on lighting DV exteriors.)*

Shoot the Magic Hour

Shooting just before dawn or after dusk has been a favorite strategy of artists for years. At the *National Geographic*, my shooting day would typically begin before sunrise and not end until one hour after sunset. In

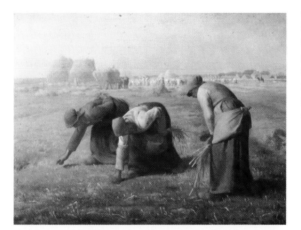

Figure 2.42 *The Old Masters took advantage of the Magic Hour light for centuries. The DV shooter and storyteller should do the same. Pictured here is "Les Glaneuses" by Millet.*

Figure 2.43 *Venice, California, beach at Magic Hour.*

summers, this would result in ridiculously long days, but it was necessary to take advantage of the Magic Hour—that exquisite time of day after sunset (or before sunrise) when the landscape is illuminated only by sky-light. Video shooters, like the Old Masters, should relish this time of day, the shooter being able to produce exquisite results easily with even the most modest gear. With the camera iris wide open and error correction off high alert, shooting at Magic Hour can be where DV really shines!

Embrace the Theory

After more than a hundred years, the conventions of cinema are well established. The DV feature shooter would be wise to understand them. Here is cinema's basic conceit:

1. We see the protagonist.
2. We see what the protagonist sees.
3. We see the protagonist react.

That's it. This triptych is then repeated over and over until the movie concludes some two hours later.

Some filmmakers, including the French avant-garde director Jean-Luc Godard, may pursue various detours along the way, but most cinema (especially American cinema) is essentially constructed on this simple premise. Indeed, one reason why Hollywood stars command such huge fees is because audiences are conditioned to experience the film story though the protagonist's point of view. This intimacy with mass audiences has the effect of contributing mightily to the market value of a relatively few stars.

While close-ups are crucial to building intimacy with the viewer, proper *coverage* is critical to maintain that intimacy. I've remarked previously how the shooter and plumber require various pipes and fittings to build a story. This coverage and range of shots is necessary in order to achieve the most compelling storytelling. Experienced shooters know that a successful production often assumes a life of its own in the editing room; the precise nature

Figure 2.44a,b,c *The cinema distilled to its three-part essence: 1) the protagonist, 2) what the protagonist sees, 3) the protagonist's reaction. In DV-originated programming, owing to the limitations of the format, the viewer should enter the protagonist's point of view as quickly as possible. This has the usually desired effect of building viewer intimacy. Stories and characters in which the viewer feels a strong connection need not be technically flawless. Strong character pieces work well in DV!*

PROTAGONIST LOOKS WHAT PROTAGONIST SEES PROTAGONIST REACTS

Video Shooter

Figure 2.45a *Moving in at an oblique angle enables the viewer to see slightly around a subject, heightening the three-dimensional illusion. Don't just zoom in, come around!*

of this transformation being difficult to fully envision during the actual shooting. Providing proper coverage therefore allows the director to adjust his or her vision as necessary to accommodate a story's inevitable evolution.

Attack Your Subjects Obliquely

Just as a tiger doesn't attack his prey dead-on, so should you not approach your subject too directly. Sometimes the lazy cameraman will simply push in with the zoom to grab a close-up, as in Figure 2.45b. This lazy close-up

Figure 2.45b *The "lazy" close-up.*

Figure 2.45c *Correct close-up. When dollying in, the size and position of the talent in frame may be subtly adjusted. Focus or exposure can also be seamlessly tweaked with the repositioning camera.*

Figure 2.46a,b *Many DV productions display an inconsistency of frame size that is evident in alternating close-ups. The problem stems in part from most cameras' lack of witness marks for zoom and focus. Make a note of the lens and distance settings for each setup, using a tape measure if necessary to maintain subject distance from the camera.*

should be avoided, however, as the intended point of view is unclear, and the story's natural flow and shot progression are disrupted. Better that the camera should come around and enter one or the other character's perspective.

Watch Your Frame Size

Recognizing that close-ups sustain the shooter, the skilled storyteller understands the importance of maintaining a consistent frame size. In narrative projects, particularly in dialog sequences, this can be a challenge. The DV shot progression quickly serves up a series of *single shots*, the close-ups of each player alternating with their respective POVs. If the players on screen are not sized consistently, the viewer may become disoriented

or detached, as the storytelling reflected in each character's POV is less clear. Owing to many cameras' poor mechanical function and design, the task of maintaining proper frame size can be difficult to achieve throughout a sequence.

Hey! No Shopping!

Providing ample coverage is a key responsibility of the DV shooter, but many directors especially those coming from episodic television will frequently ask the cinematographer to shoot everything in sight. Maybe it's insecurity or an unswerving belief in the "I must cover my ass at all costs" principle. Whatever the truth, directors who know the power of close-ups in DV production also understand the efficiency and economy of *not* shooting every scene from ten different angles. The role of the skilled shooter-storyteller is to bring a modicum of discipline to such productions. Yes, tape is cheap and appropriate coverage is desirable. But too much coverage can be just as lethal to a project as too little, as rampant overshooting will quickly put any production seriously behind schedule, and dramatically increase the level of stress across the board.

It's frustrating to work with directors who shop, and unfortunately DV productions tend to attract them in droves. The minimal cost of shooting DV is one reason as newbie directors think it's somehow okay not to do their homework when the financial stakes are so low. The experienced shooter can help these shopper-types choose a direction by helping frame the visual story well before the first day of shooting.

Figure 2.47 *Hey! No shopping! If you're the director, do your homework, know what you want, and communicate that to your crew. To tell a compelling story, the shooter needs clear direction.*

Figure 2.48 *The shooter-storyteller faces a myriad of roads to go down. Be sure you and your crew are on the same one.*

A Woeful Tale

A very green director a few years back had just landed his first national television spot—a public service announcement for a major charity. After years of directing corporate fare, he was convinced this would be his big break, working with an honest-to-goodness Hollywood celebrity, tantamount for many in this business as rubbing shoulders with the gods.

The young thirty-something tyro didn't want to blow it, so it was understandable in the face of such monumental stakes that he arrived on the set shaking like a leaf. Now enter the notoriously less-than-civil Burt Reynolds and you're talking the potential for some serious bloodletting.

As it turned out, Reynolds (reading from a prompter) nailed the 30-second spot on the first take. The take seemed flawless, impossible to improve upon. So the star smiled, nodded his thanks to the crew, and started to rise from his chair. But the green director couldn't quite accept he actually got it in one take. After all, he—God's next great gift to cinema—hadn't even started directing yet.

"Can I get one more for safety?" the director inquired meekly.

Burt hesitated, looking a tad miffed. But okay, the director's request seemed reasonable. The single take could get damaged in post, or there might've been an unnoticed dropout in the recording.

"Fine. You got it," Burt chirped and settled back into his chair. He quickly rattled off a second take—identical in every respect to the first. Once again, he started to get up.

"Hold on!" the director announced, suddenly more confident, gesturing to his stopwatch. "You were a hair off."

Ah, this was the young would-be Spielberg's finest moment. *Finally* he was directing—and a Hollywood star at that! But Burt didn't want to be directed. He just wanted to get back to his limo with the fully stocked bar idling in the driveway.

"A hair," Burt said.

"Yeah. You were a hair long," the director reiterated.

Burt glared. "That's funny. I thought I was right on."

"No, no," the director insisted. "You were a second off."

"Geez. You're tough." Burt fumed. He clenched his teeth. Here he was at the height of his career and being subject to this incompetent twit. But why make a big deal of it? It could make some embarrassing tabloid fodder. So he did it again. Exactly like the first two takes.

"How was that?" Burt growled, his contempt for the director growing with each breath. The young helmer ruminated over the last take. Some-

thing *still* wasn't right. He *felt* it in his bones. What would Francis Ford Coppola do in this situation, he thought? This was *Apocalypse Now* and Colonel Kurtz still hadn't nailed it.

"Can you give me a beat at the end? I need a beat."

Burt's talons were out, ready to annihilate the mosquito. "You need a little beat."

"Yes, please. Sir."

"But the timing was good. Right on, in fact," Burt maintained.

"Yes. The timing was good. Right on."

"I have to congratulate myself for Chrissakes!"

The star was clearly losing it. He looked off to compose himself, mumbled a string of epithets—and did another take. Burt and his hairdresser split for the door. "Thanks, guys!"

The aspiring director still couldn't help himself. "Wait! Where're you going? Some of the phrasing wasn't right to my ear!"

At the door, Burt hesitated, turned back slowly, an incredulous look on his face. He mimicked the young *auteur*'s words in a girlish high-pitched voice: "*Some of the phrasing wasn't right to my ear!*" At that moment the director sensed his directorial debut going down in flames.

Now Burt struggled for the right words. He raised his finger like a gun and pointed it ominously at the director-never-to-be. "Look, do me a favor and never direct a movie. You're tough. You're tougher than Henry Hathaway [a notorious Hollywood *schlockmeister*]. Yeah, I know you don't know who he is because you've only been in this business for EIGHT seconds!"

And with that, Burt stormed out, slamming the door behind him. The ordeal was over. The young director's indecisiveness had sunk his first brush with stardom.

You Shoot, Therefore You Are

Don't read this section if you are a self-absorbed type who believes that shooting is all about *you*. You relish your fanciful gyrations, dips, and swoons to call attention to your genius. In fact you couldn't give a rip about the appropriateness of your shenanigans—the inverted camera, pointless zooms, and weird framings—you just want a vehicle to show off your talents as an *artiste*. Look, it's the same reason you don't pay your parking tickets, put money in the toll machine on the Dallas Tollway, or treat people you don't need very well. You shoot for a living so that makes you a special person, someone to be admired, fawned over, and treated like aristocracy. *You shoot, therefore you are.*

Problem is if you're one of these "special" types someone has to clean up your mess, whether it's a poorly covered scene or an entire sequence

Figure 2.49 *Compositing tools like Adobe After Affects are becoming increasingly relevant to DV shooters who find multiple uses for AE's Color Tracker: to stabilize action footage shot with a long lens; level a bobbing camera at sea; or remove the annoying breathing of the DV camera iris in footage recorded with auto-exposure.*

Figure 2.50 *If you're shooting a racing movie and are a bit short of cars, you can easily paint in a few more with AE's cloning tool. Same for crowds. You don't have to hire thousands of extras to fill a grandstand. The cloning tool in AE can do it for you.*

in which the camera simply won't sit still. If you're a director who has been so victimized, the first order of business is to fire *Monsieur Artiste*. But what about his sickly footage?

Before opting for a costly reshoot, you should know there may be ways to remedy the diseased footage in software. In some cases, the unstable scenes may not have been intentional—for example, when shooting on a wave-tossed boat at sea. I've used the tracker in Adobe After Effects to minimize the rocking effect with excellent results. Of course, it is always preferable to capture such scenes properly in the first place as painstaking remediation later can often be time-consuming and costly.

A Jack of All Trades

So the die is cast. Today's DV storyteller must possess more than rudimentary camera skills. He or she must embrace a range of tools and capabilities that begin with a comprehensive review of the script and storyboard and extend through the completed work as it is seen in a cinema, on DVD, or on the web. At any point in this multi-faceted odyssey, the integrity of our visual storytelling may be compromised due to inept compositing or filtering, careless compression, even poor DVD layout and authoring decisions. It would be nice to think if we did our jobs as expert shooters in-camera that our images would be safe from maladroit manipulation downstream, but that is not the case, not in the wild and wacky world of the DV storyteller.

The DV Storyteller's Box 3

IT SEEMS ANY TECHNOLOGY designed for the masses would be laden with compromises. After all, the mass market is extremely price-sensitive, which means camera manufacturers and their engineers must find ever more inexpensive ways to implement the latest technology.

The demands imposed by the mass market have had a profound effect on the capabilities and features of DV cameras. In generations past, Kodak was said to have designed its popular Kodachrome film *assuming* users would leave the undeveloped film in their car's hot glove box. This expectation of less-than-intelligent behavior played a central role in the product's engineering, and the same can be said for most consumer and prosumer DV cameras. Most models are designed from the outset to require as little user brainpower as possible.

It is paradoxical that many of the folks who demand the latest and greatest camera also insist that the technology be as idiot-proof as possible. It's as if these new-style shooters want the technology to make the creative decisions for them. Auto-focus. Auto-exposure. Auto-white balance. These aren't so much features as sales gimmicks, and relegating such critical decisions to a machine does not a gifted visual storyteller make!

Increasingly, camera manufacturers appear to be transcending this mindless predisposition as more and better models enable increased control of focus, white balance, exposure, and audio levels. Some cameras go even further, allowing shooters to tweak key imaging parameters such as gamma, detail correction, and the color matrix. For the DV storyteller coming to grips with a new, unfamiliar camera, the creative options can be overwhelming.

Auto-Everything: Who Needs It?

Savvy DV shooters understand that creative mastery of the camera's basic functions is imperative for telling visually compelling stories. While novice shooters may be attracted to equipment offering as few choices as possible, the benefit of taking control of one's craft quickly becomes apparent after the first or second significant project.

Figure 3.1 *Effective storytelling with a DV camera requires strict control of focus, white balance, exposure, and audio level.*

Figure 3.2 *Taking control of your camera can be frustrating. This menu selection button may have saved the camera manufacturer a few pennies, but its skittishness will drive you nuts.*

Figure 3.3 *The auto-everything switch on the side of your camera is there for a reason— to be switched OFF.*

Down with Auto-Exposure

As a shooter, proper exposure is key to establishing a desired mood. Unless you *want* to be seen as a rank novice, the auto-exposure feature in your camera should be disabled during shooting. The telltale breathing of the camera iris continuously adjusting and re-adjusting mid-scene is the hallmark of an unsophisticated shooter and will cause untold grief later in postproduction.

Your DV camera may seem intelligent in many ways, but in one respect it most certainly is not. When set to auto-exposure, it will interpret the world and everything in it as 18 percent gray. A solid white wall will be captured as gray even though it clearly is not. A solid *black* wall will likewise register as gray even though it most surely is not. C'mon, camera designers, get with the program. The world is a rich and vibrant place full of color and nuance. It is not all 18 percent gray!

Figure 3.4a *Engaging manual exposure usually requires pushing a button at the back or side of the camera. This multi-function rotary dial controls aperture, white balance, and audio record levels, among other functions.*

Figure 3.4b *The external controls on the Canon XL2 are readily accessible, obviating the need to drill down through a multitude of cryptic menu options.*

Figure 3.5a,b *The world is full of color, but your camera's auto-exposure system, lacking in sophistication, simply assumes everything is a uniform gray. Some shooters carry a gray scale chart to set initial exposure.*

Figure 3.6a,b,c *The "zebras" in your camera can help can help you determine proper exposure. When set to 70 percent (Fig 3.6b), some stripes should normally be visible in your subject's brightest skin tones (Fig 3.6c). The Panasonic DVX features two zebra sets with the ability to input custom values for each.*

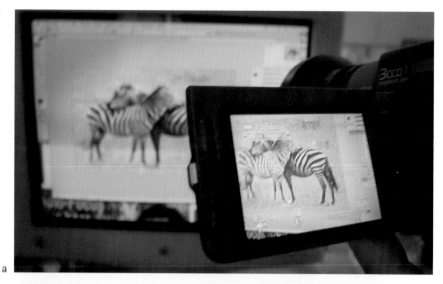

a

b

c

The China Girl

The *China Girl*—who knows who she was or is, whether she's married or single, or even if she's actually more than one person—provided film-based storytellers with a common printing reference for Caucasian skin. The fact that a large part of the world's population is *not* Caucasian seems to have eluded the designers of most motion-picture film stocks. The same appears to be true for DV camera engineers who, like their film-based brethren, mostly live and work in countries located in the northern latitudes, where the facial tones characteristic of the China Girl are the norm.

Figure 3.7a & b, c *Overexposure produces washed-out blacks and a loss of detail in an image's brightest areas (Fig 3.7a). Underexposure (Fig 3.7b) deepens shadows and may result in a loss of detail in the darkest tones. "Correct" exposure is a creative judgment as deliberate underexposure can often add drama to scenes like this one in Paris' Tuileries Gardens (Fig 3.7c).*

Now, I'm not about to dwell on the political correctness of film emulsions, CCDs, or DV cameras. Suffice it to say that your camera's auto-exposure function is trying its hardest to render every image as though we all shared the flesh tones of that China Girl.[1]

Of course, there are times when manual control of the camera iris is simply not possible, when shooting in unpredictable situations or when moving quickly from interior to exterior (or vice versa). So one ought not be too dogmatic about this auto-exposure thing. It's rare that you would

1. In British television, the girl widely used as a reference was reportedly the daughter of BBC's head of video engineering. She still appears on the UK test card though she may well have grown up, married, and had children of her own.

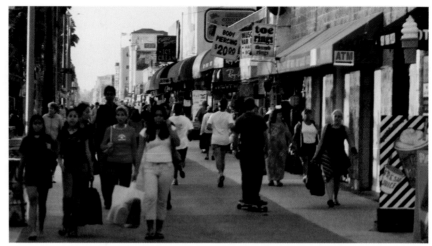

Figure 3.9 *The Caucasian flesh-tone reference presumed by DV camera engineers fails to consider the range of skin colors apparent in diverse populations.*

want to shoot in auto-mode, but when it's advantageous or necessary—say, in the back of a police car on *COPS*—you should go "auto" with your head held high and without undue apologies.

The Auto-Focus Blues

It would be easy to rant about the pointlessness of your camera's auto-focus. It's idiotic. It's only for amateurs. It's the scourge of mankind. And to a degree, it is all true. Auto-focus should generally be avoided like a Neil Diamond TV special on Christmas Eve. Indeed, the very notion of "auto-focus" from a storytelling perspective is dubious as there is no way your camera can know inherently what ought to be in focus in a scene. For the shooter, focus is a powerful storytelling tool. Why would you hand this power off to a nameless engineer who perchance designed the auto-focus parameters in your camera?

Figure 3.8 *This gal may not technically be from the Far East but for decades the flesh tones of an Asian woman have served as a visual guide for filmmakers and laboratory technicians. The China Girl "cut-in" consists of a few frames inserted into the head or tail of every film printing roll; the intent being to provide a common reference for color and density timings.*

Figure 3.10 *The white globe of a professional cinematographer's exposure meter.*

These Guys Are Not Artists

Consider the auto-focus feature in most DV cameras. For some incomprehensible reason, camera engineers have concluded that whatever is at the center area of the frame should always be in focus. Never mind the insights of the Old Masters or Law of Thirds. In most cameras, the shooter is stuck with this illogical conceit, with no ability to target an alternative portion of the frame for auto-focusing.

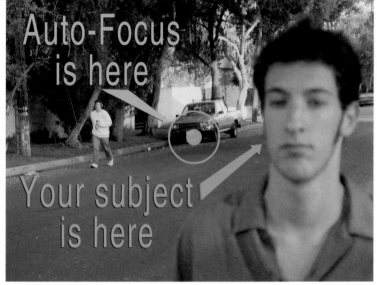

Figure 3.12 *In normal use, the DV camera should be switched to manual to prevent a constant irritating search for focus mid-scene. To focus manually, many cameras feature a push button on the side of the lens or camera.*

Figure 3.11 *The camera's proclivity to maintain focus at center-frame runs counter to most artists' notion of good visual storytelling. Normally we direct viewer's attention inside the frame by assigning relative importance to in- or out-of-focus objects. Only we, the inspired DV shooters of the world, can make this determination!*

Figure 3.13 *A rare capability in prosumer cameras, the Sony DSR-PDX10 features an LCD touch screen that permits shooters to specify an auto-focus zone.*

Thus manual focus (and follow-focus) is imperative. To set initial focus before rolling, zoom in fully, bring the image into sharp focus, then pull back to frame the shot.

You might as well get used to the routine. You'll do it often.

Stand Up for Your Whites

Our eyes can be remarkably adaptive when it comes to perceiving white. We go into a supermarket illuminated by banks of fluorescents and we don't see the noxious green hue. We blow the candles out on a birthday cake and don't notice the strong orange cast. These out-of-balance scenes appear "white" because the processor in our brains color-compensates—the green curse of the fluorescents balanced by magenta, the warm orange candlelight offset by blue—all this done without us ever being aware of it.

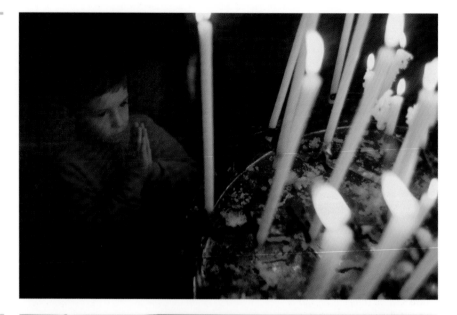

Figure 3.14 *The warmth of the candlelight may not be apparent to your eye, but it could register as excessive to your DV camera whose brain is less capable and forgiving.*

Figure 3.15 *In this London scene, we normally compensate in our mind for the strong neon cast. Your camera needs help to do the same.*

Setting White Balance

To perform a routine white balance, you must first tell your camera what is white in the scene. Direct the camera at any white surface—a white card is typically used—and zoom in as necessary to fill the frame. Press and hold the camera's white balance button or dial. A wedge-like icon in the viewfinder (see Figure 3.18) will blink and then go steady as the camera applies the compensation needed to render what you've indicated as "white" as white on screen.

Figure 3.16 *To compensate appropriately, you need to tell your camera what is supposed to be white in a scene. A white card or paper reference can be useful in scenes like this one illuminated by many sources.*

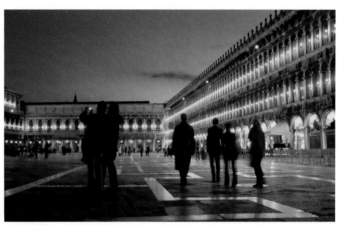

Figure 3.17 *Setting an appropriate white balance is a vital part of the video storyteller's craft. When balancing a warm scene like this one in San Marco Square, you should compensate only enough to alleviate the excessive warmth, but not so much as to remove all sense of place and drama. It's worth repeating: Don't balance your whites at the expense of your story!*

Figure 3.18 *Typical white-balance icon in DV camera viewfinder. When the icon stops blinking, the camera has applied the necessary compensation.*

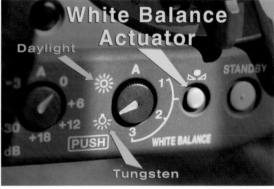

Figure 3.19 *While most DV cameras offer the ability to white-balance manually, the precise manner varies from model to model. The hodgepodge layout of buttons and dials in some models leaves much to be desired. In Canon XL models, white balance controls are easily accessible.*

Auto-White Anyone?

Left in auto-mode, your little servant will obligingly and continuously apply "correction" (even mid-scene!) to compensate for what it perceives to be an incorrect white balance. Warm sections of scenes will be "remedied" by adding blue. Cool portions will get the opposite treatment, a dose of red.

3200° K. Tungsten

Figure 3.20 *Tungsten lighting utilizes lamps that produce a near-perfect white light at 3200° K. Your camera's CCD and processor are designed to respond ideally under this type of illumination.*

PRESET = 3200° K.

Figure 3.21 *A typical camcorder white balance control features A and B manual settings in addition to a 3200° K preset. The configuration here is seen on a JVC GY-DV5000.*

Color Temperature of Common Light Sources

Artificial Light:

Match flame	1700° K.
Candlelight	1850° K.
Sodium vapor streetlight	2100° K.
Household incandescent	2980° K.
Standard studio (halogen lamp)	3200° K.
Photoflood	3400° K.
Daylight blue photoflood	4800° K.
Fluorescent (Cool White)	4300° K.
Fluorescent (Warm White)	3050° K.
HMI	5600° K.
Xenon	6000° K.

Sunlight:

Sunrise or sunset	2000° K.
One hour after sunrise	3500° K.
Early morning/late afternoon	4300° K.
Average noon (Washington, D.C.)	5400° K.
Midsummer	5800° K.

Daylight (mix of skylight and sunlight):

Overcast sky	6000° K.
Average summer daylight	6500° K.
Light summer shade	7100° K.
Average summer shade	8000° K.
Partly cloudy sky	8000°–10000° K.
Summer/winter skylight	9500°–30000° K.

Source: *American Cinematographer Manual*, 6th Edition 1986.

Deep Winter Sky

Figure 3.22 *Scenes recorded under a clear sky may exhibit a strong blue cast especially evident in the shadows. The color temperature of some winter scenes may exceed 20,000° K in the shade!*

Figure 3.23 *Common light conditions and approximate color temperatures. Standard "daylight" is the spectral equivalent of heating a tungsten filament to 5600° K—the daylight preset value in your DV camera.*

You can imagine how a constantly shifting color balance might wreak havoc in postproduction as you struggle to build a visually coherent sequence. What a mess.

Your camera's auto-white feature is an anathema to good storytelling craft. After all, *you* are the master of your camera's domain. You control how your camera sees and feels the world, and that includes, perhaps most importantly of all, instructing your camera what white is. Just bear in mind that the "white" your story demands may well have a touch of warmth or blueness in it.

The White Balance Presets

To facilitate white-balancing your camera under "average" conditions, most DV models include at least two presets for interior and exterior conditions.

The interior preset is intended to capture scenes illuminated by standard tungsten lighting at 3200° Kelvin.[2] This *color temperature* reflects that of a glowing tungsten filament inside an airless glass bulb; the kind of lamp used commonly in lighting kits, soundstages, and film sets. The metal tungsten is used because when heated to 3200° K, it emits a very even spectrum of color—a near-perfect white light.

In nature few sources match the 3200° K standard. Common incandescent household lamps usually exhibit a color temperature between 2600–3000° K, which means scenes recorded under these lights will appear unnaturally warm if the camera's tungsten preset is used with no additional filtration. White-balancing the camera manually adds the appropriate blue offset, thus compensating for the excessive ambient warmth.

For exteriors, DV cameras utilize the tungsten preset with a "standard" daylight conversion, which assumes a nominal color temperature of 5600° K to accommodate an average mixture of skylight and sunlight. The DV storyteller understands that direct sun adds warmth to a scene, while the light reflected from a clear blue sky adds a noticeably cool cast.

So What Is White?

The DV shooter-storyteller understands that white balance is subjective. Shooters for shows like *Access Hollywood* have become quite adept at capturing celebrities coming up the red carpet. These shooters often quickly re-white their cameras in advance of a particular star, adding desired warmth

2. Color temperature is measured in degrees Kelvin, named after the British physicist who first devised a system of quantifying differences in light emitted from objects heated to different temperatures. The Kelvin scale is identical to the Celsius system plus 273°.

Figure 3.24 *Commercial "Warm Cards" can help the DV storyteller achieve a white-balance consistent with a desired mood.*

or coolness to a star's "look" in accordance with the dictates of that evening's gossip mill.

Whiting the camera to a blue-tinted reference infuses subjects with a warm flattering look. White balancing to a reddish source has the opposite effect, instilling a cool cast on an actor perhaps playing a villain in his latest movie.

At first, the references used were makeshift pieces of colored construction paper that each cameraperson would maintain as part of his package. Some shooters even collected scraps of paper to match particular stars: this is the Cameron Diaz, this is the Jennifer Lopez. You get the idea.

Now, if you're so inclined, you can purchase commercially available reference cards in a range of warm and cool tints. It's an easy, inexpensive way to control white balance and mood—a matter that ought to be of interest to every shooter looking to make the most of the economical DV format.

Navigating the Format Morass

Objectively speaking, there isn't much difference between the competing DV formats. Consumer DV, Sony's DVCAM, and Panasonic's DVCPRO share the same compressor, 5:1 compression ratio and relative strengths and weaknesses.

Figure 3.25a *DV is DV. Apart from the physical cassette, the functional difference between DVCAM and DVCPRO is insignificant.*

Figure 3.25b *In Pana-sonic camcorders like the AJ-SDX900, the same one-quarter inch tape media is used for 25 Mbps and 50 Mbps recordings.*

Figure 3.26 *The term "miniDV" is often used synonymously with the consumer DV format. In fact, miniDV refers to the cassette's physical size as Sony's DVCAM and DigitalMaster tape are available in full-size and miniDV configurations.*

DV: A Brief History

In 1996, Panasonic introduced the first professional line of DV equipment. Dubbed DVCPRO, the company's first cameras and decks were an instant hit, providing ENG[3] news organizations with a low-cost digital alternative to Sony Betacam SP.

Clearly, Panasonic never envisioned DV as a mass-market medium, instead designing and manufacturing its DVCPRO gear primarily for the rigors of the ENG and broadcast markets. Citing the needs of itinerant news crews, Panasonic cameras were (and continue to be) extremely rugged, the early models lacking an IEEE 1394/FireWire interface, which at the time was thought little benefit to professionals. The DVCPRO format specified a robust 18-micron track pitch and two linear analog tracks to ensure precise

3. ENG is a common industry acronym for Electronic News Gathering.

cueing in broadcast control rooms. In every way it seemed the DV format as envisioned by Panasonic was an electronic news gatherer's tool.

A year after DVCPRO was introduced, Sony joined the fray, debuting its own DV25 version, known as DVCAM. Like Panasonic, Sony's early decks also lacked a FireWire/iLink port, underlying the manufacturer's view that DV and Apple's emerging FireWire standard were not necessarily inextricably linked.

The physical size and shape of the DVCAM cassette differed significantly from Panasonic's DVCPRO. Sony also narrowed the track pitch to 15 microns and declined to incorporate the analog cueing tracks. The resulting DVCAM format may not have been significantly better (or better at all), but it was different—and it was Sony's.

FireWire Enters the Picture

For manufacturers seeking to market low-cost cameras and decks to the masses, DV seemed to offer the ideal compromise between the high compression mandated by economics and reasonably good performance; from a business perspective; the salient point being DV's low data rate of 3.6MBps which enabled easy and cheap movement of digital files on the desktop.

DV visionary Charles McConathy was one of the first engineers to recognize the implications of DV's low data rate with respect to the nascent consumer market. He noted specifically how inexpensive IDE drives could be used for capturing and editing video in realtime on an ordinary home computer. Given DV's modest 25Mbps data rate, he realized that common hard drives, even at a lumbering 5400 RPMs, could easily handle playback of realtime audio and video DV streams. It was this capability in tandem with Apple's FireWire in Macintosh computers that ignited the DV revolution.

Figure 3.27 FireWire (IEEE 1394) precipitated the DV revolution by enabling fast and easy exchange of data to and from the camera and computer. The fragile 4-pin connector at the camera is the cause of many failures. Handle with care!

Figure 3.28 A more rugged 6-pin connector is used on FireWire drives and to interface with your computer. A native FireWire port lends increased reliability and ease of use to the Macintosh platform.

Sync via Firewire to another XL2

Figure 3.29 The Canon XL2 can be synchronized via FireWire for multicamera applications. A third-party SDK[4] protocol is necessary for this purpose. The HDV Canon XL-H1 features input and output of SMPTE timecode and true genlock capability.

4. A Software Development Kit (SDK) provides the tools and guidelines for third parties to create support applications.

The Advent of Consumer DV

Amid their proprietary posturing, the competing manufacturers enthusiastically embraced consumer DV, a low-cost variant that would have profound implications for digital video storytellers around the world.

The point of a consumer format was simple: to enact subtle changes in the DV specification that would enable a significant drop in the price of cameras and related gear. The changes were intended to increase the mass appeal of DV, by automating many "pro" features and by substantially increasing the running time of the DV cassette.

A reduced ten-micron track pitch and a 33 percent slower tape speed substantially extended the run time of the cassette, which appealed to consumers eager to stretch their three-dollar per tape investment. It also gave consumers an *understandable* basis upon which to base a buying decision. If you're hanging over the counter in Circuit City considering two similar-looking cameras—one that can record 42 minutes on a single tape, and the other that can record a full hour—it's a no-brainer which one you should buy, right?

Challenge to Shooters

The consumer format poses notable challenges to the DV shooter-storyteller. Its narrow track pitch sacrifices a degree of robustness in the video signal and effectively precludes editing back to tape. If you need to replace a scene in a two-hour program, the most expeditious thing would be ideally to *insert edit* the alternative scene in an existing tape. You can do this on some DVCAM and DVCPRO decks, but the narrow track pitch of consumer DV

Figure 3.30 *Sony's DCR-VX1000 introduced in 1995 transformed the kinds of stories that could be told—and by whom.*

eliminates this option, thus requiring the entire program to be re-output over many hours from the NLE.

Locked versus Unlocked Audio

The consumer DV format also poses a challenge with respect to audio. In the professional DVCAM and DVCPRO formats, each frame of audio is locked to a corresponding frame of video via timecode. Locked audio ensures accurate audio and video synchronization throughout the editorial process, and has in fact been integral to professional video production for years.

In DV cameras, the oscillator is a critical but expensive component, providing a precise reference for the digitized signal. To reduce cost and presumably sell more cameras, the manufacturers opted to incorporate a less precise clocking mechanism that allows the audio to drift. The camera thus can take a fraction of a second longer if necessary to compress the video; the associated audio for any given frame being allowed to slip and then catch up (hopefully) in due time.

Normally this slight drift is hardly noticeable as the discrepancy is limited to a seemingly insignificant one frame every ten minutes. A continuous one-hour interview, however, is another matter as the drift then might extend to as many as *six* frames, a sizeable offset in sound and picture that would be immediately obvious.

Unlocked audio in consumer DV thus has implications in the NLE timeline, since at any point a cut through the video may not associate the correct audio frame. The DV storyteller should bear this in mind when capturing consumer DV into Adobe Premiere Pro, Apple Final Cut Pro, or other editing system, the potential exists for a loss of sync, especially in very long takes.

Figure 3.31 Once upon a time, Final Cut Pro 2 provided Auto Sync Compensation to help monitor and correct the drift from consumer DV sources. The system proved unreliable and was subsequently abandoned in later versions of the software.

Tale of the Tapes

It seems only logical after you've spent thousands of dollars on a camera that you should *not* buy the cheapest tape media you can find. After all, a lot is riding on the critical point in your camera where the cobalt meets the road.

In a world of optical media, WiFi and Bluetooth, the physical dragging of evaporated cobalt grains across an electromagnet may seem crude, but for the DV shooter-storyteller, this seemingly unsophisticated process underlies our very existence.

The capture and reproduction of images from videotape is a process fraught with peril. Dew or condensation can form under humid conditions and instantly shut the camera down. Dust and debris can migrate from the tape edges onto the recording surface and produce ruinous dropouts.

The risk is serious and the choices many as DV shooters face considerable confusion when selecting tape media. First, there is the dubious consumer ilk you can pick up for a few bucks at your local Walgreen's. You know you shouldn't be using this stuff for anything serious, but you swear you can't tell the difference, so why not scrimp?

Then there is so-called "professional-grade" media. This is the next step up from the consumer fare, and it should be the least you consider for serious work. Sony's DVCAM stock is particularly robust, and conveniently comes in a miniDV configuration for use with consumer-format cameras like the Canon XL and Panasonic DVX.

Adding to these choices, DV shooters now have a third option: *master-quality* tape. The slitting of master-grade stock is considerably more precise than lower grade media, and thus reduces the amount of edge debris that can potentially migrate onto the tape surface. This dirt can lift a camera record head from the medium and cause dropouts and loss of data. Master-grade tape reduces this risk by 60 percent, according to engineers at Sony.

Figure 3.32 *Just as in life you face a lot of choices in tape media. For your own sanity and piece of mind, stay away from the cheap stuff.*

The DV shooter should always exercise care in tape handling and storage. Carelessly tossing loose tapes into the bottom of a filthy knapsack is asking for trouble—and you'll almost certainly get it. Shooting in less than pristine locations such as manufacturing plants or on a beach amid blowing sand and grit can also be conducive to dropouts as dirt can penetrate the tape storage box, cassette shell, and ultimately the camera transport itself

Dirt and other contaminants are a significant cause of tape deterioration over time. The short shelf life of consumer media (as little as 18 months under some conditions) should be of concern to every shooter as many producers routinely delete the capture files from their hard drives, and thus rely exclusively on the integrity of the original tape media for backup and archiving upon completion of their projects.

Mixing Brands of Tape

It is usually not advisable to mix brands of tape as the chemical lubricants used by different manufacturers may adversely interact and cause head clogs or corrosion leading to dropouts. Be a loyal user of a single brand of tape media if you can.

As we look ahead to more demanding HDV high bit-density recordings, it's clear we'll be working our 6mm tape media very hard. Master tape's reduced dropouts and lower noise floor (to help minimize read errors) is especially crucial to the HDV shooter who demands optimal image quality and maximum reliability from his tape media.

Dropouts and Errors

When evaluating tape media, the standard should be no dropouts, no errors. Some shooters may not understand the difference so let's set the record straight. A dropout is a loss of data caused by the lifting of the record head from the tape surface, usually as a result of dirt or debris. A bit stream error may have multiple causes, including worn heads or excessive tape noise that can obscure a signal. Shooters must recognize that while bit errors in the video stream may be correctible, similar errors in the *audio* are not, leading to the loss potentially of critical dialog.

Recording to Hard Drive

Recording directly to a camera-mounted hard drive offers many advantages as tape and transport snafus, media damage, and dirt or humidity issues are eliminated. Workflow is also more efficient as the need to capture in real-time into the NLE is averted since the FireWire drive can be mounted on the computer desktop just like any other drive. As HDV comes of age with its more stringent demands on tape media, direct-to-hard-drive recording may become more commonplace.

Hard-drive recorders offer the DV shooter a range of options not possible on tape-based systems. For one thing, a hard drive recorder may enable recording to tape *and* disk simultaneously, a distinct advantage for applications with fast turnaround times such as the preparation of rough

Figure 3.34 *The Frame-Store FS-3 hard-drive recorder fitted to a JVC GY-DV5000. Once removed from the camera, the unit operates like a standard FireWire drive, mountable on any Mac or IEEE 1394–equipped PC. This 40GB drive can record up to 184 minutes of DV video.*

Figure 3.35 *Sony's PDW-510 brings XDCAM efficiency to the DV shooter.*

cuts or DVD dailies on a commercial set. Some hard drive models can record continuously from tape-to-disk or disk-to-tape in order to extend overall media recording time. For ENG, wedding, and event shooters, the loop mode ensures that the camera will never run out of media, the same disk space being recycled continuously if desired.

Recording to Optical Disc

Sony's XDCAM blue-laser disc system offers many workflow advantages. Recording in DVCAM, the shooter generates thumbnails of every scene, which can be referenced later when creating a *meltdown reel*. Good takes can be saved; the crap deleted.

Which brings up a salient point about recording to optical disc (or memory card for that matter). Each shooting day we generate a large volume of footage, which must be off-loaded to a hard drive. The good takes culled before the original tapes in their entirety are logged, labeled, and consigned to shelves or boxes in a closet or some Kansas cave. It's a colossal waste of time, money, and space to back up and archive terabyte upon terabyte of captured media, 98 percent of which we've *already* rejected. No wonder we face such immense media overload; we don't separate the wheat from the chaff soon enough.

The XDCAM disc-based system enables much needed efficiencies in this regard. Culling the original camera material in the field dramatically reduces the volume and subsequent handling of footage downstream. The meltdown cut becomes a key part then of the DV shooter's updated workflow as it can be prepared easily and quickly prior to offloading only the select takes to a workstation hard drive.

Recording to Memory Card

The speed, efficiency, and reliability of recording to optical disc or memory card are compelling. No shuttling through hours of tape cassettes. No pesky dropouts due to migrating dirt or edge debris, and no camera shutdowns due to condensation forming on the record heads. File handling is as simple as mounting the disc drive or card reader on the computer desktop, providing simple and fast drag-and-drop transfer of files. Realtime capture sessions are no longer required.

Panasonic's P2 memory card system offers additional advantages. The solid-state cards eliminate moving parts in the camera, which contains no springs, tensioners, pressure pads, or spinning disc mechanism. The memory card system also features a faster recording response time compared to tape or disc recorders. Recording can begin instantly upon startup without the need to wait for a drive mechanism to properly engage or "get up to speed."

Figure 3.37a,b The Panasonic AJ-SPX800 records DVCPRO at 25Mbps or 50Mbps onto five P2 memory cards. The camera features virtually no moving parts ensuring absolute reliability in the field. The flip-out screen is a first for a camera of this high quality.

Seeing What You're Getting

In general, you want to be sure to record 30 seconds of bars and tone at the head of every camera cassette. This will help ensure a proper A/V reference and smooth workflow through postproduction. Not all DV cameras output standard SMPTE color bars, which you'll need to set up your field monitor.

Figure 3.38 *The P2 card is the epitome of simplicity and reliability. With a 4GB capacity, it can store about 16 minutes of DVCPRO video at 25Mbps. Future higher capacity cards will extend practical running times substantially.*

Figure 3.40 *The Canon XL2 enables the reference color bars via an external switch.*

Figure 3.39a,b *The SMPTE color bars at upper left are the industry standard. The non-standard bars below are colorful but relatively useless. The zebras seen in the yellow swatch are set to 70 percent.*

Figure 3.41

Proper Calibration of NTSC Monitor

I. To Set Brightness ("Luminance")

Also known as black level. You can use a wave-form monitor if necessary to verify black level at 7.5 IRE—the U.S. black level standard. (In Japan this black level is set to 0 IRE.) Refer to the *pluge* at the lower right of the color bars.

Figure 3.42a *Color bars*

The 5 IRE bar at left is blacker than U.S. NTSC standard. The bar at right is lighter than standard at 10 IRE. The bar in the middle is correct at 7.5. Adjust the brightness until the left and center bars appear the same, but you can still distinguish the bar at right.

Figure 3.42b,c *Pluge detail incorrect; correct.*

II. To Set Contrast

Adjust the contrast in the white patch at left so the white appears to bloom into the adjacent areas. Back off slightly until the blooming disappears. The brightness and contrast are now set properly.

Figure 3.42d *White Bar*

III. To Set Color Saturation ("Chrominance")

Turn on *Blue Only* on the monitor and note the bars at each end of the pattern. Adjust the chroma until these bars match the reference patches below them.

Figure 3.42e *Chroma Bars*

IV. To Set Hue

Now adjust the hue until the middle pair of bars match the lower set. When properly adjusted, the two sets of bars at top and bottom should appear continuous.

Figure 3.42f *Chroma Bars*

Black Level Setup Quandary

The black level or "master pedestal" setting in your camera establishes the video level for pure black. When set too high, blacks appear gray and washed out. If set too low, darker gray tones appear "crushed."

The setting of the camera's black level should be a simple affair. In digital video the camera invariably records to tape pure black at level 16 and pure white at level 235. In NTSC 8-bit space, that's the way it works—nice, easy, straightforward.

The confusion regarding black levels arises as DV shooters output to an *analog* monitor for evaluation, or record to their camera from an analog source like VHS or Umatic.

Figure 3.43 *In 8-bit digital video NTSC and PAL, the range from pure black to pure white is 16 to 235. While level 16 always represents pure black in digital video, there are two black level standards to deal with in analog video.*

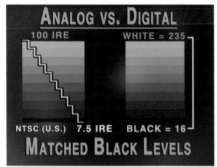

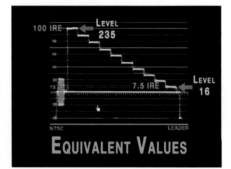

Figure 3.44 *The equivalent (U.S.) values for analog and digital video are noted on the waveform.*

Figure 3.45 *To determine the black level of unknown video, check the waveform against the darkest portion of the frame.*

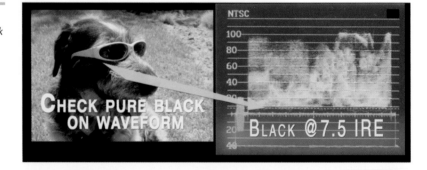

Figure 3.46 *Many DV cameras, especially older models, output analog black at Zero IRE so images appear deceptively dark on standard displays in the U.S. Setup levels at zero and 7.5 IRE are apparent in the two waveforms.*

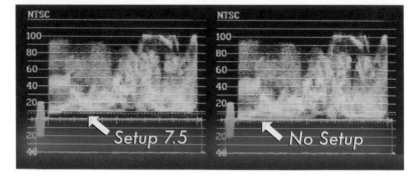

Figure 3.47 *Serious Magic's DV Rack recreates the utility of a waveform monitor and other hardware in software.*

Figure 3.48a,b *Maintaining proper black levels throughout a production is a key responsibility of the video storyteller. When capturing analog video to a digital VCR or camera, be sure the capture device knows where black is.*

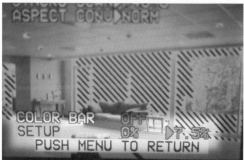

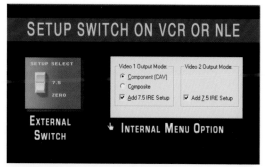

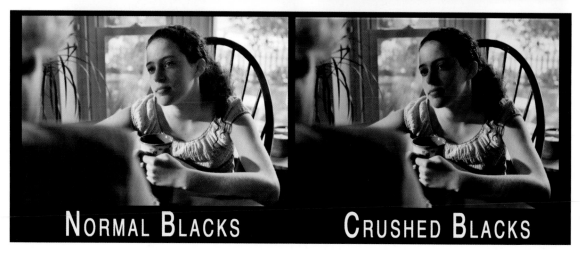

While there is a single black level setup in digital space (level 16), there are two in analog: 7.5 IRE as found in the United States, and Zero IRE as found most notably in Japan. Many consumer DV cameras especially older models output black via their analog jacks with Zero Setup. In such cases,

Figure 3.49 *Crushed blacks drain life from your images and suppress detail that may be crucial to your story.*

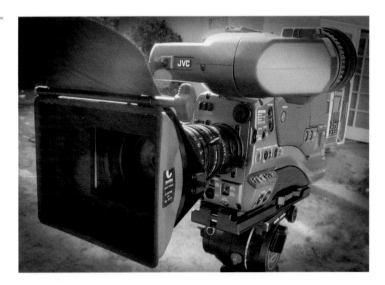

viewing of DV images on an NTSC display set to 7.5 Setup will result in scenes with noticeably crushed blacks. The shooter should then not compensate in lighting or exposure, as the dark images on the monitor are not indicative of what is being recorded to tape. This means if you're shooting with a Canon XL1, XL1-S, Sony DSR-PD150, Panasonic DVX100, or similar vintage camera, what you see on an external monitor is *not* necessarily what you're getting.

If you're shooting with one of these cameras, the easiest way to address the black level problem is to adjust the monitor's calibration to reflect the analog output Zero Setup condition. You can accomplish this by setting the pluge value slightly higher when displaying the color bars. The raised brightness in the monitor will give you a better idea of what is actually being recorded to tape, however imprecise this makeshift approach may be.

Beware in some DV models, the camera Setup switch in the menu options *also* affects the *recorded* black level, so the 7.5 setting actually raises the digital black level to 32—twice as bright as normal! To determine if your camera is affected in this way, attach your camera's DV output to a digital VCR or NLE, then watch the effect on a monitor as you alter the switch position. There should be no difference in the viewed image since the Setup switch should not be affecting the digital levels in-camera.

The Imperfect CRT

In the ideal television system, there is a precise 1:1 relationship between what the camera sees and what the monitor ultimately displays. If equal amounts of red, blue, and green are fed into a camera, the same proportion of red, blue, and green should be evident in the display device.

The NTSC television system is rife with compromises, not the least of which is the (assumed) CRT display. Interestingly, your camera's CCD is capable of producing near-perfect images, but this perfection must be sacrificed in order to compensate for the anticipated distortion in the home receiver. The Achilles' heel of our digital world is the pathetic NTSC display, which subjects the entire visual storytelling process to the vagaries of skewed digital-to-analog wrangling.

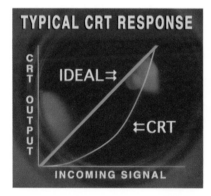

Figure 3.52 The default settings of many cameras contribute heavily to the "DV Curse," a condition characterized by harsh, brassy, high-contrast images. The shooter seeking to alleviate the curse can access an array of menu options to help alter the look and feel of the visual story.

Figure 3.51 A straight green line reflects the ideal camera and NTSC display response. A DV camera must compensate for the distortion in the NTSC CRT display by skewing its response in the opposite direction. Not all cameras apply this compensation (aka gamma correction) sufficiently or in the same way.

What's on the Menu

With DV cameras gaining increased acceptance among industry professionals, the shooter-storyteller is finally gaining the capability to perform meaningful tweaking under the hood. Remember that shadows communicate the essence of your visual story, delivering to the viewer a sense of genre, mood, and, often times, the protagonist's mindset.

Black Stretch

There are a number of ways to tackle overly dense shadows. Proper lighting and/or the appropriate camera diffusion filter[5] can certainly improve the situation substantially. So can enabling *black stretch* in cameras like the Panasonic DVX. Black stretch can improve shadow detail by producing more shades of gray in the darkest areas. The potential drawback is an increase in noise, so black stretch should always be applied with proper caution.

5. See Chapter 9 for more information on camera contrast-control filters.

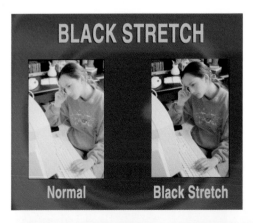

Figure 3.53 *Pictorial representation with and without black stretch applied. (Illustrative images courtesy of JVC.)*

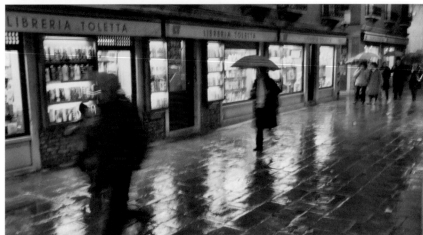

Figure 3.54 *While many shooters use black stretch routinely to enhance shadow detail, its counterpart, black compress, may be useful in night scenes to suppress noise in underlit shadows. The correct look will depend on the story you're trying to tell. Suffice it to say that low-contrast scenes are seldom a problem in DV.*

Figure 3.55 *Black stretch/ compress toggle switch on JVC GY-DV5000.*

Gamma

Not to be confused with gamma correction, which compensates for the distorted response in the NTSC display, camera gamma determines the range of tones reproducible in the straight-line portion of the characteristic curve (see Figure 3.56a). A lower gamma (i.e., a less steep line) enables more tonal graduations, and thus may help retain shadow detail. A too-low gamma, however, will produce lifeless washed-out images as the midtones and highlights are likewise lifted along with the shadows. Conversely, a

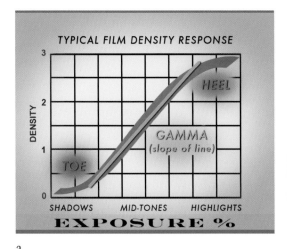

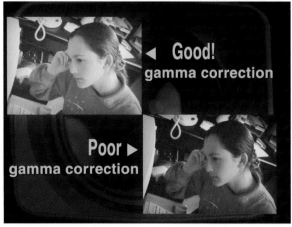

a b

Figure 3.56a,b *Even though a lower gamma (less slope) helps attenuate dark shadows, most shooters will want to stick with a normal gamma for routine applications. The cine-look mode is designed to mimic the gentle toe and knee response of motion picture film. (Illustrative images courtesy of JVC.)*

higher than normal gamma may yield images with a plastic surreal look as the increased contrast imparts a wax-like finish to faces and flesh tones. Hey! This may be the effect you're looking for!

An increasing number of DV cameras are offering a range of gamma modes, including *cine-look*. The intent is to modify the characteristic curve to better reflect film's wider tonal response in the shadows and highlights ("toe" and "heel").

Detail Correction

Detail level affects the perceived sharpness of a scene by placing a hard, high-contrast edge around objects. Altering the detail setting affects the thickness and appearance of this edge.

When detail is set too high, images acquire a "video" look that many folks associate with the DV Curse. When camera detail is set too low, images may appear soft and lacking in definition. Some cameras allow reducing detail specifically in the flesh tones, which may be desirable to cover imperfections in a starlet's complexion. Use care when dialing down *skin detail,* however, to avoid a ghoulish look. I knew a shooter once who leaned on this gimmick too much, transforming an actress's face into a soupy undefined blob. That shooter is now selling shoes somewhere in the Midwest.

Reducing the default detail setting in the camera should be the first priority of every shooter as the elevated values favored by manufacturers contribute mightily to a hard plastic look. One reason that manufacturers seem to prefer high detail is to compensate for a camera's inexpensive optics that lack good resolution and contrast. Some camera makers also apparently believe that many unsophisticated buyers *prefer* a "sharper" hyper-real look.

In the natural world, objects seem to transition gently from low to high contrast areas. The smooth transition is evident even in high-contrast scenes like this silhouette of a skateboarder (see Figure 3.57) framed against the bright evening sky.

Figure 3.57 *This silhouette would test the mettle of any camera with a high detail setting, as most models would rim the skateboarder with an unnatural hard edge.*

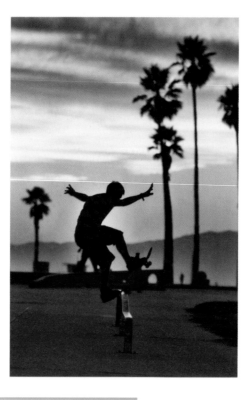

hard transition

Figure 3.58 *Smooth transitional boundaries like this one tend to produce more realistic, natural-looking images.*

Figure 3.59a,b *Hard edging around objects is an indication of excessive detail correction. This Venice dusk scene was recorded with minimal detail whereas the blow-up at right reflects the same scene with high detail. Many cameras are shipped from the factory with elevated detail; a ruse intended to foster the illusion of increased image sharpness.*

Excessive Correction

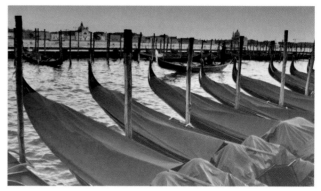

Figure 3.60 *When shooting a Hollywood starlet, dialing down skin detail may help conceal blemishes in the face and skin.*

Figures 3.61a,b *In the Panasonic DVX, camera detail may be reduced in seven increments. Higher end models like the Sony DSR-570 offer a greater range; an initial detail setting of –25 to –30 being usually optimal.*

Figure 3.62 *Soft detail is analogous to the Unsharp Mask in Adobe Photoshop. When excessively applied, the resultant thick lines can become objectionable and help remove viewers from the story. (Illustrative images courtesy of JVC.)*

No Gain, No Pain

The camera's *master gain* controls overall sensitivity, the level of which may be raised (or lowered) by altering the signal amplification from the imager. When camera gain is raised, the imager's sensitivity in low light increases along with the noise. When compressing subsequently to DV and DVD, this noise may contribute to a maelstrom of ugly artifacts, as the encoder is unable to separate unintended noise from *intended* image detail.

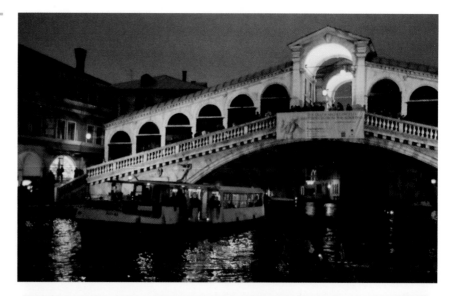

Figure 3.63 *The Grand Canal at midnight. Raising the camera gain +6dB can coax more detail from the Venetian night but at the price of increased noise.*

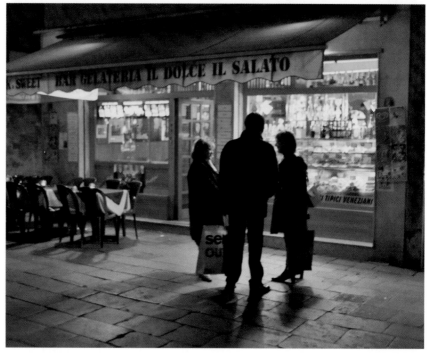

Figure 3.64 *Negative gain (-3dB) can reduce noise in night scenes with inadequately filled shadows. An ultra-contrast filter may also help reduce shadow noise. (See Chapter 9 for more insight into contrast control filters.)*

When shooting in very low light, increased camera gain should be the last resort, not the first, in order to achieve an acceptable range of gray tones. Many cameras offer increased gain up to +36dB (or higher), the elevated noise at such levels making such scenes suitable for ENG or surveillance applications only.

While the low gain setting in most DV models is 0dB, some cameras feature a *negative* -3dB gain to further suppress noise in the darkest shadows. While lower noise is usually desirable, the reduced tonal separation may also obscure critical shadow detail, and thus exacerbate DV's widely perceived hyper-real look.

Be sure the camera you're contemplating for purchase offers the ability to manually control video gain levels. The automatic gain setting common in low-end cameras should be disabled in almost every instance.

Watch Your Highlights

While shadow control is imperative for effective storytelling, the retention of highlight detail can be just as critical. Blown-out or *clipped* highlights are a sure sign of the novice shooter, so proper care must be taken to preserve the detail in your images' brightest areas.

Preservation of highlight detail is a function of your camera's knee setting. A gentler slope in the knee section of the characteristic curve means more tonal graduations and thus more detail can be accommodated. Analogous to black stretch in the toe, a gentler knee can dramatically improve the look of an interior scene that includes bright exterior windows.

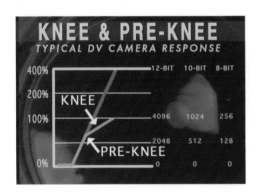

Figure 3.65 *In some cameras, the shooter can set the "pre-knee," that point in the characteristic curve where the slope lowers to accommodate a greater range in the highlights. Pre-knee values typically range from 85 to 95 percent.*

Auto-Knee

Your camera's auto-knee function sets the appropriate threshold dynamically in order to retain as much highlight detail as possible. Today's 10-, 12-, and 14-bit cameras sample far more picture information than can actually be recorded to tape. Auto-knee provides a mechanism by which some of this excess detail can be infused into the 8-bit NTSC and PAL gamuts. How much highlight detail is retained is a function of the knee setting and slope of the heel, which in most cases is more effectively controlled in auto mode.

Figure 3.66a,b *The "pre-knee" is usually settable as a percentage in the menu setup options. An external toggle in some models allows shooters to disable the auto-knee function. You will seldom want to.*

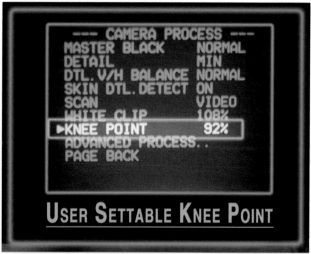

USER SETTABLE KNEE POINT

--- CAMERA PROCESS ---
MASTER BLACK NORMAL
DETAIL MIN
DTL. V/H BALANCE NORMAL
SKIN DTL. DETECT ON
SCAN VIDEO
WHITE CLIP 108%
▶KNEE POINT 92%
ADVANCED PROCESS..
PAGE BACK

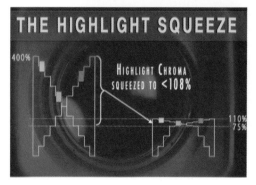

THE HIGHLIGHT SQUEEZE

400%

HIGHLIGHT CHROMA SQUEEZED TO <108%

110%
75%

Figure 3.67 *The Highlight Squeeze. While a gentle knee helps preserve detail in an image's strongest highlights, the "pre-knee" represents an actual threshold point on the characteristic curve. This critical value impacts the amount of image detail that can be retained after squeezing into NTSC/PAL's 8-bit space.*

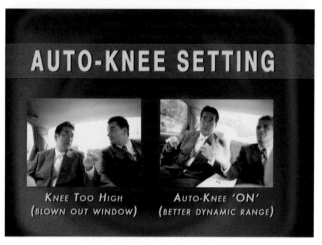

AUTO-KNEE SETTING

KNEE TOO HIGH
(BLOWN OUT WINDOW)

AUTO-KNEE 'ON'
(BETTER DYNAMIC RANGE)

Figure 3.68 *The increased highlight detail enabled by auto-knee can be dramatic as evidenced in the windows at right. (Illustrative images courtesy of JVC.)*

Matrix

Some cameras allow the shooter to vary the colorimetry. Specific colors can be made more intense while others are toned down to create a certain look or support a storytelling goal. Cameras like the Panasonic DVX and Canon XL offer a choice of matrices for shooting under fluorescent lighting or to simulate the color response of motion picture film. The DV shooter may also want to tweak the matrix settings to offset shifts in color due to increased video gain. Color matrix changes do not affect black or white levels.

Figure 3.69a,b,c *As a video storyteller, you can use the matrix function to punch up or tone down colors that are integral to your story. The muted color in Figure 3.69a helps meld the cat with similar hues into the Roman canvas. The intense red rhino in Figure 3.69b amplifies its dominant storytelling role. Same deal in Figure 3.69c where the green umbrella IS the story.*

Figure 3.70 *The color matrix menu option in the JVC GY-DV5000.*

In-Camera Digital Effects

To maximize a camera's mass-market appeal, many DV models feature a plethora of cheesy built-in effects. Such digital gimmicks as negative-tone, flash trails, or "Old Movie Magic" are almost always better applied in the NLE or compositing environment where greater control can be exercised. The only exception might be for shooters working in a live (or nearly live) venue where

Figure 3.71 The "slim" filter is typical of the useless digital effects found in many consumer DV cameras. This particular effect is well named since there is a slim chance you'd ever actually use it.

Figure 3.72 Timecode utilizes four fields based on a 24-hour clock: hours, minutes, seconds, frames. A semi-colon is commonly used in software applications to represent drop-frame timecode.

Figure 3.73 Just as the earth doesn't spin precisely at 24 hours per day, so does NTSC video not operate at exactly 30fps. When timecode compensates for NTSC's actual frame rate of 29.97fps, this is called drop-frame. No actual video frames are dropped; the required compensation is applied every minute (except every ten minutes) by omitting frames 00 and 01 in the count. As for the calendar, we compensate with some exceptions every four years by adding an extra day—February 29.

recorded images must be hastily displayed with minimal or no editing.

The Timecode Dilemma

Timecode is integral to the workflow of the video storyteller as it provides a reliable means of referencing and synchronizing audio and video throughout a production. In the PAL television system, timecode is a simple matter. Video moves along at 25fps, and timecode invariably reflects that reality.

In the NTSC system, things are more complex as we must deal with both drop frame and non-drop frame timecode modes, although in the case of consumer DV, drop-frame (DF) timecode is generally employed by default.

> **Troubleshooting Tip 4**
> *When troubleshooting an out-of-sync condition in the NLE, mismatched timecode modes should always be suspected. Capturing DF footage as NDF (or vice versa) will result in the program audio drifting out of sync at a rate of 3 seconds 17 frames per hour.*

Figure 3.74 *While consumer DV cameras utilize drop-frame timecode by default, many models including DVCAM and DVCPRO types can also record NDF timecode. So which timecode mode should you use? If you're shooting a commercial for broadcast and need to track running time precisely, drop-frame (DF) timecode is preferable. On the other hand, if you need to reference a continuous frame count, e.g., for closed-captions or subtitles, NDF is better. It really doesn't matter as long as you recognize the difference and your workflow consistently reflects one or the other.*

Figure 3.75 *VCR and hardware displays often use a single dot separator (rather than a colon or semi-colon) to indicate a drop-frame recording. The Sony DSR-1500 display is shown here.*

Figure 3.76 *Given the large amount of footage in a typical DV or HDV project, the ability to assign a unique timecode to every cassette is imperative for efficient handling and archiving of assets.*

Figure 3.77 *A slower shutter with increased motion blur helps capture the frenzy and hyperactivity of this New York City street scene.*

Working the DV Shutter

The camera's variable shutter can impact your storytelling in profound ways. At slower than normal speed (<1/60th second), the increased motion blur produces streaking that adds a surreal look to your images. At higher shutter speeds (>1/60th second), individual frames may appear sharper with reduced blurring, but the freezing of action in individual frames may contribute to stutter or objectionable strobing. Varying your camera's shutter speed may dramatically impact your visual story.

Figure 3.78 *A faster shutter freezes action inside the frame but the reduced motion blur can produce choppiness between frames, especially at 24p. In this scene, the frozen shoots of water add emphasis to the large splash swallowing a speeding vehicle.*

Figure 3.79 *To avoid strobing when panning or tracking across a white picket fence, be sure to shoot at an oblique angle, especially when operating at higher than normal shutter speeds or when shooting 24p.*

Synchro Scan

Figure 3.80 *The variable shutter that can help reduce or eliminate the undesirable rolling when shooting out-of-sync computer monitors.*

The variable shutter feature known as *synchro scan* or clear scan enables shooters to capture out-of-sync computer monitors without the distracting rolling bars or pulsing convulsions. Not all DV cameras offer sufficient control to handle every display and scan rate, so some shooters may want to examine this feature closely prior to any purchasing decision.

Using the Shutter to Control Flicker Abroad

Shooting with NTSC 60Hz equipment in Europe, or with PAL 50Hz equipment in the U.S., will often produce a disturbing flicker in television screens, fluorescent light banks, neon signs, and other discontinuous light sources. The DV shooter traveling overseas should therefore be mindful of the flicker risk, especially in supermarkets and other commercial locales, as the noxious defect is usually not apparent in the camera's LCD viewfinder.

Progressive versus Interlaced

To shoot "progressive" or not shoot "progressive," that is the question. For many DV shooters, the advantages of 24p production are not entirely clear. After all, NTSC monitors must necessarily display 60 interlaced fields per second anyway, so what's the point?

For one thing, 24p (actually 480p) offers substantially better resolution over conventional NTSC as images are captured in a continuous fashion at a rate of one complete scan/field per frame. This is in contrast to the interlaced strategy of scanning every frame twice, the combined odd and even fields producing the finished frame. Progressively scanned frames eliminate the temporal (¹⁄₆₀th) second artifacts that occur between fields; the suppression of these combing artifacts being a major factor in improving the real and perceived resolution of DV at 24p.

Figure 3.81 *Setting the camera shutter to ¹⁄₁₀₀th second may reduce or eliminate the flicker from fluorescent sources when shooting NTSC in 50Hz countries.*

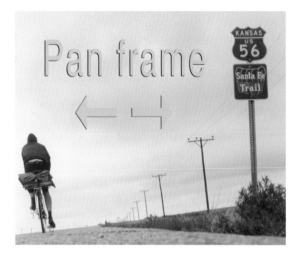

Figure 3.82a,b *When panning across an interlaced frame, the telephone pole is displaced ¹⁄₆₀th of a second, leading to a "combing" artifact when the odd and even fields are merged. Shooting in progressive mode eliminates the aliasing seen commonly in interlaced images.*

Progressively scanned frames don't always mean better images, however. When shooting sports, interlacing may be preferable as 60 fields per second provides a smoother, more faithful representation of the action.

24p DV Style

Figure 3.83 *Due to the higher frame rate and increased number of fields, interlaced images generally convey a better representation of fast-moving objects. Frames comprised of a single field (as in progressively scanned images) must rely on motion blur alone to convey a sense of motion.*

For shooters with aspirations in feature films, the advent of 24p DV models represents a major shift in workflow. Before NAB 2002, many filmmakers simply shot PAL at 25fps in order to achieve a more cinematic look. This changed with the introduction of the Panasonic DVX100. With its 24p capability, latest-generation CCD, and better than average optics, the camera represented a quantum leap forward in DV imaging and process.

Figure 3.84 *Cartoon speed lines are often used to convey a sense of motion inside progressively scanned film frames. These fake artifacts in effect mimic the aliasing associated with interlaced images.*

Figure 3.85 *To facilitate the synchronization of audio recorded at 29.97fps, most cameras including the Panasonic DVX record 24p video at 23.976fps. Close attention to frame rate is critical when shooting "double system"—that is, when recording audio to a separate DAT, MiniDisc, or hard drive. Shooting 24p does not mean capturing video at exactly 24fps!*

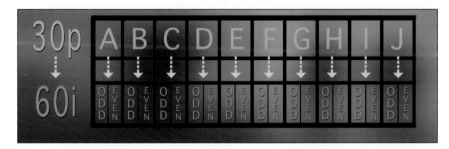

Figure 3.86 *Regardless of scan mode or frame rate, the Panasonic DVX records 29.97fps NTSC to tape. Shooting at 30p (actually 29.97p), the DVX records two interlaced fields to tape consistent with the NTSC standard.*

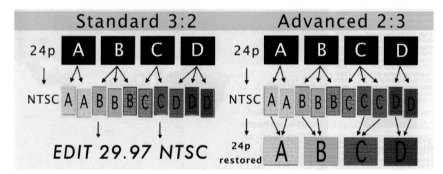

Figure 3.87 *At 24p the Panasonic DVX provides two distinct recording modes. In standard mode, images are captured progressively at 24fps (23.97p) then converted to 29.97fps (60i) via a conventional 3:2 "pull-down." This process repeats and merges certain fields to make up the time differential and contributes substantially to 24p's noted film look. Footage recorded in 24p standard mode is treated like any other 29.97fps asset in your NLE.*

Images captured in advanced mode are also scanned progressively at 24fps, but the transfer to NTSC tape is handled differently. Complete frames are added to compensate for the 29.97 time shift; the extra frames are then weeded out during capture into the NLE to restore the original sequence. In this way the shooter can avert NTSC artifacts throughout a production from 24p capture in camera through output to film or DVD.

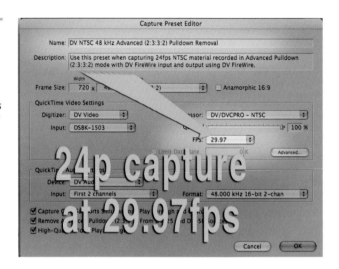

Figure 3.88 *Current NLE software, including Apple Final Cut Pro, supports 24p capture in standard and advanced modes. Note that 24p capture from DV sources is accomplished at 29.97fps!*

The DVD Advantage

And therein lies the real benefit of shooting 24p. Even if not outputting your DV epic to 35mm or the DiamondVision screen at Dodger Stadium, you will be almost certainly be transferring your show to DVD. Suffice it to say that every DVD player is native 24p!

It stands to reason. Since DVD's introduction in 1996, movie studios originating on film have logically encoded their movies at 24fps for DVD. Relying on the player to perform the required telecine conversion to

Figure 3.89 *Surprise! Every DVD player is inherently a 24p device, which may be the best reason of all for the video storyteller to originate in 24p.*

29.97fps NTSC, the DV storyteller can shoot, capture, edit, and encode an entire production at 24p, thus averting the most egregious NTSC artifacts while also reducing the size of the encoded program by 20 percent—not an insignificant amount in an era when producers are jamming everything and the kitchen sink on a DVD. *(See Chapter 10 for more on DVD and the video storyteller.)*

24p on the Set

Because entire frames are repeated as opposed to fields, 24pa (advanced mode) produces a staccato effect when viewed on a normal NTSC display. Some directors may find the stutter distracting when evaluating an actor's performance, so the smart 24pa shooter should be sure to inform the creative team of the unusual condition.

Shoot 16:9

Centuries ago, the School of Athens recognized the power of the widescreen canvas to woo audiences. Today, the video shooter should adopt the same philosophy, as there is little reason other than for news and some

Figure 3.90 *When shooting 24p, the DV camera outputs standard NTSC regardless of frame and field mode selected. This arrangement allows use of standard NTSC monitors and greatly facilitates working with 24p video in the field.*

Figure 3.91 *Ah yes, the Golden Rectangle. There's a reason we love our credit cards! The rectangle's 16:9 shape can be highly seductive.*

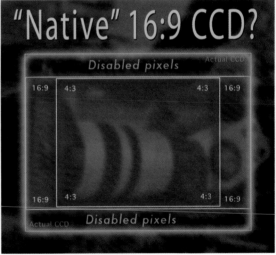

Figure 3.93 *The Canon XL2 utilizes a 4:3 chipset permanently masked to produce a 16:9 aspect ratio. The 4:3 frame is mortised out of that.*

Figure 3.92 *In a true 16:9 camera, the imager is natively configured for widescreen, with 4:3 framing cropping a bit from each side.*

commercials to continue shooting 4:3. Widescreen TVs are becoming increasingly common and DVD players invariably support 16:9 playback. Even the most unsophisticated television viewer now accepts widescreen's mysterious black bars at the top and bottom of a conventional "square" screen. Storytelling in 16:9 simply seems more modern, more cutting edge, more HD-esque, and so it is the obvious choice for most video shooters, especially as more cameras are able to capture now in true 16:9.

It used to be that few DV cameras offered native 16:9 imaging. The most popular ⅓-inch models like the Panasonic DVX and Canon XL cropped and/or squeezed the original 4:3 image to acquire the widescreen aspect, leading to a substantial loss of resolution. While once thought impossible due to physical constraints, an increasing number of DV and HDV cameras now offer ⅓-inch CCDs in a native 16:9 configuration.

Going HD

The handwriting has been on the cassette for years: HDTV is finally here—or is it? For sure there is a lot of hoopla right now, and at *some* point, high definition storytelling *is* coming to a television near you. Yet after almost three decades of false starts and promises one has to wonder where are all the HD programs to go with the boatloads of HD sets and displays currently being sold.

The answer is hardly straightforward. One problem: no one has yet to define what HDTV really is. Is it 720p, 1080i, or 1080p? Is it 16:9, 15:9, or even 4:3? Many viewers with widescreen TVs simply *assume* they are watching HD due to the 16:9 aspect. This appears to be especially true for

Figure 3.94 *The short viewing distance in most electronic stores helps sell the superior resolution of HD images. Viewers at home at normal viewing distances can barely (if at all) perceive greater definition—even on 60-inch displays!*

folks experiencing the brilliance of plasma or LCD displays for the first time. If it looks like HD, it must be HD, right? In truth, there are no federal or even industry-accepted guidelines. To manufacturers and marketers, the format can be pretty much anything, and indeed we have almost twenty HD variants in the U.S. alone. Yes, there is an FCC mandate for television stations to broadcast *digital* television (DTT) in coming years; there is no mention or mandate for *high-definition* transmission, let alone at a specified resolution and frame rate.

Public bewilderment regarding HD is based on a simple inescapable truth: most viewers are hard-pressed to tell the difference between standard definition and high-definition images at a normal viewing distance from the screen. At a typical U.S. viewing distance of nine feet, TV viewers would require an enormous eight-foot display (fixed pixel plasma or LCD) before they could perceive any improvement in resolution over standard definition video[6]. In Japan, where living rooms are typically much smaller, HDTV's improved resolution is much more apparent, and thus, unsurprisingly, HD has gained far greater acceptance there.

The High-Definition Storyteller

The HD shooter today faces a cavalcade of competing standards: HDCAM, HDCAM SR, DVCPRO HD, Windows Media, MPEG-4, H.264, to name a few. All of these formats are capable of supporting at least 720 lines of video, the minimum recognized by most folks as "HD" resolution.

For many storytellers, HD origination will likely assume the mantle of *HDV*—a highly compressed consumer format championed primarily by Sony and JVC. The format's attraction to the DV crowd is not surprising: it supports standard and HD recordings at 720p and 1080i utilizing low-cost dual-use cameras and standard DV tape.[7]

Employing the same transport, tape speed, and track pitch, HDV camera manufacturers have found it relatively easy and cheap to produce equipment compatible with current standard definition DV. For the DV shooter, the transition to HDV has turned out to be fairly painless, as the latest HDV gear appears to *enhance* the current standard rather than render it obsolete.

6. Source: Videography, August 2004 "HDTV: Myths and Math" by Mark Schubin
7. Owing to the high bit-density requirements of 720p/1080i recordings, superior grade digital mastering tape is strongly recommended when shooting in HDV mode.

Figure 3.96 *The Sony HVR-ZU1 records DVCAM and HDV (1080i) at 25Mbps. Its latest generation 16:9 chipset is the first available in the ⅓-inch format. The NTSC model records exclusively at 29.97fps.*

Figure 3.97 *The JVC Pro-HD GY-HD100u records 720p at 19.2Mbps. Unlike the Sony models, it features interchangeable optics and a 24p record mode. For the serious DV storyteller, HDV is becoming an increasingly viable option.*

ProHD—the 720p implementation championed by JVC—is defined as 720 progressive scanning lines with 1280 horizontal pixels at 60p, 30p, 50p, or 25p. At 1080i (Sony's format of choice in the HVR-Z1U and HVR-FX1), the HDV standard specifies 1080 interlaced lines with 1440 horizontal pixels at 60i or 50i. Regardless of implementation, HDV is native 16:9.

But Is It HD?

According to the Advanced Television Standards Committee (ATSC), HD at 1080i is supposed to have 1920 horizontal pixels. By that standard, Sony's image capture in HDV (and HDCAM) at 1440 horizontal pixels

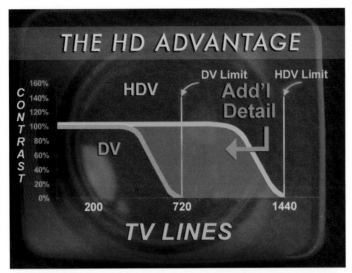

Figure 3.98 *The perceived sharpness of an image is a function of contrast. Two bell-shape curves plot the relative contrast ratios of DV and HDV against detail fineness. At 1440 resolution, HDV's fine detail is maximized, but the low contrast at this resolution reduces perceived sharpness. The format's advantage becomes more apparent to viewers when viewed in standard definition owing to the higher contrast at the 720 pixel cutoff.*

Figure 3.99 *The Panasonic AG-HVX200 utilizes the DVCPRO HD format. Superior in image quality to HDV with less noise, the sub-$10,000 camcorder can shoot at multiple resolutions from DVCPRO at 25Mbps to DVCPRO HD at 100Mbps. When introduced at NAB 2005, the P2-based camera featured twin 8GB memory cards. The approximate recording time at HD resolution for each card is about eight minutes.*

would appear to fall short of true HD. The Consumer Electronics Association (CEA) for its part stipulates a minimum of 810 active sample lines, so by that definition at least HDV *is* HD.

Entering the fray, the HDV storyteller faces the choice of 1080i or 720p. If the highest definition is demanded, 1080i is the better option since there are 1920 active pixels on each of the 1080 active scanning lines. This represents roughly two million pixels, or about twice that of 720p. Even at 720p resolution, HDV offers five times the number of pixels of standard defini-

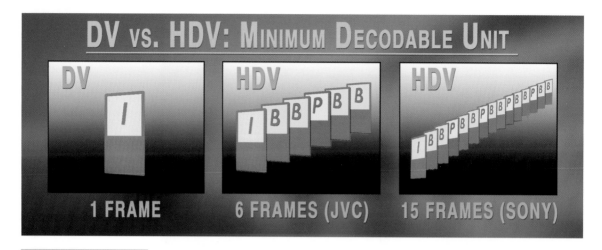

DV vs. HDV: Minimum Decodable Unit

DV — 1 FRAME

HDV — 6 FRAMES (JVC)

HDV — 15 FRAMES (SONY)

Figure 3.100 *Whereas the frame is the minimum decodable unit in DV, the GOP (group of pictures) is the minimum unit in HDV. JVC's 720p implementation uses a GOP of 6 frames, while Sony HDV at 1080i utilizes a longer 15 frame GOP. Most NLEs decompress, then recompress the HDV stream in realtime to enable editing at frame level. A fast computer is imperative.*

tion DV. This additional sharpness contributes substantially to the polished, more professional look of HDV images when down-converted to standard definition DVD.

Some shooters working with HDV will want to immediately bump their source tapes to HDCAM or DVCPRO HD for editing, thus circumventing the nagging issue of HDV's non-frame based structure.

FORMAT	Resolution	Compression	Aspect Ratio	Audio
DV	720 × 480 720 × 576	25Mbps	4:3 / 16:9	PCM audio at 48 KHz/16 bits
HDV	720/60p 720/30p 720/50p 720/25p 1080/60i 1080/50i	19.2Mbps or 25Mbps	16:9	MPEG-1 Layer 2 (JVC's ProHD uses PCM audio)
DVD-VIDEO	720 × 480 720 × 576	9.8Mbps maximum	4:3 / 16:9	PCM audio @ 48 KHz/16 bits Dolby AC3 DTS

Your Window On The World 4

MORE THAN ANY OTHER piece of equipment, the effectiveness of your visual storytelling depends on it. So does the quality of every image you create. Any way you rotate it, your lens is critical to your survival as a shooter and craftsman.

In Chapter 2, we looked at how the choice of focal length can help or hinder the story you intend to tell. At extreme telephoto, the lens can dramatically compress space, increasing the apparent size of crowds or objects stacked strategically inside the frame. A very short focal length has the opposite effect, expanding the viewer's sense of scope by drawing nearby objects closer and pushing background objects further away. The wide angle is therefore commonly used for landscapes and in action sports to heighten the sense of motion, especially in objects passing very close to the camera.

The darling of the skateboard crowd ins the "fisheye." Its ultra-wide perspective creates severe distortion, exaggerating the height and speed of skaters' jumps and movements—an effect entirely consistent with the intended story. The very short focal length also minimizes the apparent shake of the handheld camera, a valuable benefit in itself when shooting extreme sports.

Figure 4.1 *An extreme wide-angle or "fisheye" increases the apparent speed and height of the skateboarder sweeping within inches of the front of the camera. Here, support rods are used to mount the oversize Century Xtreme on a Sony HVR-Z1U. The lens features an astounding 180º horizontal field of view!*

a

b

Figure 4.2a,b *Lost in Venice. The wide-angle in Figure 4.2a effectively conveys the disorientation of my son in an unfamiliar city. By comparison, the long lens in Figure 4.2b helps separate him from the background, thus reinforcing in a way his mental separation from the alien environs. Which story is correct? As a storytelling tool, your choice of focal length can often reflect your subject's mental condition.*

Control Your Space

Rigorous control of screen space is critical for effective storytelling, and nowhere is this more apparent than in action or chase scenes. To communicate clearly, your viewer needs to understand the geography of the scene, the location of the players, their direction of movement, and their relative proximity. Utilizing a telephoto lens can make a pursuer seem closer, the exploding boxcar behind him more perilous, the opening car door into the path of a biker more menacing. The wider lens in contrast expands space and thus minimizes these perils. It's your story. Use the power of lens perspective wisely.

Figure 4.3a *The wide-angle captures the emptiness of this Parisian park.*

Figure 4.3b *A wide field of view amply captures the exhausted spirit of this group of tourists in Venice.*

Figure 4.3c *In San Marco Square, the young boy and pigeons appear to share the same physical space owing to the foreshortened perspective of the telephoto lens.*

Figure 4.3e *Oh, watch out! The peril of a car door opening into the path of a biker is amplified by the telephoto perspective.*

Figure 4.3d *The long lens helps draw the billboard into this Los Angeles street scene.*

Figure 4.4 *Novice shooters may love the effect, but your narcissistic star will hate you forever. The wide-angle close-up grotesquely distorts the facial features of your talent.*

Figure 4.5 *In contrast, the long focal length lens unnaturally flattens facial features. The painted effect of the ears and nose appearing in the same plane undermines the intimacy you're (usually) trying to foster with your audience.*

Handle Talent with Care

When shooting talent, your choice of focal length is critical as it's not just a matter of framing a "close-up" since the wide-angle can produce the same size image on screen as a telephoto from further away. The savvy shooter understands therefore the advantages of utilizing one focal length over another, the short telephoto usually producing the most flattering representation of talent in close-up.

Figure 4.6 *A slight telephoto offers the most flattering perspective when shooting talent. Here the soft focus background contributes to the three-dimensional effect.*

Use Your Full Bow

Just as the accomplished violinist uses a full bow for maximum expression, so should the video shooter use the full range of the DV camera's zoom lens. In documentary work, I often use the zoom at full wide angle to capture essential action, so shooters looking to invest in a camera should seek out a model with a sufficiently wide field of view. Most DV models with permanent lenses are woefully inadequate in this regard, offering far too narrow wide-angle coverage. For most projects shooting with a ⅓-inch CCD camera like the Canon XL2 or Sony DSR-PD170, a 4.5mm (or shorter) wide-angle is imperative.

To address the issue of cameras with insufficient wide angle coverage, manufacturers like 16x9, Inc. and Century Precision Optics offer a range of supplemental adapters that can increase coverage as much as 30 to 40 percent. The practical use of such lenses varies. Some permit partial or total zooming, others don't. Some create barrel distortion akin to a fisheye, others don't. What works for you depends on the story you're trying to tell.

Figure 4.7 Wide-angle lens adapters may complicate the addition of a matte box and filters, so shooters should consider their filtration requirements before purchasing.

Go Long for the Touchdown

While a sufficient wide-angle can be extremely useful, the same is true for an adequate telephoto, which offers the perfect and necessary complement. Instantly narrowing the viewer's point of view from long shot to close-up (or vice versa) can be highly effective, even thrilling, to audiences.

Note that I am not advocating *zooming* to achieve the desired change in perspective. The effective video storyteller understands that a hard cut is almost always preferable to zooming in or out, unless the zoom itself is intended for dramatic or stylistic effect.

In documentaries, the zoom can be a valuable assist to shooters looking to quickly reframe between questions in an interview or add visual emphasis to a contrite ax murderer's confession. In such work, the subject's lack of predictability often makes it necessary to reframe while rolling. The zoom can then be used subtly to exclude an unwanted background element or mic pole without stopping the camera or action.

Now, I know it's tough for many shooters to resist the urge to zoom. But if you can discipline yourself, you'll be a far better shooter for it. *(See Chapter 5 for more on the merits of dollying vs. zooming.)*

Figure 4.8 indicates the optical zoom ranges of several popular DV and HDV models.

Figure 4.8 The optical zoom range of lenses affixed to popular ⅓-inch CCD cameras. Some manufacturers' claims with respect to lens performance should be taken with a grain of emulsion.

Lens Zoom Ranges (manufacturer rating)

Sony HVR-Z1U	12X
Sony HDR-FX1	12X
Sony DCR-TRV950	12X
Sony DCR-VX2100	12X
Sony DSR-PDX10	12X
Sony DSR-PD100A	12X
Sony DSR-PD170	12X
Sony DSR-250	12X
Panasonic AG-DVC60	10X
Panasonic DVX100A/B	10X
Canon XL-H1	20X*
Canon XL2	20X*
Canon XL1-S	16X*
Canon GL-2	20X
JVC GY-HD100u	16X*
JVC JY-HD10U	10X
JVC GR-DV800	10X
JVC GY-DV300	14X

* with standard lens. Model accepts interchangeable lenses.

Figure 4.9 *The zoom range emblazoned on the side of a camera or lens is often fanciful and may have little bearing on reality. Indeed, the magnification indicated can be any value a manufacturer likes—if performance is ignored. The 12X zoom on this camera, for example, feels more like a 4X to me.*

Figure 4.10 *Some "ramping" is inherent to all zoom lenses as light-gathering power decreases with extended focal lengths. Some telephoto scenes—like this one, lacking contrast and sharpness—may prove ultimately unusable.*

Beware of Dubious Claims

Just as most of us wouldn't buy a car on the basis of horsepower alone, so we shouldn't automatically opt for a lens with the greatest stated zoom range. What's the zoom range of a lens, anyway? 12X? 15X? 22X? Truth is, *any* lens can be a 50X or more if one discards any notion of performance. Just omit a convenient stop or two on the lens barrel—and *voilà*! Suddenly you've got a longer *improved* lens for the next trade show. This happens all the time as manufacturers vie for bragging rights with respect to whose camera model offers the longest zoom range.

An overstated zoom range has craft implications for the video shooter-storyteller, as such lenses typically exhibit poor performance when fully extended. Telephoto scenes lacking brilliance, contrast, or definition can stick out like a sore thumb in the finished program and thus alienate the viewer, so the shooter is wise to understand his particular camera's optical limitations.

Optical versus Digital Zoom

It doesn't matter that no one in the history of mankind has ever knowingly *used* the digital zoom on a DV camera.[1] Manufacturers still recognize the ad-

1. Alright, I'm exaggerating a bit. Some high-end cameras including the Panasonic AJ-SPX800 feature a 2X digital zoom that can be actually quite useful, especially in low light.

Figure 4.11 *700X?? Whoa! What's going on here? Some folks may be seduced by such lofty-sounding pronouncements, but you don't have to be one of them.*

a

b

c

Figures 4.12a,b,c *The effect of optical (Figure 4.12b) versus digital zoom (Figure 4.12c). Most shooters will find little use for the digital zoom, especially at high magnification.*

Figure 4.13 *A 2X optical extender or "doubler" markedly lowers contrast and typically results in a loss of two stops. The digital zoom at 2X may be preferable, therefore, in low light.*

2X Extender

vantage of pasting a large impressive-sounding number on the side of a camera: 300X Digital Zoom! 360X Digital Zoom! 480X Digital Zoom!

Whereas the optical zoom magnifies the image prior to capture, digital zoom magnifies one or more pixels *after* capture to fill the DV/HDV frame. The result is often something akin to a scene from Michelangelo Antonioni's 1966 movie *Blow-Up*. It might be artsy to some folks, but such an effect is usually better implemented and with greater control in the NLE using Adobe After Effects or other compositing tool.

An Occupational Hazard

The mediocre lenses that typically accompany DV cameras pose a major challenge to shooters attempting to do first-class work. This is because the manufacture of high-quality optics is a mature technology, requiring costly labor-intensive processes any way you grind it. The few dollars that manufacturers allocate for the lens in lower-end cameras does not buy a whole lot.

So put aside for the moment your camera's stunning signal-to-noise ratio, 14-bit DSP, and staggering array of menu options. The quality of its optics is more critical—and certainly more apparent on screen.

Figure 4.14 *For the modest DV shooter, less-than-stellar optics often come with the territory as manufacturers rely on mediocre lenses to maintain a camera's low price point.*

Figure 4.15 *This broadcast lens (seen on a Sony DSR-500) will produce superior images to support your storytelling.*

Tale from the Trenches

I recall reviewing the JVC GY-DV500 several years ago. The camera was impressive with a ½-inch 3-CCD chipset and range of professional options. For the $5,000 price, the DV500 was an excellent camera despite a look that tended towards the brassy and harsh. But fitted with a $10,000 lens, the camera no longer just looked decent, it looked spectacular! Such is the power of high-quality optics mounted on *any* camera.

The lesson should not be lost on the DV/HDV storyteller. Today's cameras are so good in so many respects that lens performance has to be considered the number one factor when evaluating a new camera. Of course, this poses a dilemma for manufacturers of cameras with built-in, non-interchangeable optics.

Logically, there's no way you'll find a $25,000 broadcast lens on a $2,500 camcorder. The world just doesn't work that way. We can hope, of course, and some manufacturers may even foster the notion by slapping the names of respected lens manufacturers on second-rate optics. But don't be fooled. When you spend only a few thousand dollars on a camera, there

Figure 4.16 *While most DV cameras do not support interchangeable lenses, the Canon XL2 (pictured) and JVC HD100U are notable exceptions. Be sure the optics you select are optimized for small-format video. Most 35mm SLR lenses fare poorly in DV applications.*

is something you're not getting. And that is, more likely than not, a lens that you can hang your career on.

After more than a decade, shooters have grown accustomed to regular and significant advances in camera technology, and it is perhaps in this light that we also expect comparable gains in the quality of lenses. We all want a zoom that is lightweight, fast, with a long range and close-focus capability. The problem is these demands are often at odds with each other. Extending a lens's zoom range, for example, tends to work against greater speed. And greater lens speed tends to work against maintaining low weight.[2]

Considering the compromises inherent to any zoom lens, one can imagine the relative shortcomings of inexpensive optics. Poor or nonexistent lens coatings, chromatic aberrations, lack of sharpness and contrast to the corners—these are real drawbacks that can deleteriously impact our images.

The smart shooter knows that lens *resolution* is not nearly as critical as *contrast*—that is, how well the lens performs to the corners of the frame through the entire zoom range. Low contrast can be especially problematic at longer focal lengths where some light loss is inevitable due to increased image magnification. But poor quality lens coatings can also be a factor, contributing substantially to the loss of contrast in cheaper lenses.

2. Increased lens speed—i.e., light transmission—is largely a function of lens diameter; larger diameter optics translating into increase weight and mass. Most shooters would prefer lighter-weight lenses and equipment all around.

Not an Aberration

One of the characteristics of inferior optics is the lack or even absence of satisfactory lens coatings. In my camera and lighting seminars, I often demonstrate how some DV lenses actually perform *better* with the front element covered with a thin layer of nose grease! This thin veneer if applied finely enough can serve as a crude lens coating that reduces internal reflections and flare.

When light strikes the hard glass surface of a lens, a portion of the beam (as much as five or six percent) is reflected. This light loss is compounded in complex lenses with many elements, leading to a potentially significant reduction in lens speed. The introduction of improved coatings reduces this light loss to as little as one tenth of one percent, enabling today's better optics to be made smaller and lighter while still maintaining relatively high speed.

Lens coatings increase light transmission by reducing the relative difference in density between the air and glass surface. Normally, light is slowed as it passes from air into the glass, which is of substantially higher density. This slowing or loss of energy results in a percentage of light being reflected.

Superior lens coatings are expensive so it's no surprise that some DV lenses come up short. Internal reflections or flare inherently reduce contrast and, with it, viewer-perceived sharpness in the diminutive format.

Chromatic Aberration

While up to 6 percent of the incident light striking a lens is reflected and lost, the remaining 94 percent is transmitted but substantially slowed as the wave front penetrates the dense glass material. The degree of slowing is a function of wavelength as higher-energy blue wavelengths are refracted more than lower-energy red wavelengths.

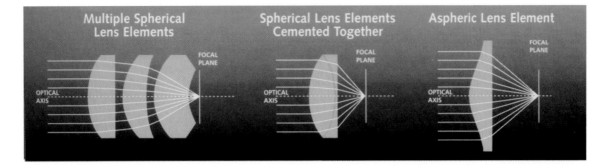

Figure 4.18 *The aspheric zoom offers many advantages to the DV shooter: reduced wide-angle distortion, improved resolution to the corners and significantly better contrast. As shooters seek to reduce bulk and weight wherever possible, a complex lens employing aspherics is ideal as multiple corrective groups of elements can be eliminated. (Graphic courtesy of Fujinon Broadcast and Communications Division.)*

As a result, some low-end DV lenses display a rim of red or blue artifacts, especially evident around bright light sources. As shooters, there is usually little we can do to ameliorate chromatic aberration other than to avoid shooting into strong point sources that tend to accentuate the defect.

In broadcast lenses, precision-sculpted *aspheric* elements reduce the number of lens elements and air-to-glass surfaces, which results in less flare, lighter weight, and substantially less chromatic aberration. Thus far, economics have largely precluded widespread use of aspherics in low-end lenses, although as DV shooters become more sophisticated and demanding, some manifestation of the technology will likely be seen in better DV, HDV and HD models.

Making Peace with Your Not-So-Hot DV Lens

To compensate for marginal optics and coatings, camera makers will often ratchet up a camera's default detail to create the *illusion* of increased contrast. In Chapter 2, we discussed how reduced detail should be a top priority for all shooters. Some caution should always be exercised, however, as this can produce washed-out, poorly defined images if detail is lowered too precipitously.

Given the permanent nature of most DV camera lenses, there's usually no point excessively lamenting your camera's mediocre optics. Better you should learn as much as you can about its shortcomings and (hopefully) find ways to work around them.

We've mentioned the obvious ramping inherent to many zoom lenses, along with the manufacturers' overstated zoom ranges that contribute to the condition. We've also cited the substandard coatings and insufficient color correction as additional areas of concern. But beyond carping and shedding a few drops of cleaning fluid, is there anything you can actually do to ameliorate the situation?

How Sweet It Is

Your camera's inexpensive lens may look acceptable on a small monitor, but large-screen projection is an entirely different matter. As more HDV shooters enter the fray with intentions of displaying their work on a cinema-size screen, the high magnification will reveal hitherto unseen image defects; the situation being particularly onerous for the shooter who must somehow coax a decent level of performance out of what amounts to a very modest piece of glass.

Luckily, decent performance *is* possible from many cheaper lenses by simply identifying their *sweet spot*. Truth is, your camera's low-end optics may actually perform quite well at a specific focal distance, zoom range and f-stop.

Of course finding that sweet spot is not often easy. The best way is to shoot a scene from your intended project, blow it up to 35mm or HD, and then display it in a suitably large theatre. Large-screen projection will quickly reveal any serious problems such as breathing of focus, loss of contrast, poor tracking, and other common faults. On the big screen you can run but you can't hide. Most lens shortcomings are painfully obvious under such scrutiny.

Of course, such a test may not be always practical or economical. In the days before DV when cameramen were a revered and reasonably well-paid lot, shooters would dutifully test every unfamiliar lens before a shoot. This was our livelihood, after all, and our mortgages and car payments depended on capturing pristine images. Lens performance was too important to leave to chance or a bleary-eyed rental house technician.

When evaluating your DV lens, it's essential that you reference a high-resolution production monitor capable of displaying 700 lines or better. Such a monitor is one of the best investments you can make; the precision and piece of mind it offers being especially critical to HDV shooters looking ahead to a big-screen presentation.

When evaluating performance, a correctly calibrated monitor can offer the shooter valuable insight into the quality of optics. In Chapter 3 we discussed proper calibration of the NTSC monitor. We'll go a bit further now to assess basic lens performance.

Laying Down with Your Lens

Being able to assess lens performance is critical to developing your prowess as a digital craftsman. Here is what works for me if you're lucky enough to have a lens with actual engraved footage markings:

1. Start with the camera on a tripod focused on a distant object. I prefer a telephone pole, but any object with a hard vertical edge will do. Set

Figure 4.19 *Accurately assessing the performance of your camera lens is critical to achieving optimal image quality. Such insight is especially important when large screen projection is anticipated.*

the lens to "infinity" and check the setting. Can your camera and lens find sharp focus? Cameras that focus past infinity or interchangeable lenses that do the same should be rejected. I recently shot a commercial with a DV lens that tracked okay but focused a bit past infinity. This bizarre behavior drove my assistant nuts and ruined several takes.

2. Now place your camera and tripod exactly six feet from a wall. Use a tape measure and be sure to measure from the camera's CCD focal

Figure 4.20 *A typical star chart used to check focus (and backfocus). For years, shooters have used such a reference to perform routine lens checks. The gradient patterns and fine lines appear to snap in and out of focus on a high-resolution display, a great help when attempting to locate a lens's sweet spot. (Chart courtesy of DSC Labs. Look for the free backfocus chart (PDF) included on the accompanying 'Video Shooter' DVD.*

plane. A few models indicate this point on the camera body. Most DV cameras don't, so you'll have to estimate.

3. Retrieve yesterday's newspaper from the recycling and tape five pages to the wall so the center and all four corners of the frame are covered. Depending on the wide-angle coverage of your camera this area will vary. At a 6mm focal length on cameras with a ⅓-inch CCD, the image area will cover an approximate area 5 feet wide by 3.5 feet high.

4. Set up two lights beside the camera about 45° to the wall. Angle the lights to avoid hot spots and zoom in fully on the newsprint. Focus critically and check the lens ring for accuracy. Some lenses may not have a six-foot witness mark so you might have to estimate or use an alternative reference distance. Any discrepancy should be noted to assure accurate focus and follow-focus during production.

5. Now zoom out slowly while eyeing the high-resolution monitor. Note any breathing of focus in the newspaper text. Most lenses will soften slightly in the course of their travels. Watch especially for sharp sections and note any obvious sweet spots. If your camera is so equipped you can record these points on the external focus ring. Also while pulling back, note any off-center shifting, as tracking can be a significant problem in cheaper lenses.

Focusing on What's Important

The ability to focus selectively lies at the heart of our visual storytelling since the relative sharpness of objects communicates to audiences what is important—and, perhaps more fundamental, what is *not* important—in the frame.

Figure 4.21 *Horror of horrors! The focus rings on many DV cameras are completely useless. In this model, the knurled ring spins continuously in both directions without having an apparent effect on screen.*

Figure 4.22 *The typical DV camera zoom control is notoriously balky, making smooth and tasteful zooms all but impossible.*

Figure 4.23 *The Zoe is a commercial-duty controller capable of producing well-feathered zooms in even the most modest DV cameras. This particular unit features a pendulum rocker with none of the backlash or slop typical of consumer units. Of course, the really smart shooter refrains from zooming without a compelling reason to do so.*

Figure 4.24 *The external zoom controller is enabled through the Control-S/LANC input. The Panasonic DVX utilizes a slightly different protocol, requiring shooters to purchase a dedicated controller for this model.*

Figure 4.25 *The remote connector on the Panasonic DVX100A. An additional connector for remote control of focus and iris was added in the updated 100B model.*

Because precision machining of lens rings and components are expensive, camera manufacturers tend to look here first to cut corners. Perhaps for this reason, most prosumer DV cameras generally exhibit poor mechanical function. Focus rings in particular are either nonexistent or constructed shoddily, thus denying the shooter the critical ability to precisely set and shift focus.

Following Focus

The absence of a reliable DV follow-focus has been apparent for years. Many shooters (like myself) using DV cameras for narrative projects have been hobbled by our inability to accurately follow-focus. Of course this has placed a major crimp in our creative juices.

The Alfred Chrosziel DV follow-focus system is an engineering *tour de force*. Its meticulously crafted handwheel and drive mechanism displays a reassuring heft that veteran shooters will immediately find comfortable and reassuring. The large knurled focus knob can be easily grasped by a harried or rain-drenched assistant. Its white marking disc can be easily removed and recalibrated for other cameras or lenses—a significant time-saver on projects where multiple cameras and lens combinations are used. A typical reality show may employ upwards of six cameras or more, so the ability to swap accessories from one camera (or camera model) to another is imperative.

Figure 4.26 *Don't scrimp! An investment in top-quality camera accessories will pay you dividends for decades to come. The Chrosziel 4X4 DV matte box, follow-focus and support rods are pictured here.*

Figure 4.27 *Most prosumer DV and HDV models accept a pro-caliber follow-focus that will help ensure accurate frame size through various setups. The Chrosziel DV follow-focus mounts on standard support rods and thus can be easily adapted for service on multiple camera systems.*

Of course, high-quality accessories do not come cheap, and at $1,500 the Chrosziel follow-focus approaches almost half the price of a competent DV camcorder. With the appropriate support rods, mounting plate, and drive gear, one's total investment could well exceed $2,000 for the package.

So, is it worth it?

Absolutely. Top-quality camera accessories last for decades long after your shiny DV camera *du jour* is relegated to a doorstop. If you're serious and intend to shoot for a living, it simply makes sense to invest in pro-level accessories. The superior craft that top-level equipment enables will pay you dividends for a lifetime.

Figure 4.28a,b,c *The follow-focus engages a lens ring specific to a camera and lens. This ring from Century Precision Optics features a built-in focus stop and white marking surface to record focus points.*

For the shooter, a robust follow-focus system is critical in order to maintain proper continuity and frame size on screen. In this respect, the shooter (or his assistant) should be sure to maintain a detailed log specifying the scene, focal length of lens used, subject distance, and f-stop. This will enable precise repositioning of the camera and talent in the reverse angles, while also allowing for seamless retakes as necessary at a future time.

Figure 4.29 *Some newer one-piece camcorders feature lens markings for zoom and focus, a boon to the shooter hoping to exert better control over frame size and continuity.*

Figure 4.31 *In narrative projects, lens data such as focal length, f-stop, and distance should be recorded for every setup. An assistant will typically use a 50-foot tape measure to determine the distance to the camera's focal plane. On a crowded set, a cloth measure (not steel!) is preferred because it is quieter, more flexible, and less likely to snap back and decapitate an actor.*

Figure 4.30 *Maintaining consistent frame size can be challenging as most DV cameras lack a focal plane indicator. The witness mark seen here is from a Sony MSW-900, an IMX model.*

The Matte Box

The need for an effective matte box or lens shade cannot be understated. The low contrast inherent to many DV and HDV "package" lenses is made far worse by stray light striking the camera's front lens element at an oblique angle. The off-axis rays entering the lens are then reflected internally, bouncing off and around multiple elements, substantially increasing flare and further diminishing performance.

Figure 4.32 *Screw-in filters are awkward to handle, prone to cross-threading and offer fewer creative possibilities than square or rectangular filters used in conjunction with a professional matte box.*

Figure 4.33 *This Chrosziel 4×4 matte box is extremely well designed with a rotatable stage in order to accommodate a polarizer, graduated, or effects filter. The 3×3 version is considerably lighter in weight and therefore may be better suited for smaller 4:3 DV camcorders.*

Figure 4.34 *A chamfered filter holder helps prevent light leakage around the tray edges.*

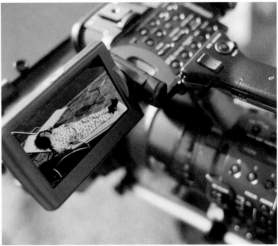

Figure 4.35 *Don't take widescreen shooting lying down! An appropriately proportioned matte box offers maximum protection from off-axis light striking the lens and lowering contrast.*

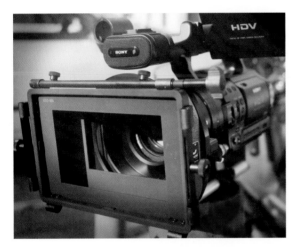

Figure 4.36 *A 16x9 matte box is imperative for the latest generation HD/HDV cameras. Pictured here is the Sony HDR-Z1U.*

Screw-in filters offer the advantage of lower cost and easier availability in retail photo shops, but the fumbling and risk of cross-threading when the chips are down (so to speak) can be a serious occupational hazard, especially when facing the rigors of a tense set or charging grizzly.

Slide-in square or rectangular filters used in professional matte boxes offer greater ease of handling in addition to more creative possibilities. Some of these capabilities include better and more accurate positioning of graduated and effects filters, and optimal rotation of the polarizer, the orientation of which is critical to fine-tuning the level of darkening in the sky or to control window reflections.

Not all professional filters are available in screw-in sizes. This is particularly true of certain Tiffen types like the Black and Gold Diffusion/FX as well as filters from Schneider Optics. *(See Chapter 7 for more insight into camera filters.)*

Figure 4.37 *A professional clip-on matte box is economical and convenient for most projects.*

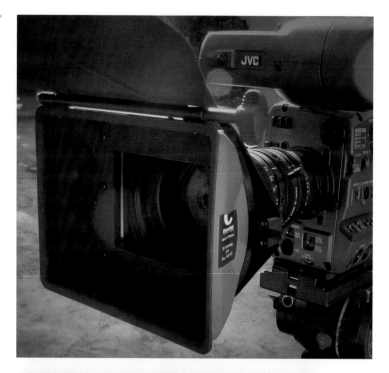

Figure 4.38 *When mounting accessories like a follow-focus and heavy production matte box, appropriate support rods affixed to the camera base plate are required.*

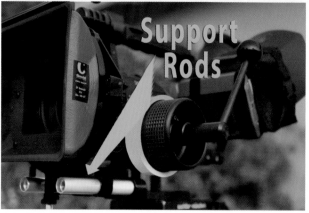

Clip-on versus Rod Support

A matte box that clamps directly to the front of the lens is more economical and convenient, but the extra weight may place excessive stress on the front elements and lead to impaired performance or serious damage. The front section of the Panasonic DVX appears particularly fragile in this regard so shooters should take note. If you're using a full-size production matte box and follow-focus, you'll need a rod-support system to ensure smooth operation and safely support the additional weight.

Figure 4.39 *French flag affixed to a matte box.*

Hang Out the Tricolor

A French flag mounted on or near a camera's matte box prevents unwanted sun or backlight from directly striking the front of the lens. Such direct rays when impacting at an oblique angle negatively impacts lens performance by increasing internal reflections and flare and thereby reducing contrast. Some professional matte box systems provide simple mounting of a French flag using thumbscrews.

Use of Cine Lenses

There are times when a camera's mediocre optics will not suffice regardless of a shooter's expertise or insights. In such cases one might consider the use high-quality cine lenses instead.

Costing many thousands of dollars, cine lenses invariably employ superior coatings, finely machined cams and the finest optical glass. Overall performance with respect to light transmission, resolution, and contrast is often dramatically better than the low-cost fare you might be used to, with cine lenses' stated specs regarding speed and zoom range in general more accurate and honest.

Cine and cine-style lenses may also significantly improve the video shooter's workflow. Commercial-grade optics from Fujinon and Canon feature large brightly inscribed witness marks that can be easily seen and logged by an assistant or script supervisor across a set. High-end lenses also feature integrated gear rings for precise follow-focus and zoom. Of course, film shooters are long used to such functionality, but the capability until recently had been tough to come by in the DV realm.

From a technical perspective, digital lenses differ significantly from their cine brethren. Whereas in film we focus on microscopic grains of silver, the

Figure 4.40 *Cine-style lenses feature large bright lens markings and integrated gear rings for zoom and focus.*

same cannot be said when focusing on a CCD where pixel size is typically several orders of magnitude larger. Indeed, for years, shooters had little reason to improve the performance of their video lenses since the low resolution of the NTSC and PAL systems was seen as a limiting factor.

With the advent of high definition 1080i/720p camcorders, however, lens performance must again be a real concern to all shooters.

Thus cine lenses would appear to be a viable alternative for the shooter whose equipment supports interchangeable optics. Keep in mind, of course,

Figure 4.41 *Traditional video lenses have miniscule markings, as if their designers wanted to keep these settings a tightly guarded secret.*

Figure 4.42 *Reduced depth of field is often the key to effective visual storytelling. Adaptable to many popular DV and HDV cameras, the P+S Technik Mini35 Adapter allows the mounting of high-quality cine lenses with their shallow depth of field characteristic intact. Utilizing a 35mm SLR or cine lens without such an adapter will yield little or no advantage.*
A version of the P+S Technik adapter is also available for ⅔-inch full-size camcorders.

that most cine lenses were not designed for digital applications. Covering a ⅓-inch CCD (actually 6mm) in most DV cameras, these lenses intended to cover a much larger 35mm frame, must work proportionately harder to fill the screen if only the center of the lens is utilized. As a consequence the resulting images may appear washed out and lacking in contrast, unless a specialized adapter like the P&S Technik Mini35 is used.

Taming the Depth-of-Field Beast

We noted in Chapter 2 how excessive depth of field is a nagging problem for the video shooter. This is due mainly to most DV and HDV cameras' tiny CCD imagers that tend to work against well-defined focal planes. This means your close-ups—your storytelling workhorse—are less effective as backgrounds remain too sharp. Strong compositions also suffer as the viewer's attention cannot be appropriately directed inside the frame. Clearly if the shooter-storyteller is to achieve a convincing illusion of three dimensions in DV video, the relative inability to place objects in well-defined focal planes must somehow be addressed.

The most viable solution today is the Mini35 Digital Adapter from P+S Technik This front-mounted accessory permits high-quality cine lenses to be mounted on select DV cameras while preserving the lenses' original (narrow) depth-of-field attributes.[3]

3. Depth of field is defined as the range of objects in a scene from near to far said to be in reasonable focus. Small f-stops (i.e., f8, f11) will reflect increased depth of field; large f-stops (i.e., a smaller number, f1.6, f1.8, etc.) will produce a narrower range of objects in focus.

Figure 4.43 *A shallow depth of field helps your images attain the look and feel of a top feature film or commercial. For this scene a Canon XL-1S was fitted with a cine lens utilizing the P+S Technik Mini35 adapter. (Courtesy of P & S Technik)*

When utilizing the P+S adapter, the shooter should be sure to operate with the cine lens aperture as wide open as possible in order to establish a shallow depth of field. The image forms on a ground glass inside the adapter with the favorable DOF intact, this image in turn is relayed to the camera's imager through a series of optics fitted with a supplemental iris to control exposure. The setting of the camera iris thus has no bearing on the recorded image's previously established narrow depth of field.

Supporting Your Storytelling Goals

<div style="text-align:right">**5**</div>

TELLING VISUALLY COMPELLING stories with a video camera demands rigorous control of the frame. Like the Old Masters of centuries ago, we are providing a unique window on the world, a proscenium arch through which we expose, compose, and *exclude* what is not essential to our story. It is on this stage that we as shooters apply our sweat and inspiration, and the many rudiments of good storytelling craft.

This storytelling mandate requires rock solid support of the frame. You shake and weaken its walls, you better have a good storytelling reason. We've seen and suffered through unmotivated *shakycam* for more than 25 years, so the world has had quite enough, thank you.

Of course, as MTV has demonstrated the unsteady camera can also work quite successfully. Because shakycam obscures what the storyteller is up to, it makes the viewer work harder to figure out what the heck is going on. As we pointed out in Chapter 2, this obfuscation of intent *can* be an effective storytelling technique. Unfortunately, long after shakycam stopped serving a legitimate storytelling purpose, many shooters kept at it, and at it, and at it. Shakycam then became more about the shooter himself and his pointless gyrations. It no longer had anything to do with visually supporting a good story. Truth is, today, nine times out of ten, the unsettled camera is just plain distracting, an impediment to good storytelling—a once clever gimmick run amok.

Appropriate support of your camera and frame should reflect the impetus of the story at hand. Is the frame anchored solidly in reality as in most establishing shots or landscapes, or does the handheld camera more

TCR 03:01:13:02 TCR 03:01:23:15 TCR 03:01:03:20

Figure 5.1 *A shaky handheld camera can reflect a character's peril and serve a legitimate storytelling goal. Here, in the streets of Warsaw two decades ago, my handheld camera captured the chaos and savagery of a public demonstration turned violent.*

Figure 5.2 *A Dutch angle used sparingly can often suggest the mindset of an unbalanced character.*

accurately reflect the point of view, say, of a deranged villain?

Strong compositions built on solid support work in tandem with all the other aspects of good craft. Logical well-modeled lighting, adept use of focus (and follow-focus), and good depth of field control all play key roles as does the inspired placement of objects within the frame that can help foster a three-dimensional sense. In most cases the video storyteller's aim is to build intimacy with the audience, drawing its eye into the canvas by helping identify those frame elements critical to the story. Attracting unwarranted attention to the edges of the frame (as in the case of some ants-in-the-pants shooters) is counterproductive. The smart shooter knows that appropriate camera support is imperative in order to maintain the integrity of the frame and the story housed in it.

In my case, love of tripod came to me the hard way, in the trenches of battle facing down the water cannon of a dying Communist regime. It was 1980s Poland, and being able to scurry and set up the tripod quickly meant I could use a longer lens to capture the soldiers' faces atop the armored personnel carriers and the reaction of citizens crumpling under the cannons' decapitating blast. Of course in the middle of total pandemonium, it is not always possible reach for the tri-

Figure 5.3 *Establishing shots like this London night scene usually benefit from a well-supported camera.*

Figure 5.4 *Some scenes, like this launch of a Saturn V rocket, were never meant to be captured with a handheld camera.*

Figure 5.5 *My close-up of this hawk has been seen numerous times in high-profile music videos and commercials. For the video shooter and storyteller, close-ups pay the bills—and solid camera support gets you those close-ups!*

pod, but when I could, the solid platform enabled some of the most intense and riveting close-ups that I've ever shot. So it's simple to me: solid camera support gets me the close-ups I need to pay the bills, make my career, and tell compelling stories.

Figure 5.6 A well-designed fluid head is worth its weight in gold. Smooth with large operating surfaces, high-quality support gear will pay you dividends for years, long after your present and future cameras du jour are relegated to doorstops. My Sachtler head continues to serve me reliably after more than two decades of almost nonstop use around the world.

Figure 5.7a,b Don't waste money on flimsy consumer gear. The Sachtler DV2 fluid head offers ideal support for DV and HDV camcorders at a reasonable price. Heavier-duty high-end models offer an illuminated spirit level—a great help when working in low-light situations.

Figure 5.8 Miller tripods have accompanied National Geographic shooters into the wilds for decades. This model supports DV camcorders up to about 11 pounds (5 kg.).

Getting Ahead in Support

If you're serious as a shooter and video storyteller, you'll need to invest in a pro-level tripod and the most rugged *fluid head* you can find. Fluid heads typically use a silicon dampening system to enable smooth pans and tilts. The viscous liquid is forced through a series of drillings like the oil through an automatic transmission; the intent being to provide a predictable amount of resistance regardless of ambient temperature. The incremental drag dials on some models vary the resistance; the precise amount of drag being selectable and repeatable. In this way the shooter can gain confidence in his or her ability to execute consistently smooth moves. Like the clutch action on a car, the feel from vehicle to vehicle may vary, but once you are accustomed to the clutch on *your* car, the driving experience quickly becomes seamless and second nature.

While a low-cost friction-type head may seem like a good option, the well-designed fluid head is the video shooter's best choice. Its precision engineering, low weight, and robust construction are critical to withstand the rigors of real-life conditions. The action should be glitch-free, impervious to the elements, and with no perceivable backlash—that is, the tendency of some heads to bounce back slightly when handle pressure is relieved. Pan-and-tilt locks should be of the lever type with large surfaces to facilitate single-handed operation even in winter with thick gloves.

You may go through many cameras in your lifetime, but you will likely only need one fluid head—if you make the right investment. In my nearly

Figure 5.9 Equipped with a pro-style ball-leveler and quick release plate, the Bogen/Manfrotto 501 provides exceptional functionality at an economical price.

Figure 5.10 For winter shooting, a thin pair of polypropylene gloves is indispensable. These gloves (from EMS, Eddie Bauer, and others) offer protection from direct contact with a tripod's metal surfaces while preserving the tactile sensitivity necessary to operate the typical small camera's less than robust controls.

Figure 5.11 C'mon. True professionals use the proper terms! A horizontal movement of the camera is called a "pan." A "tilt" refers to a vertical movement. Every shooter must make it a point to learn his bread and butter. My grandfather, seen in front of his Brooklyn deli in 1937, had to learn his bread and butter too.

three decades as a shooter, I've only owned two. The first—a Sachtler 3+3 Panorama model—was lost at Mount Saint Helens in 1980, a victim of volcanic ash and pulverized granite that penetrated the drag dials and destroyed the fine German action. The second—a replacement 7+7 model—I still use regularly to this day. That's well over 25 years of the most grueling punishment imaginable from tropical rain forests to arctic tundra and everything in between. Not bad for (what seemed at the time) a ludicrously expensive $1,900 investment. Of course, it was worth that sum many times over. I built my career literally on that one fluid head.

What Pretty Legs You Have

I often hear whistling from onlookers when I work and it's not because I prefer to shoot in my briefs (I don't!). The catcalls and stares of envy—okay, so I'm imagining all this—are really directed at my legs, my *tripod* legs, which just happen to be extremely rugged, versatile, and sexy as hell. You can't buy a pair like them now and mine aren't for sale, so don't email me. The point is I love my legs—and you should fall in love with yours, too.

To facilitate the bonding process, here are a few features to consider when shopping for legs. They should be lightweight yet able to stand up to substantial abuse, whether facing down stormtroopers in Eastern Europe or a panicked rhino in Zimbabwe. The leg locks should be simple in design to facilitate setup with minimal fuss. Leveling should be accomplished via a ball-mount and large knob that can be grabbed easily even in winter with heavy mittens. I recommend leg adjusters with inscribed height increments,

Figure 5.12 *Dual-stage tripods can eliminate the need for carrying multiple pairs of legs on a job.*

Figure 5.13 *Key features include: secure leg locks; incremental leg markings to facilitate level setup; a raised spider that stays clean and can serve as a monitor platform; a center column that permits easy raising of the camera in tight spaces. Watch for legs with hidden pinch points that can crush unsuspecting fingers!*

Figure 5.15 *A secure quick-release plate facilitates mounting and dismounting of the camera from the head. You don't want to be fumbling with a ¼ x 20 screw when facing a enemy dive bomber!*

Quick Release
plate

snaps in here

Figure 5.14 *Ouch! Some tripod legs (like mine) have multiple pinch points that can cause serious injury. Make sure the people you love are duly warned.*

Ouch!
Pinch Point!

Figure 5.18 A spirit level in conjunction with the clawball enables rapid leveling of the camera. To facilitate setup in the dark, the spirit level is illuminated on some models.

Figure 5.16 The leveling of the head and camera is accomplished with the claw-ball. Make sure it operates smoothly and has a sufficiently large knob adjuster. On a typical job you'll level the camera many times a day, so you'll want this operation to be as easy and secure as possible.

Figure 5.17 Dial-in drag rings help the shooter pan and tilt in a predictable fashion by precisely setting the amount of resistance. Some models feature up to seven user-settable drag settings in each direction. Lower-cost heads may only feature one or two drag positions in the horizontal and vertical axes. Fluid heads using such a dial system should always be shipped in the "zeroed" position to prevent damage.

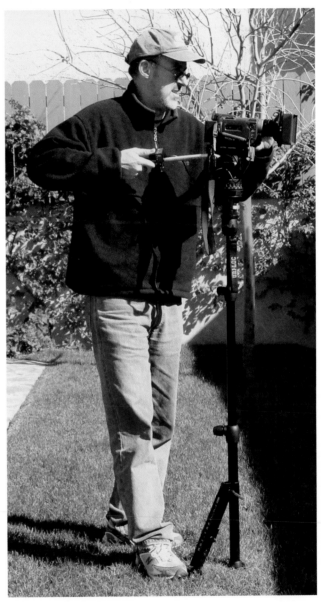

Figure 5.19 Some wedding and event shooters might opt for the DuoPod, a lightweight single post support that can accommodate a pro-level fluid head in its top configuration.

HOW TO COUNTERBALANCE THE CAMERA

ASSEMBLE THE CAMERA
Mount the lens, battery, microphone and any other accessories you will be using on the camera.

FIND THE BALANCE POINT (C.G.) OF THE CAMERA
Place the camera on a flat rigid object that's not too heavy, like a clip board. Put a pencil on a smooth table and place the camera and board on the pencil and roll it back and forth until you find the balance point.

ATTACH THE CAMERA MOUNTING PLATE
Fasten the center of the camera mounting plate as close as possible to the balance point of the camera (with lens, battery and accessories installed).

BALANCE THE CAMERA ON THE HEAD
Adjust the slide plate assembly on the head so the indicator notch is over the center of the head (zero mark). Mount the camera to the slide plate. Set the tilt fluid drag lever to zero. Release the platform lock lever. Find the balance point for the camera while the camera is in the level position by sliding the camera back and forth. Re-lock the platform lock lever.

ADJUST THE COUNTERBALANCE
It is very important to make sure the weight of the complete camera configuration is centered on the head. After balancing the camera on the head, tilt the camera forward and back. If the camera continues to drift forward or back when tilted, increase the counterbalance adjustment. If the camera has a spring-back reaction, decrease the counterbalance adjustment. Our infinitely adjustable counterbalance allows you to stop adjusting at whatever feel you like best and quickly readjust for minor changes in weight. The counterbalance is properly adjusted when the camera holds its position when tilted up or down. Now you can adjust the pan and tilt drag settings to your preference.

PROFESSIONAL CAMERA SUPPORT SYSTEMS

Figure 5.21 *The Microdolly ships with 13 feet of track and can be set up in less than two minutes. It's one of the few truly portable dolly systems that actually work.*

a useful feature when leveling the camera by eye or with the help of an overtaxed assistant.

You should learn to love your legs. They support everything you do.

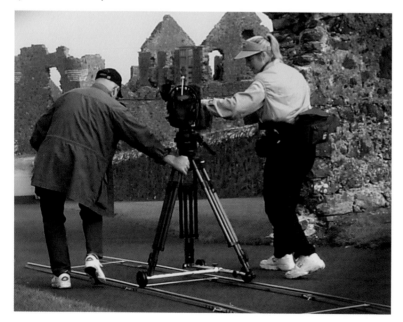

Seeking Other Means of Support

Besides the standard legs and fluid head, shooters might also consider a set of baby legs and a high hat to achieve the occasional ground level or low-angle shot. Such support can also be useful for securing the camera in difficult locations such as atop a stepladder or car bumper.

Video Shooter

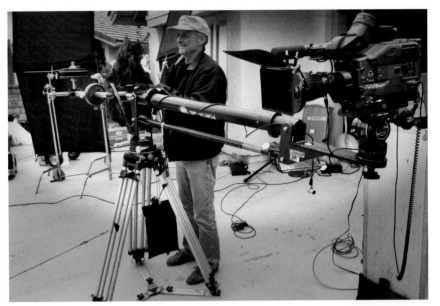

Figure 5.22 *When considering a lightweight crane or jib arm, make sure it is sturdy enough to enable smooth takeoffs and landings. The Porta-Jib has been around for years.*

Figure 5.24 *The utmost heft and simplicity of the Chapman PeeWee contribute to its efficiency and reliability in the field.*

Figure 5.23 *The Intel-A-Jib from Industry Advanced Technologies is extremely stable and robust, and sets up in less than two minutes.*

Figure 5.25 *The skilled use of a jib arm or small crane helps convey a glossy professional feel. The Jimmy Jib can be extremely effective for automobile drive-bys or flying over large screaming crowds. (Photo courtesy of Steve Wills/KY Video Services.)*

Figure 5.26 *Camera stabilization systems like the Steadicam Mini often reduce the need for more elaborate setups requiring track and dolly. Smooth operation demands considerable expertise, however, so be sure to practice your skills before the first day of shooting! (Photo courtesy of Tiffen.)*

Figure 5.27 *The Twister from Alfred Chrosziel supports a small camcorder balanced between two ball-bearing grip points. Its elegant construction allows for a smooth booming effect without the many hours of practice usually required for other stabilization systems.*

With the advent of lightweight camcorders and improved zoom and focus controllers, there's no longer any reason to shy away from more advanced support options like a jib arm or dolly. Many manufacturers have recently introduced lower-cost versions of their pro products, expressly for the small-format video shooter.

Be wary, however, of flimsy gear. Such equipment is unlikely to see much service, as performance is invariably poor owing to lack of stability. Shooters should always test the ruggedness of any camera support before purchasing. If additional weight is not an issue, a more substantial jib arm or dolly is always preferable as the increased mass provides smoother movement along with better takeoffs and landings.

For those on the move who must travel light, the Microdolly is an excellent option, combining the flexibility of a professional dolly and jib arm with a compact unit that weighs a mere ten pounds and fits in a 34-inch soft case.

Figure 5.28 *I bought this computer-controlled turntable at a Hollywood yard sale several years ago. Such gear helps the shooter achieve the signature product shots critical to establishing a viable niche.*

Figure 5.29 *The original battery (top) that accompanies most DV cameras is often inadequate to perform useful work. A high-capacity battery is therefore imperative, especially if an on-camera light or other power-hungry accessories are contemplated.*

More Power to You

The camera battery is a sore point for many shooters as the undersized units typically provided by manufacturers are entirely impractical. Thankfully, this is slowly changing as camera makers slowly see the error in their ways. Still, shooters price-shopping for a camera will want to budget for a proper-size battery—usually the *highest-capacity* power source they can afford.

Seeing What You're Doing

It's a common source of frustration for shooters: the inability to make out an image on a camera's LCD screen in bright daylight. One solution is a low-cost hood that affixes with elastic straps or Velcro to the camera's swing-out finder. Such hoods are available to fit almost every type camera or monitor.

Figure 5.30 *An inexpensive hood is indispensable for viewing your camera's LCD screen in bright daylight.*

Monitoring Your Image

Whether it's the ability to follow-focus, check color and contrast, or simply see what you're doing, an on-board monitor has become increasingly essential to the DV/HDV and small-format HD shooter. While the DV camera has always featured an IEEE 1394 FireWire port, for some reason unbeknownst to logical men and women, the industry has been slow to embrace the need for a pro-level on-board monitor with a DV interface.

Perhaps this reflects a lingering industry bias against DV and FireWire, which for years were thought too consumer-oriented to be of much interest to professionals. Now that DV cameras are figuring more and more in prominent TV series and feature films, we are finally seeing IEEE 1394 compatible monitors entering the market. Venders of high-end broadcast gear are applying their technical expertise to a new generation of on-board DV-native monitors.

So what should a shooter look for in an on-board monitor? First, the unit must be compact and frugal on power. I for one have grown dog-tired of carting around 75 pounds of batteries simply to power the camera, monitor, and a few odds and ends accessories. With the recent move away from tape-based cameras, perhaps more power will become available for larger and brighter on-board displays. Power consumption for a typical seven-inch LCD monitor should not exceed 20W (at 12VDC), a reasonable power draw for adequate visibility under most conditions.

Be mindful of some monitors' excessive weight. While increased mass may reflect a more robust construction, some displays are simply too heavy for mounting atop certain camcorders, such as the Sony DSR-PD170 and Canon XL2. Lacking a built-in LCD display, the Canon XL2 would appear to be the perfect candidate for a lightweight on-board monitor. Unfortunately, despite the Canon's thick alloy body and handle, the fragile accessory shoe is ill-designed to support a four-pound mass suspended at the end of an Israeli Arm.

Figure 5.31 *The Datavideo TLM-70 monitor and Israeli support arm.*

Use Proper Support Language

As stated previously, using proper jargon can help elevate your status as a professional shooter. On a feature set or commercial, efficient communication is critical as there are too many ways for things to go awry to let chaos rein. The director and talent can only do their best and most creative work if loud conversations between shooter and his support crew are kept to a minimum.

Figure 5.32 In low light, the image visible on an external monitor may be the only clue to what you're actually capturing. Native DV support offers shooters direct digital monitoring of sound and picture.

Figure 5.33a1,2 Bring the baby legs.

Figure 5.33b1,2 *I need the high hat.*

For this reason, I recommend a system of gestures and hand signals. I've indicated a few of my favorite (non-obscene) gestures I use in my camera department. You can devise your own.

Here are a few lines you can shout at any time and gain instant respect from your crew:

- *I need an inky with some milky stuff!*
- *Can you take the curse off that red head?*
- *What ever happened to that blondie and stinger?*

Translations:

- *I need a 200W fresnel with diffusion.*
- *I need a piece of light diffusion on a 1000W open-face instrument.*
- *I'm still waiting for that 2000W open-face light and extension cord.*

Figure 5.33c1,2 *Fetch the French flag.*

Making Light of Your Story 6

THE SHOOTER HAS VERY specific requirements when it comes to selecting appropriate lighting gear. In the prehistoric days of my youth when I earned my living shooting industrial films on 16mm ASA 25 film, the "standard" travel kit consisted of four open-faced Lowel lights fitted with 1000-watt lamps. Such relatively high-wattage gear was necessary in many instances to achieve minimum exposure—indeed, any image at all.

With the advent of extreme low-light sensitive cameras, the Big Bang approach to lighting is no longer the only or preferred way to go. Today, your credo should be *less is more*. Operating at low light levels means fewer and smaller instruments with less tweaking and futzing. It means fewer cutters, C-stands, and gobo arms to control the spill, which in turn saves money on crew, speeds setup time, and cuts transport requirements significantly. All of this can enhance your value as a shooter and the likelihood of garnering bigger and better work opportunities in the future.

Lower light levels also translate into a more comfortable working environment for talent and crew; the reduced chance of tripping circuit breakers also being a big plus for productions that draw power from standard wall outlets on location.

Aesthetically, there are many advantages to thinking small. Shooting at low light levels means decreased depth of field, a *very* good thing for the DV and HDV shooter hoping to exploit selective focus as a potent storytelling tool. Image quality and color fidelity are also vastly improved as the CCDs in most cameras exhibit significantly less noise and undesirable artifacts in minimal illumination.

Figure 6.1 *The DV shooter's ultimate lighting kit. The four low-wattage fresnels are fitted with four-way barndoors that are highly controllable, thus reducing the need for a multitude of flags, cutters, and cumbersome grip gear.*

Figure 6.2 *Me and my babies. When investing in lighting gear, it usually doesn't pay to scrimp. Unlike your camera, which you'll likely upgrade every two to three years, you'll probably be using the same lighting kit decades from now. From left to right, a venerable line-up: a 750W Mole-Richardson "Baby Baby"; a vintage Mole "Tweenie"; and a 150W Arri fresnel.*

Figure 6.3 *This 200W "Inky" manufactured by Mole-Richardson in 1927 has been handed down to me through multiple generations of cameramen. Virtually unchanged today, the model #2801 is still available. Note the two-leaf barndoor offered as standard equipment eight decades ago.*

Figure 6.4 *Serial Number 22. This Inky still sees daily use after almost 80 years of service!*

For these reasons the ability to work with small instruments is essential to the success of the DV shooter-storyteller. In my own work, I usually prefer small focusable fresnels to less expensive open-face instruments

that produce lots of light with far less control. I recall one History Channel documentary that I shot a few years back with a single four-head 150W fresnel kit!

Of course, for some shooters, old habits are hard to break. I recently witnessed a macabre DV shoot in which the veteran DP dragged two 1200W HMIs, three 4 × 4 bounce cards, three large cutters, two five-foot *meat axes*, seven C-stands, a six-foot piece of track, and a Western dolly into a ten- by twelve-foot windowless room. Aside from the personnel and many hours needed to accomplish this Herculean task, what did the DP then do? Flag the lights. Squeeze the barndoors. Drape the heads with black foil and put double double-scrims in them. He spent almost *two* hours cutting the lights down to a manageable level. Do you see the logic? I sure don't.

For the savvy shooter with the proper insight and skill, a few small high-quality lights can take the place of a dozen larger less versatile units.

HMI Lighting: Expensive But Worth It

For many years I traveled the world with a small tungsten kit and two 400W HMI[1] PARs. An HMI *parabolic arc reflector (PAR)* is the shooter's dream light—strong enough to punch through a 4 × 4 diffusion silk yet

Figure 6.5 *My twin 400W PARs have served me well on dozens of documentaries and feature films since 1994. The instruments' high initial cost has been recouped many times over in rental fees— and peace of mind.*

Figure 6.6 *The Kobold DWP 400 is rugged enough to withstand the rigors of a torrential downpour.*

1. HMI = Hydrargyrum Medium Arc-length Iodide

Figure 6.7 *Low-wattage lighting can take advantage of a standard wall outlet, a huge plus on location as the need for a messy "tie-in" is eliminated.*

Figure 6.8 *Small HMI PARs provide the shooter with the option of bounce or direct lighting. At night, several instruments can be used to create pools of light or lift overall illumination.*

Figure 6.9 *For the small-format videoshooter working mostly in close-ups, there is usually little advantage to high wattage lighting. The HMI PAR utilizes a series of drop-in lenses that help define its beam and character. The proficient use of fewer but higher quality instruments can be critical to the DV shooter-storyteller's ultimate success.*

efficient enough to plug multiple units into an ordinary household outlet. For interiors, you can bounce the PAR off a white card to simulate a flattering window source. Outside, the PAR can be used directly through a silk or grid cloth to provide a natural facial fill. The 200W or 400W HMI PAR is easily one of the most valuable instruments you can own.

It is also one of your best investments as such lighting can instantly elevate the look and feel of one's images on screen. Unlike other sizeable

equipment outlays, the impact of utilizing HMI, CID, CSI[2] or other high-quality lighting is obvious and thus readily billable to clients. A small HMI PAR costing thousands of dollars may seem extravagant, but I can assure you it is not. Packing ten times the punch of conventional tungsten lighting, the HMI PAR's power and versatility can often eliminate a trunk full of less useful lighting and grip gear. For the itinerant shooter, this efficiency alone will justify the considerable investment.

Think Small but Also Think Big

Huh? What's this? So you want to light like Néstor Almendros? Now there was a craftsman who could light (*Days of Heaven, Sophie's Choice, Kramer vs. Kramer*) with little more than a small mirror and a single fresnel. Of course, years ago, Néstor wasn't shooting DV, so just think what he could've done with today's *lo-lux* cameras. Being able to shoot in the dark—what a fabulous notion!

When working with talent, a large diffused source is often necessary to help soften facial shadows and suppress undesirable texture visible in the skin. In general, shooters seek to maximize texture when lighting and composing scenes, but this is generally *not* the case when shooting close-ups of talent, especially star female talent.

Minimum Illumination for Popular DV/HDV Cameras (manufacturer provided data)

• Canon XL1-S	2 lux
• Canon XL2	5.5 lux (20X zoom/60i/4:3)
• JVC HD100U	Not specified
• JVC DV300U	2.65 lux (f1.6 LoLux mode)
• JVC DV5000	0.40 lux (f1.4 LoLux mode)
• Panasonic DVX100A	3 lux (f1.6, 18db, 50 IRE output)
• Panasonic SDX900	0.01 lux (f1.4 +48db +20 db Gain)
• Sony HDR-FX1	3 lux
• Sony DSR-PD100A	4 lux (500 TV lines)
• Sony DSR-PD150	2 lux (f1.6 18 db)
• Sony DSR-PD170	1 lux (f1.6, 18db)
• Sony DSR-370	0.5 lux (f1.4 w/HyperGain +36 db)

Figure 6.10 *The low-light capability of popular DV and HDV models according to the manufacturers. Shooters should look warily at such specs since adequate performance is not always a consideration when determining these values.*

2. CID (Compact Iodide Daylight) and CSI (Compact Source Mercury Halide) are another common daylight source technologies. A 1000W CID lamp produces approximately 2.5 times more light than a 2000W tungsten source.

Figure 6.11 *Today's LED units can mimic the look and feel of HMI lighting at a fraction of the cost. The versatile LitePanel 1 × 1 can be configured as a large soft source capable of outputting any color temperature from tungsten to daylight. An ingenious mini-fresnel panel provides a variable beam pattern from a narrow 12º to 90º flood.*

Close-ups should be every video shooter's top priority, and so it matters that uneven color compression in DV and HDV cameras can wreak havoc with a star's flesh tones. Compression anomalies and hue shifts apparent in the shadows can produce ugly contours like an open pit mine—hardly a great way to treat your leading lady!

Large sources directed through a silk or medium grid cloth produce a flattering near-shadowless wash of light that can help suppress DV/HDV's objectionable artifacts especially in the shadows. The advantages of a high-quality soft light cannot be overstated, as the excessive error correction apparent in many DV cameras is also mitigated.

Figure 6.12 *Blasting hard undiffused light at your subject is lazy and unprofessional, and will make any scene look like adult entertainment. Don't even think about lighting like this— even if you are shooting adult entertainment!*

Figure 6.13 *Since soft light dominates the natural, spiritual, and manmade worlds, the shooter is usually expected to mimic this quality with gently modulated shadows. Remember that shadows tell your story! Treat them with dignity and respect.*

Figure 6.14 *A large bounce card can serve as an excellent soft source.*

Soft Is Key

From a craft perspective, the shooter must recognize the relative effect of hard and soft light.

Figure 6.15 *This vintage 750W zip light continues to perform well in the current DV/HDV environment. The more powerful 1500W and 2000W units are less useful to the DV shooter who usually benefits from lower light levels.*

Choosing a Soft Light

A large soft source may be achieved through a silk or diffusion gel, by bouncing off a white card or foam core, or by employing a dedicated soft

Figure 6.16 *The Chimera light box mounted on a 400W HMI PAR. This is one of my favorite setups— an instant window producing a beautiful soft northern light. The Old Masters would've killed for this gear!*

Figure 6.17 *The "book" light provides a simple approach to lighting close-ups. The bounce off the show card is further softened through the diffusion gel.*

light fixture. However you accomplish it, an effective soft light must be a part of every video storyteller's tool kit.

Spilling the Beans

One downside of large sources like a Chimera light box or bounce card is the need to control their copious spill. In most cases this requires the careful placing of a *flag* (or cutter) to protect a nearby wall or set element. A fresnel offers better control with a focusable lens and barndoor, but its beam is harsher and thus more likely to produce objectionable shadows.

In general, the more confined the location, the more time and grip gear required to rein in

Figure 6.18 *Large sources often require multiple well-placed flags to prevent unwanted spill on walls and set elements. A shooter may spend many hours adjusting such flags, undermining the advantage of using broad soft sources in the first place. Shooters who cover many setups per day should consider first utilizing small fresnels as such instruments are more easily trimmed and controlled.*

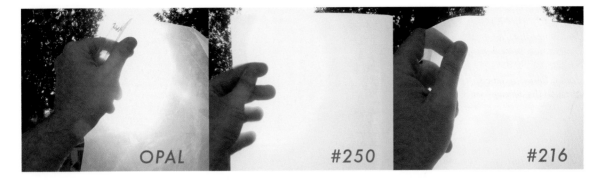

OPAL #250 #216

Figure 6.19 *The three diffusers essential to every shooter. Be sure to carry at least several 10-inch by 12-inch sheets of each type: #216, #250, and opal. The Lee references are understood widely in the industry and are often used generically. Rosco produces a comparable line of diffusion gel.*

the unwanted spill. On large sets, the spill may fall off harmlessly into space and produce no ill effect. In more intimate setups typical of many DV and HDV shoots, the shooter is afforded no such luxury.

Types of Diffusion Gel

For the shooter-storyteller, adept use of diffusion gel is crucial in order to control a source light's character and the resultant depth of shadows in a scene, this shadow depth being the number one factor determining the tone and effectiveness of your visual story.

There are dozens of diffusion gel types on the market, but most shooters only need three basic varieties in their kits: a strong diffuser for on-camera fill and keying talent, a moderate diffuser that can provide a bit more edge when needed, and a light diffuser to take the curse off strong direct sources. The gel available from various manufacturers may be purchased in long rolls or in single 20-inch by 24-inch sheets at any film and TV expendable supply house.

#216 in gel frame

Alternatively, if you're like me and want to save a few dollars, you can simply rummage through the trash of a feature film, commercial, or TV show that happens to be shooting in your neighborhood. The gel discarded each day from a typical high-end production is enough to supply most DV shooters for a lifetime.

Figure 6.20 *In this typical setup, the 750W "Baby Baby" key is directed through a #216 heavy diffuser.*

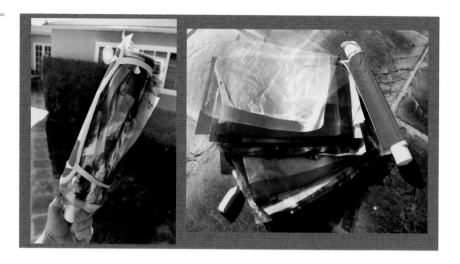

Figure 6.21 I never leave home without my jelly roll! Given its use on virtually every shoot, the 12-inch storage pouch for gels is the DV/HDV shooter's best friend.

The Jelly Roll

While you're scavenging through the trash of *Rocky XXII*, you might also avail yourself of other forlorn gel. These scraps can help fill your *jelly roll*—an elastic pouch that is easily one of the most valuable pieces of gear you can own. My jelly roll contains an assortment of diffusion, color correction, and party gel from various shoots and trashcans over the years.

Selecting Gel

When ascertaining what gel to include in your jelly roll, it's useful to think in terms of diffusion, color correction, and *party* types. We've discussed the three essential diffusion varieties. With respect to color correction gel,

Figure 6.22 The range and effect of common color correction gel. Blue CTB increases the color temperature of a source light and makes it appear cooler; orange CTO gel decreases color temperature and makes the source appear warmer. Lee filter references are shown.

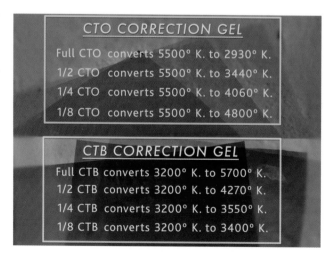

CTO CORRECTION GEL	
Full CTO	converts 5500° K. to 2930° K.
1/2 CTO	converts 5500° K. to 3440° K.
1/4 CTO	converts 5500° K. to 4060° K.
1/8 CTO	converts 5500° K. to 4800° K.

CTB CORRECTION GEL	
Full CTB	converts 3200° K. to 5700° K.
1/2 CTB	converts 3200° K. to 4270° K.
1/4 CTB	converts 3200° K. to 3550° K.
1/8 CTB	converts 3200° K. to 3400° K.

I make sure to include a range of blue gel, from one-quarter to full blue (CTB), this latter deep blue gel ostensibly but not quite converting a tungsten 3200° K source to daylight.

Blue correction gel is the most used in my kit, as tungsten sources must frequently be cooled to better represent the effect of daylight spilling into a scene. Typically, I add only a hint of blue (e.g., half blue) to reflect a cool source in or out of frame. I don't transform the tungsten source completely to daylight because I want to preserve the realistic feeling of mixed illumination. Conversely when working with HMI or other daylight sources, a half CTO (orange) gel helps alleviate the blue curse while still preserving the sense of daylight streaming from an exterior source. In fact, I often mix warm and cool lighting, painting a scene with CTO or CTB correction gel to add texture while at the same time maintaining the faithful interplay of light emanating from multiple temperature sources.

While full blue CTB is intended to convert 3200° K tungsten sources to daylight, the strategy in practice comes up short when compared to actual daylight or the output, say, from an HMI. If true daylight balance is your goal (and it may well be), an actual HMI, LED, or color-correct fluorescent is required. Also note that due to high heat absorption, full blue CTB is subject to rapid fading, so the wise shooter is sure to include several extra sheets in the basic kit.

The party gel in my jelly roll is used to add a splash of color or contrast to otherwise sterile backgrounds. These gels, like the swatches of paint spread across an artist's palette, reflect the shooter's own sensibilities and experience. I maintain an assortment of violet and rose gel to add a dash of panache as needed. The deep crimson is one of my favorites, capable of injecting intrigue, if not full-scale alarm, into any scene. A little goes a long way, however, so shooters should use such heavy effects sparingly, and as always, with a modicum of good taste.

Figure 6.23 *In a typical setup, the subject directs his look between the camera and key light. The key and fill lights are fitted with a heavy diffuser. The backlight and "kicker" are gelled with lighter diffusion to preserve the character of their beams. Most interior and exterior scenes are set up this way, the camera looking into the subject's facial shadows in order to maximize the three-dimensional illusion.*

The Standard Setup

By maximizing texture in lighting and perspective, the shooter promotes the *illusion* of a third dimension. Accordingly, when shooting a talking head, we generally direct the subject's gaze at a point between the camera and key light. One or more small fresnels are then set as backlights to add highlights to the subject's face and hair and to achieve the needed separation from the background. The background in turn

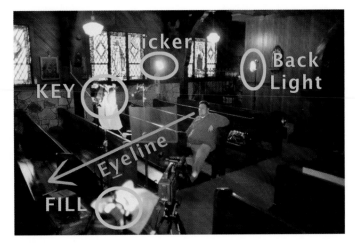

Figure 6.24 *The kicker from screen left is stronger and more focused, simulating the effect of the window source in frame.*

is painted with a tightly focused fresnel fitted with a party gel or cookie to add interest. *(For more on cookies, see "Snoots and Kooks" later in this chapter.)*

Having Your Fill

The savvy shooter recognizes the substantial craft required to apply appropriate fill light to a scene. Too little fill leads to excessively dark shadows and a potential increase in noise. Too much fill can wash out a scene and impart a lifeless artificial look.

For shooters accustomed to working with 16mm or 35mm film, DV and HDV's fill requirement is something of an Achilles' heel as *some* frontal fill is almost always required. This is especially true in the higher resolution format owing to the greater compression and many cameras' less-than-stellar optics that tend to sink shadow detail into the murk.

A little fill applied passively with a bounce card may be all you need to return a portion of the key light into the shadows. The appropriate camera filter might also help by transferring surplus highlight values into the darker image areas. *(See Chapter 9.)*

On-Camera Options

If an active fill is desired, a small fresnel directed through diffusion or a China ball at the end of a fishing pole can work fine. An on-camera solution is often preferred, and for this the shooter can opt for a ring light, or one of several dedicated top-mounted units. The options run the gamut from the traditional tungsten-balanced sungun to a potent daylight-balanced LED or

miniature 10W HMI. You'll want a camera fill light that packs enough punch to produce a natural wash even through a layer or two of diffusion. Depending on the ambient light, a 25W tungsten unit might work okay. Most shooters however will want considerably more power and versatility—and with daylight balance.

Overfilling

A common challenge facing shooters is often *too much* fill as copious amounts of stray light spilling from windows and other uncontrolled sources make effective control of shadows difficult, if not impossible.

Figure 6.26 *The Bebob Lux features a flexible design that permits precise orientation to avert shadows. An unusually bright lamp and series of built-in filters adds to its versatility.*

Figure 6.25 *If you tend to work weddings and "people" events, chances are you could benefit from an on-camera fill. Though lacking in control and subtlety, the 25W Anton Bauer Ultralight has been a popular choice for years.*

Figure 6.27 *The Kino-Flo Kamio combines the functions of a dimmable on-camera ring light with a professional matte box.*

Figure 6.28 *The LED Mini LitePanel provides a smooth daylight source that is frugal on power yet packs a surprising punch. The versatile unit is an indispensable part of my basic camera package.*

Figure 6.29 *An "Israeli Arm" provides support for a wide range of camera accessories. Its single knob permits easy positioning of a camera light to eliminate eyeglass reflections or the shadow from a matte box.*

The smart shooter must thus understand the concept of *negative* fill—that is, the strategy of removing unhelpful light from a scene in keeping with our credo to exclude, exclude, exclude. Just as in framing the world, the shooter must take care to contain uncontrolled spill that can undermine the visual story. Depending on the setup, this might include the blocking of windows, the flagging off of a large China ball, or shutting down banks of fluorescent overheads. Truth is, most shooter-storytellers share the same malady: scenes that are illuminated by too much light, not too little.

Lighting in Planes

I'm not talking about Boeing 737s. I mean *visual* planes as in a scene's foreground, mid-ground, and background. When lighting a scene, every light must have a purpose like every element in a composition must support a

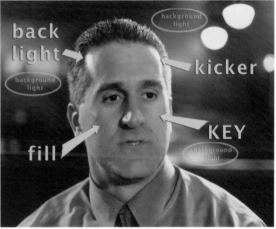

Figure 6.30 *Learn to recognize and control the spill that can cripple a scene and undermine your visual storytelling. Here a large show card is used to block an exterior window.*

Figure 6.31 *The character and quality of the light striking the background, foreground, and mid-ground should be independently controlled for maximum visual impact.*

common storytelling goal. In general, we illuminate each plane independently. We place our key to tastefully model our subject in the mid-ground. We light our background (usually) to achieve separation and help lift our subject from the canvas. And we light our foreground to help frame and direct viewer attention to what's important in the visual story.

Analogous to a layered Photoshop composition, the planes are treated independently so the shooter can precisely tweak the look of each plane. A hard raking light may be used across the background to add texture and separation. A soft front light may be used at mid-ground to preserve detail in the subject's facial shadows or suppress unwanted texture in an actress's face.

Lighting in planes can be a challenge to the documentary shooter who must often shoot in narrow or confined locations. Since one light can seldom optimally light multiple planes at once, the DV/HDV shooter is constantly looking for ways to control unwanted spill—that is, the cross-contamination of one plane's light into another.

Figure 6.32 *The Century C-stand provides solid support for bounce cards, nets, cutters, and other lighting control gadgets.*

Figure 6.33 *Here the C-stand supports a microphone boom—an obvious benefit to the DV shooter operating single-handedly.*

Get a Grip

On most projects, the small-format video shooter should take advantage of a basic grip package, which at a minimum should consist of four or five C-stands and a flag kit. Transporting weighty C-stands is not always practical, however. If a shoot requires grip gear in a distant city, I try to rent a package locally, and save the aggravation of transporting hundreds of

Figure 6.34 *Watch your step! If you're serious about lighting, you'll stumble on scenes like this often.*

pounds of gear in checked baggage. The same applies to other unwieldy expendables like large sheets of foam core and show cards. Packing these items on airplanes no longer makes much sense given the extra baggage costs and the relative easy availability of these items in most large cities.

Figure 6.35 *A medium 18" by 24" flag kit.*

Flagging It

A medium-size 18-inch by 24-inch flag kit consists of several cutters, a triple, double, two single nets, and a silk. Such kits are inexpensive, will last a lifetime, and is essential for proper lighting control.

Figure 6.36 *Since the eye is invariably drawn to the brightest part of the frame, we usually want the most light on the subject's face. Here, the priest's bright collar may divert viewer's attention, so a double (red) net is placed at neck level to feather the light off the offending wardrobe.*

Figure 6.37 *A net at the end of a gobo arm feathers the light off the edge of a set.*

single net

gobo arm extended

Blackwrap

Known to most folks by its trade name, Blackwrap has almost unlimited uses. Affixed to the back or sides of a lighting instrument or clipped to its barndoors, the aluminized black foil can be efficient at eliminating or reducing spill. Blackwrap can also be used to fabricate makeshift *snoots* and *cookies*—a common task for the enterprising shooter.

Snoots and Kooks

For shooters making ample use of low-wattage fresnels, some type of snoot is often useful to properly focus attention in a scene. This might take the form of narrowing a beam on a wall painting or perhaps a photograph on a dresser. Precise control of these "specials" with their inevitable spill is critical to maintaining an effective overall lighting strategy.

Figure 6.38 *The black foil referred to as Blackwrap is a practical and inexpensive way for the shooter to control spill in tight locations. While Blackwrap does not obviate the need for C-stands and cutters, adept use of the malleable foil can greatly reduce the need for substantial grip gear.*

Figure 6.40 *Snoots are often used to narrow a projected beam on a painting or other set element.*

Figure 6.39 *A 1920s vintage snoot mounted on my Mole-Richardson Inky #22.*

A cookie (short for "cookaloris") is an effective way for the DV/HDV storyteller to add texture and interest to flat uninteresting scenes. Every shooter with a few notches under his battery belt has reached for a *kook* now and then, most often to break up a shadowless wall, floor, or other large surface. Kooks can be improvised using strips of gaffer's tape and a C-stand, or even more simply by poking a few holes in a piece of Black-wrap. The makeshift pattern can be anything from a prison cell to the dappled projection of a streetlight through trees.

I know a shooter at NBC who has kept the same well-worn pieces of Blackwrap in his package for over 15 years. Job after job he just keeps pulling out the same tattered old kooks. Not bad for a few pennies investment. By the way, you can usually find a good supply of the black foil in any feature film trash, along with all the discarded gel, gaffer's tape ends, and uneaten lunches you might like.

Clamping Down

It was something of a status symbol at *National Geographic* to carry the most beat-up grip gear imaginable. This applied particularly to the various clamps, which tended to last for eons and carried the imprimatur of *experience,* their ratty condition (it was thought) reflecting the pain endured in far-flung battle-borne adventures. To this day I still carry an assortment of mangled clamps just to maintain this impression: pipe clamps, Mafer clamps, gator clamps, C-clamps—all beat to heck. My scissor clamps are especially full of personality, these clamps being the darling of every shooter who has ever faced a CEO beneath a suspended ceiling. Of course, I also carry a few dozen clothespins, the common spring kind. They count as clamps, too.

Figure 6.42 *The resourceful shooter carries an array of clamps to tackle any mounting challenge. I also keep a small suction cup (far left) in my package for mounting a small light on a car hood or other smooth surface.*

Figure 6.43 *Industry pros often cutely refer to a clothespin as a C-47—its one-time catalog designation. The extension cord we say is a "stinger." An overhanging tree branch placed into a scene we call a "Hollywood." Using proper lingo will increase your perceived prowess as a shooter and contribute to the omniscient halo above your head.*

The Tale of the Tapes

Every shooter is expected to be familiar with basic filmmaking tools, including a range of industry utility tapes. Camera tape is especially useful as it may be safely applied to camera bodies and lens barrels without fear of damaging the finish or leaving a gummy residue. The video shooter should make sure to have at least one roll of one-inch white camera tape on every job. Camera tape is widely available from any film or video supply houses.

Gaffer's tape is a heavy-duty cloth adhesive definitely *not* for use on cameras, lenses, or pricey electronic gear. Its powerful grip will easily remove the paint from light fixtures, apartment walls, and priceless works of art. Gaffer's tape in gray or black is commonly used on the job for such rou-

Figure 6.44a,b *One sign of a pro shooter is the range of tapes he or she carries on the job. Gaffer's tape should never be confused with the gooey household duct variety (left) that should not be seen at or near pro camera and grip gear of any kind. Use only high-quality camera tape on cameras and lens bodies.*

Figure 6.45 *A roll of white camera tape is a must on every job. Use it for marking focus and zoom on a lens barrel, or as markers on the floor or ground for blocking talent. Hang a well-used roll from a carabiner on your belt and the world will regard you as a seasoned pro.*

Figure 6.46 *Camera tape "tickets" affixed to the matte box help keep track of filters in use.*

tine tasks as sealing shipping cases or covering a rough seam on a dolly board. It should not be used to secure cabling to floors or walls, however, as the sticky adhesive can make a nasty mess of things in short order. Look for a brand with a high cloth content to reduce the potential mess factor.

The Ditty Bag

I've carried the same ditty bag (more or less) on jobs for the last 25 years. Below is a list of its contents modified slightly for the DV age:

Figure 6.47

- Diagonal pliers
- #1 and #2 Phillips screwdrivers
- ½" and ¼" flat screwdrivers
- Needle-nose pliers
- Slip-joint pliers
- Wire stripper
- Precision screwdriver set
- 6-inch vice-grip
- 6-inch crescent wrench
- 8-inch crescent wrench
- Metric combination wrench set
- Awl
- Precision tweezers
- Assorted Sharpie markers
- Dry-erase marker
- 2 or 3 grease pencils
- ¼" X 20 & ⅜" X 16 hardware
- Superglue
- Metric/SAE nut driver set
- Assorted BNC/RCA adapters
- 8-inch steel ruler
- Lens tissue and fluid
- Spare tripod touch-go plate
- Tube of lithium grease
- Sunblock
- Jeweler's loupe
- Sewing kit (steal from hotel room)
- Safety pins
- Carabiner
- Velcro strips
- Space blanket
- Soldering gun
- Solder
- Can opener
- Corkscrew
- Leather hole puncher
- 3 two-prong adapters
- 2 screw-in bulb socket adapters
- VOM multimeter
- C-47s
- Small flashlight with spare lamps
- Ear plugs
- Protective eye gear
- Swiss Army knife
- First Aid Kit
- Metric/SAE Allen wrench sets
- AC circuit tester
- Rosco and/or Lee gel swatch
- Cable ties (various sizes)
- Cloth 50-foot tape measure
- Lens chamois
- WD40 lubricant
- Emery cloth
- Bug dope
- Pepto-Bismol/Kaopectate
- Shower cap (for lens)
- 35mm film core (nostalgic)
- Spare 9V, AA, and AAA batteries

The Ditty Bag

Every shooter worth his lens cap has a small case or ditty bag that he carries religiously to every job. I take great pride in mine, having rescued many panicked producers and productions over the years. Everything from re-soldering a power cable and changing a flat tire to treatment of diarrhea—it's all part of being a competent shooter and team member. On many shows, your resourcefulness in time of need can earn you hero—almost godlike—status.

Fluorescents and the Green Plague

Fluorescent lighting for film and video used to be a perilous proposition. Yes, the fixtures ran cool, used little power, and threw off tons of light, but who cared? The color balance was horrible, exhibiting invariably a sickly green hue. Facial shadows and darker complexions were particularly susceptible to the insidious green spike, requiring shooters to apply a wash of healthy light, often from a pricey HMI source.

In 1993, I recall shooting at a popular health club in New York City. Of course there were the usual banks of fluorescents in the ceiling, all emitting the horrid green pall. Employing the wisdom of the time, I dutifully balanced every one of the *220 tubes* in the club, fitting each lamp with a full minus green gel. This compensated for the green by bathing the entire club in a deep magenta, not unlike a bordello.

Naturally this drew more than a few scathing looks from the agency rep and the spot's young director, who demanded that I rectify the "mess" pronto. He couldn't believe that his smiling workout babes would appear normal on film. I tried to reassure him, pointing to my Minolta Colormeter, but his eyes kept telling him otherwise.

The green plague is often exacerbated by the fluorescents' overhead placement. To satisfactorily capture such scenes, the shooter typically employs an eye-level fill by borrowing a few diseased lamps from overhead to provide the necessary frontal or side illumination. The strategy has the advantage of maintaining consistency in the fill light, albeit with the miserable green curse intact.

In theory, cool white fluorescent lamps are supposed to mimic a daylight source. But this is only to the unsophisticated eye, which is a lot more forgiving of spectral deficiencies than the CCD and processor in your camera. The reviled green spike is integral to every fluorescent tube's design that employs mercury vapor to achieve its high lumen/watt ratio. It's a pact with the devil in some ways as the high luminosity and efficiency comes at a steep aesthetic price.

In the last few years, fluorescent tube manufacturers have made considerable progress in addressing the plague, as newly developed phosphors largely compensate for the green cast. But as manufacturers drive the lamps harder to achieve greater output, the off-color spike has increased proportionately, necessitating the formulation of yet another generation of compensating phosphors.

Kino-Flo of Sun Valley, California, develops its own line of fluorescent tubes, mixing different phosphors to produce a tungsten or daylight lamp that *appears* balanced to the eye. This is a key issue to shooters prone to violence at the sight of fluorescent fixtures displaying the slightest hint of green.

Figure 6.48 *The Green Plague is very evident in this fluorescent-lit market. At right is the same scene after white-balancing, a process entailing the addition of copious magenta. If you're shooting close-ups of talent, be sure your supplemental lighting matches the overall green condition.*

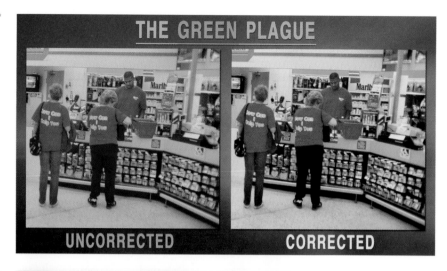

Figure 6.49 *Found ubiquitously in commercial establishments around the world, the cool white fluorescent offers plenty of light at low cost. Problem is, all that light comes with a potent green curse.*

Beyond the noxious green hue, there is also the potential for flicker, a hazard associated generally with discharge-type lighting. Apparent to shooters at increased camera shutter speeds or when shooting NTSC in 50Hz countries, the pulsating effect manifests itself most obviously in out-of-sync streetlights and neon signs.

Today, high-frequency ballasts have largely eliminated the flicker risk in professional lighting instruments, but proper caution should still be exercised when shooting under ordinary discharge-lighting conditions abroad or in areas known to experience power irregularities.

A New Generation of Fluorescent Lighting

With improvements in tube and instrument design, the latest breed of fluorescents now offers excellent color balance and softness with a surprising amount of punch. Indeed, today's fluorescent lighting is ideal for the DV and HDV shooter seeking a reasonable alternative to costly HMIs.

Figure 6.50 *Modern color-correct fluorescents make for a powerful and efficient soft light. Balanced lamps without an apparent green spike are available in tungsten and daylight types.*

Figure 6.52 *The ParaBeam from Kino-Flo features a directed beam more characteristic of a fresnel than a broad fluorescent array.*

Figure 6.51 *The Lowel Caselite permits mixing of daylight and tungsten tubes to achieve a desired color balance. The silvered barndoor serves to increase beam intensity and control spill—a crucial consideration for shooters working with broad sources.*

The Magic Wand

The Gyoury system is built around the concept of a wand—a tube assembly that may be detached and mounted behind a car visor, under a computer screen, or even inside a refrigerator.

Placed inside a China ball, the wand may be suspended at the end of a painter's pole to provide a soft fill ahead of walking talent. For episodic TV, political conventions, and awards ceremonies, this mobile, easily placed soft key produces a highly flattering frontal wash.

Beyond their relative low cost, the latest generation fluorescents like the Gyoury consume far less power than their tungsten or HMI brethren. Cooler running, they provide talent and crew a welcome respite from the heat of conventional lighting.

Figure 6.53 *The Gyoury wand produces a gorgeous light that can be placed almost anywhere.*

Figure 6.54 *Set into a wire frame and draped with grid cloth, the broad fluorescent provides a flattering key or subtle fill for close-ups.*

A Great Backlight

The fluorescent array's rapid light falloff is also a consideration for shooters looking for a smooth, tasteful backlight. While a fresnel may project a hard shadow back onto the set or talent, the broad fluorescent produces a near-shadowless wash without the bulk or hassle of a light box or bounce card. Such economy in tight locations such as office cubicles and supermarket aisles is one of the main advantages of utilizing a broad fluorescent lighting.

Lighting for Green Screen

One area where smooth illumination is a must is in blue and green screen applications. When lighting for green screen, I typically use two or more crisscrossing umbrellas or fluorescent broads to assure an even wash. Even if you don't have access to a waveform, you can use the camera's exposure zebras to achieve a smooth illumination. I use the same broad setup to shoot flat art off a tabletop or wall—a common task, especially for the documentary and corporate-type shooter.

Figure 6.55 Broad instruments like this nook light produce a lot of light albeit with little control. Just what you need for lighting blue and green screen!

Figure 6.56a,b In a typical setup, two or more umbrellas or "broads" are used to produce an even wash across the green background. Your camera's zebras set to 70 percent can help achieve an illuminated panel devoid of hot spots.

You might also opt for a *nook* light to wash large surfaces such as walls and cycloramas. Remember, when lighting a large screen panel, beam control is less important than achieving an even overall illumination.

Why Green?

Green screen is favored over blue screen for several reasons. First, primary green occurs rarely in our everyday world, so we needn't usually worry about inadvertently keying out our starlet's beautiful blue eyes. Of course if you're shooting sun-dappled leprechauns in a rain forest, you might consider utilizing a blue screen instead.

Another reason for using green: the green channel in digital video is not compressed. Compression always tends to produce some noise that can complicate the execution of a clean key. Since the eye is especially sensitive to green wavelengths residing in the middle of the visible spectrum, engineers choose not to compress the green channel since any discarded pixel information may be readily apparent to viewers. In NTSC, DV's red and blue channels are sampled at one-fourth resolution in the 4:1:1 color space. The green channel sampled at full resolution is thus usually the best choice for keying.[3]

Red, green, and blue plus several other colors, including yellow and amber, may be used for keying. Red is usually not a good choice owing to the amount of red in human flesh tones. White or black keying is certainly possible, and may in fact be the only option when a chroma-key screen must be improvised on location, say, in front of a large white or black wall.

A Reflection of Our Times

An alternative to a physical green or blue screen, Reflecmedia's Chromatte utilizes a special fabric consisting of millions of tiny beads to achieve a smooth illumination. The advantage is ease of setup; the screen's texture eliminating the need for the usual umbrella or broad lighting array.

The key to the Reflecmedia system is the lens-mounted ring light used to illuminate the panel, which appears gray to the eye but registers as a solid blue or green surface to the camera. The result is a chroma-key system that sets up in seconds and allows placement of talent close to the screen. This is an obvious advantage to the DV/HDV shooter who must often shoot in tight locations, such as a network production trailer or press box.

3. The same is true for HDV in the 4:2:0 color space, and DVCPRO HD which operates in 4:2:2. *See Chapter 8 for more discussion.*

Shooting DV Exteriors

Capturing well-balanced exteriors under bright sun has always been a challenge to the video shooter owing to the often extreme contrast range. Working with modest prosumer gear, the DV/HDV shooter faces particular peril,

Figure 6.60 *One solution may be to shift such scenes earlier or later in the day. Here, the soft raking sun adds warmth and texture. Your DV camera eats this stuff up!*

Figure 6.59 *Owing to the extreme contrast range, shooting in full sun can be a major challenge to the DV/HDV storyteller.*

Figure 6.61 *Properly filled shadows facilitate compression in-camera by easing the extreme transitions in high contrast scenes. The result is improved performance from even the most modest DV camera.*

as these cameras tend to exacerbate the loss of detail in deep shadows. At the same time, the strongest highlights may also appear blown out and similarly devoid of detail. For the small-format video storyteller, shooting in the glare of the midday sun is lose-lose at both ends of the characteristic curve.

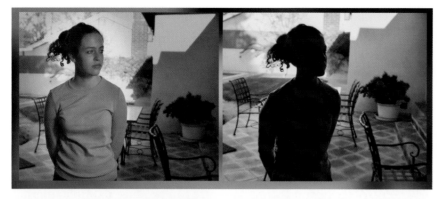

Figure 6.62 *The soft day-light fill from an HMI lifts the foreground scene and shadows in my daughter's face. An active fill is sometimes the only way to tackle such high-contrast conditions. At right is the same scene without fill.*

Figure 6.64 *A metal reflector can be extremely efficient when filling shadows in bright sun. If you do a lot of traveling, a collapsible-type reflector is more practical.*

Figure 6.63 *A collapsible silver or gold reflector should be a part of every shooter's basic kit. Some models have a white surface on the flip side—a very useful feature.*

Avoid Small F-Stops

As discussed in Chapter 4, the small apertures required to shoot midday exteriors tend to exacerbate small-format video's already unfavorable depth of field condition. Shooting at narrow f-stops can also negatively impact lens performance, as all lenses incur some diffraction artifacts and loss of contrast when stopped down. The bending and scattering of light through and

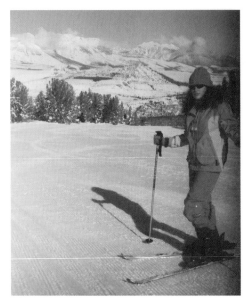

Figure 6.66 *At small apertures, the edges of the iris blades are transformed into tiny light sources, scattering light in all directions and dramatically lowering contrast. For the DV/HDV storyteller, the inferior lens performance at small f-stops is another compelling reason to shoot as early or late in the day as possible.*

Figure 6.65 *This ski scene recorded at a minimum f-stop appears washed out due to severe diffraction.*

around a tiny aperture can produce multiple internal reflections and a concomitant increase in flare. As a result bright daylight scenes typically appear washed out or otherwise lacking in sharpness.

I usually try to shoot exteriors with the aperture as wide open as possible using a suitable strength neutral density (ND) filter for exposure compensation. Many cameras incorporate only the basic 0.6 ND that provides a nominal two-stop advantage. You may need additional ND in bright sun, and for that you'll have to use a supplemental glass filter to achieve proper exposure.

My DV Lighting and Grip Package

You can argue this list forever, but here is what works for me:

Figure 6.67 *Most cameras feature a built-in neutral density filter that can be engaged via an external switch. You may also need a supplemental glass ND to achieve optimal exposure. (See Chapter 9 for more detailed filter discussion.)*

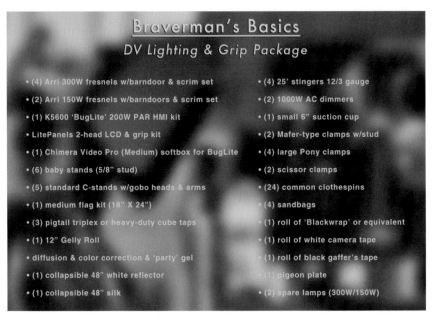

Braverman's Basics
DV Lighting & Grip Package

- (4) Arri 300W fresnels w/barndoor & scrim set
- (2) Arri 150W fresnels w/barndoors & scrim set
- (1) K5600 'BugLite' 200W PAR HMI kit
- LitePanels 2-head LCD & grip kit
- (1) Chimera Video Pro (Medium) softbox for BugLite
- (6) baby stands (5/8" stud)
- (5) standard C-stands w/gobo heads & arms
- (1) medium flag kit (18" X 24")
- (3) pigtail triplex or heavy-duty cube taps
- (1) 12" Gelly Roll
- diffusion & color correction & 'party' gel
- (1) collapsible 48" white reflector
- (1) collapsible 48" silk
- (4) 25' stingers 12/3 gauge
- (2) 1000W AC dimmers
- (1) small 6" suction cup
- (2) Mafer-type clamps w/stud
- (4) large Pony clamps
- (2) scissor clamps
- (24) common clothespins
- (4) sandbags
- (1) roll of 'Blackwrap' or equivalent
- (1) roll of white camera tape
- (1) roll of black gaffer's tape
- (1) pigeon plate
- (2) spare lamps (300W/150W)

Figure 6.68

The Audio Story 7

FOR THE SHOOTER, a substantial investment in audio gear would appear at first to be illogical. After all, we are concerned foremost with our images, and good quality audio seems like something that ought to just happen like the changing of the seasons or day turning to night. Of course, recording proper audio is no fluke, and most of us realize that superior sound and superior images go hand in hand. As visual storytellers, we know that crisp, clean audio is critical to the way our pictures will ultimately be regarded. Professional high-performance audio gear—mixer, cables, and microphones—are in every way as essential to the shooter's craft as a tripod, camera, and lens filter.

It is understandable that camera manufacturers focus almost exclusively on video performance since we as shooters tend to pay scant attention to camera audio. This is unfortunate when you stop to think about it since the intelligibility of our audio is so critical to telling a successful story. In fact, audiences will (and routinely do) tolerate bad picture but *never* bad sound, so audio integrity should be paramount in every shooter's mind. Sure, it may be possible to replace bad audio later in a complex and potentially expensive ADR[1] session, but this is hardly practical for most shooters, especially for those of us operating on low- or no-budget projects.

In general, the more professional cameras do not exhibit the range or depth of audio shortcomings compared to their lower-end brethren. So

1. ADR (audio dialog replacement) is a common process of replacing unusable production audio in a controlled environment.

Figure 7.1 *The external audio controls can be the source of significant noise in DV recordings. While newer cameras, including the Panasonic DVX, feature markedly quieter preamps than previous models, proper care and technique should always be exercised to ensure quiet professional audio.*

Figure 7.2 *Keep an ear outKeep an ear out for this guy and always handle for this guy and always handle with care! Avoid unnecessary plugging and unplugging to reduce wear and risk of intermittent connections.*

here's another reason (if you ever needed one) to purchase higher-quality gear—to ensure better audio recordings.

Despite issues of distortion and poor frequency response, noise continues to be the major culprit when recording audio direct to camera. The gain control knobs are the source of significant noise in many popular camcorder models, so shooters should make it a habit not to set these pots above 50 percent. Poor quality cables, jacks and cheap adapters are also major noise contributors. Don't scrimp in this vital area or you'll most surely regret it.

Bad Connections = Bad Sound

For shooters working mostly with consumer and prosumer cameras, poor quality A/V connectors are an ongoing source of frustration. Indeed, veteran shooters know from hard-won experience that cables and connectors are the primary cause of failure in the field. This is due in part to normal wear and tear, and the physical stress to which these connectors are regularly subjected.

The ubiquitous ⅛-inch mini-plug is Public Enemy Number One in this regard, providing a dubious connection at a critical juncture with the camera. Common mini-plug-to-XLR adapters offer only a partial solution, facilitating a professional interface on one side while retaining the fragile (unbalanced) mini-plug on the other. Worse, the heavy XLR adapter weighing on the mini jack may contribute to an intermittent condition.

Mind Your Connections

Consumer-grade RCA-type plugs and jacks offer easy interoperability with home-based gear, but separate easily when subjected to the stress and strains of a shooter's day. For this reason, the BNC twist-bayonet design is preferable, although few under-$5,000 DV models feature this type connector.

Figure 7.3a,b *The ⅛-inch mini plug is not without its accomplices. Two female cohorts are shown at right.*

Figure 7.5 *While the BNC bayonet (left) provides a more secure connection, most compact camcorders feature consumer RCA-type jacks.*

Figure 7.6 *Flimsy plugs and jacks are not just a matter of economics. As cameras have shrunk in size, the real estate available for more robust connectors has diminished. The placement of the XLR connectors on this Panasonic DVX100A seems cramped.*

Figure 7.4 *The proper handling of cables is critical for noise-free recordings. For storing, cables should be loosely coiled with an alternating back twist to ensure they lie flat and free of damaging kinks. Getting the knack of it sometimes take a while.*

Figure 7.7 *The Canon XL2 features a BNC video connection for security and peace of mind.*

Figure 7.8 *For the itinerant shooter, an assortment of audio and video adapters is a wise investment. The right one can save a shoot or career!*

Figure 7.9 *Balanced audio through secure XLR connectors provides superior noise cancellation and should be considered de rigueur for serious work.*

Figure 7.10 *On cameras fitted with the dreaded ⅛-inch mic input, a low-cost matching transformer may be used to attach a professional microphone. Such solutions do not convert an unbalanced camera to a balanced system, nor do they eliminate the fragile ⅛-inch plug that often leads to trouble.*

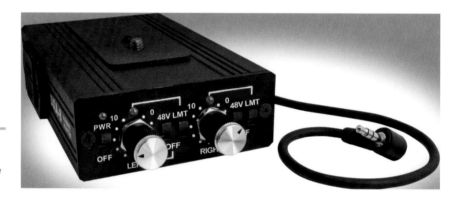

Figure 7.11 *The Beachtek DXA-10 adapter features phantom power and built-in limiters.*

Keep Balance in Your Life

Shooting can be fun, but you have to keep some balance in your life. That means paying attention occasionally to your loved ones, spouse, or kids. It also means selecting camera gear if possible with professional *balanced* audio.

The difference between balanced and unbalanced audio is a third conductor. An unbalanced connection has only two wires, the signal (+) and ground. A balanced line has three conductors, the signal (+), the anti-signal (-), and ground. Any audio cable—especially over longer runs—can act as an antenna and serve as a potent noise collector. Thus the need for an effective noise cancellation strategy.

Balanced audio cables are shielded to resist noise and the corresponding loss of signal. This is achieved by the third conductor carrying a parallel signal 180 degrees out of phase. The out-of-phase signal is flipped back

into phase at the camera connection, effectively restoring the original signal by canceling out any noise that might have been introduced along the way. An unbalanced adapter utilizes only two of the three conductors, thus defeating the noise-canceling capability of any balanced components you might have in your system.

Thankfully, an increasing number of camcorder models are offering balanced audio with integrated XLR connectors.

No Garbage Stuff for Me

If you've been reading this book, you know I don't stand ½₄th of a second for flimsy gear masquerading and marketed as "professional" equipment. As a veteran shooter with a large mortgage and two kids, I demand a lot from the tools I use and depend on every day. These tools have become like part of my family, and I rely on them in much the same way, through thick and thin, ice and snow, for richer and for poorer. You get the idea.

When it comes to audio, your mixer is control central, for it is here that you set record levels, monitor audio quality, and apply limiting, padding, and filtration. Its layout of controls must be logical and easy to decipher. I'm a real stickler for workflow, and when a piece of gear is frustratingly designed or too awkward, it is quickly relegated to a closet, back shelf, or eBay. A mixer's gain and fader knobs must have a solid feeling and be easily grasped even with gloved hands—a particular need of documentary folks shooting in winter outside the coziness of a heated studio or corporate boardroom.

And while we're discussing shooting on location, the mixer's output meter should be clearly visible under the brightest conditions whether at the beach or atop a mountain in the glaring snow.

The shooter can usually evaluate a mixer's performance based on its ability to handle low frequencies. The Sound Devices 302, a compact three-channel field mixer, uses balanced transformers to provide the necessary isolation from the incoming source. Input signals are transformed magnetically; there is no direct electrical connection as is typically the case in low-end mixers. For the shooter working in uncontrolled situations, superior low-frequency response is the key to capturing realistic high-quality audio.

Ideally your mixer should also interface effortlessly with any hard-wired or wireless microphone you might own. For me, I continue to use my 20-year-old Sennheiser MKH-416T, a trusted and devoted friend that has accompanied me literally to every continent on earth. From arctic cold to Amazon heat and humidity, the 12T-powered mic has more than earned its place in my family of Most Trusted Stuff; its ruggedness, reliability, and performance simply cannot be questioned. Your field mixer should be in this league.

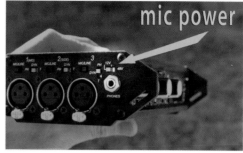

mic power

Figure 7.12 *The Sound Devices 302 is a rugged three-channel mixer ideal for the shooter assembling a first-class audio package. Its display is clearly visible even in bright sunlight, a major advantage for shooters who operate in widely varying conditions.*

Figure 7.13 *The mixer should accommodate a range of mics without external adapters, cables, or bulky boxes.*

Figure 7.14 *To reduce noise, most shooters should enable the mixer's high-pass 80Hz filter. There is usually little audio worth recording below this point, especially in dialog scenes.*

High-pass filter

All told, your mixer should ameliorate, not exacerbate, the noisy pots and preamps that plague many low and mid-range cameras. It should feature two, three, or four microphone preamps with a wide gain range to accommodate various line levels. A range of 75dB from mic input to line output is ideal. For the small-format video shooter, a mixer with a built-in 80Hz (high-pass) filter is desirable in order to suppress low-frequency noise like wind and traffic. The effectiveness of a high-pass filter, especially to the DV/HDV shooter, cannot be overstated.

Most shooters should also take advantage of a mixer's "safety" limiter. Since the limiter's threshold is not normally reached, it should in normal use have no effect on the recording. In noisy unpredictable environments like barroom brawls, however, the limiter kicks in gently to prevent clipping, an unwelcome loss of detail akin to blowing out highlights in video.

Figure 7.15 *A two-channel mixer is ideal for shooters who typically use a boom and wireless lavalier and seldom have need for more a elaborate configuration. The simpler interface may also appeal to shooters who tend to work alone.*

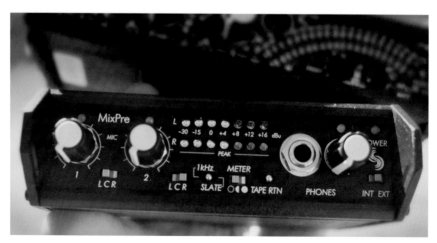

Automatic Gain Control

I've asserted throughout this book the importance of taking manual control of your storytelling. Whether it's setting proper exposure, white balance, or focus, only you—the talented painter of light—can apply the necessary craft and make the appropriate determinations. With respect to audio, the same logic applies: disabling your camera's automatic gain control (AGC) should be a top priority as this will prevent unwanted background noise from ramping up during quiet passages.

When ascertaining levels, you should set the maximum possible without clipping. The –12dB reference in most cameras doesn't leave much headroom for loud passages so the onus is on the shooter or soundman to record proper levels in the first place.

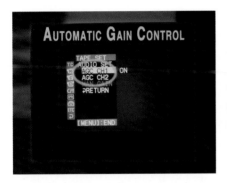

Figure 7.16 *In most cases, AGC (automatic gain control) should be disabled in your camera's setup menu.*

Figure 7.17 *When adjusting levels, care should be taken to avoid clipping as any detail lost is lost forever.*

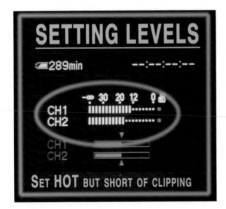

Figure 7.18 *Referencing channel 2 at 6dB below channel 1 offers the shooter some protection against sudden loud passages.*

Figure 7.19 *Noise reduction can be more precisely applied later so you'll want to switch the internal camera control off.*

Cameras either combine the left and right microphone inputs in a single ⅛-inch jack or maintain the channel separation in individual XLR connectors. While dialog is recorded in mono, it is common practice to split the incoming audio into two channels, the second channel setting 6dB below the first to accommodate unexpected loud outbursts. Many shooters employ a common microphone configuration of placing the boom on channel 1 and a lavalier (or wireless) on channel 2.

For the Love of Mic

Figure 7.20a,b *My Sennheiser 416 and I have worked together for over 25 years. In the scene below, my 416 works its magic inside a Rycote windscreen.*

The shooter's goal of reduced noise begins with optimum placement of the microphone. Locating the mic too far from a subject or positioning it significantly off axis is the leading cause of elevated background noise. Shooters should take note: mic placement is too critical to leave to an untrained person, a reluctant friend or relative perhaps, pressed into service to cheaply fulfill the task of "holding the boom". Not recognizing the value of accurate microphone placement will yield unusable sound and quickly sink the viability of any production.

The shooter working with modest DV equipment should reduce as much as feasible the record level of the camera's internal preamp. This can usually be achieved by enabling the microphone's built-in attenuator. Most electret condenser microphones like the Sennheiser ME-66 and Azden SGM-1X offer such a capability. Dynamic mics without the attenuation feature can be routed through an external mixer to achieve the same goal.

Choosing Your Weapon

Of course, no shooter can be expected to assume all the responsibilities of a professional sound recordist. Heaven knows the talented shooter-storyteller has enough responsibility handling the camera as it is. Still, I suggest that camera people carry a basic sound package—lavalier, short shotgun (like the 416), boom pole, cables, and a small mixer. Having this capability is critical to grabbing an unforeseen shot, say, when stepping off an airplane in a distant location, or in the middle of the night when your real soundman is recovering from a drunken stupor. My philosophy is simple: arrive on location ready to shoot. This means you carry the essentials with you—tape, battery, minimal sound gear—to get the shot, alone if necessary.

Figure 7.21 *The economical Sennheiser ME-66 is well suited for the shooter who must often work single-handedly. The ME-66's low weight complements the size and mass of most DV camcorders.*

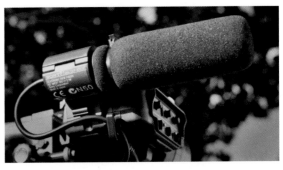

Figure 7.22 *A camera-mounted mic can sometimes provide satisfactory audio for subjects in close proximity of the camera. Many cameras' built-in stereo mic is omnidirectional, and therefore only useful to record ambient sounds.*

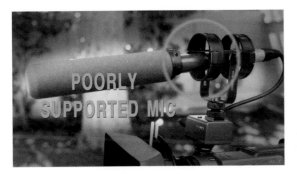

Figure 7.23 *The Sony ECM-672 is a rugged short shotgun optimized for ENG-style shooting. Here the mic is poorly supported, its mass a bit much for the lightweight suspension.*

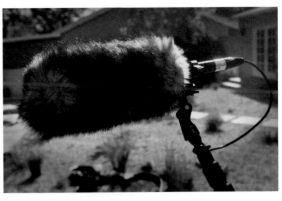

Figure 7.24 *A perfect combination for the DV/HDV shooter, the combined K-Tek pole and windscreen is economical and robust. It will serve you well for many years.*

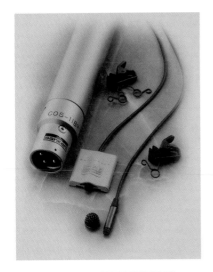

Figure 7.25 *Recent lavalier mics like the Sanken COS-11s can be configured for wired or wireless operation.*

Figure 7.26 *Many shooters include at least one wireless mic in their basic package. The compact Lectrosonics 400 receiver and transmitter feature 256 selectable UHF frequencies and a clean LCD display. Such units may obviate the need on some shows for a boom and boom operator.*

Sound Advice: Record 48kHz

Industry hype is often quick to point out the virtues of 48kHz DV audio, but as we've seen there is a lot more to it than that, as cheap pots, jacks, and noisy pre-amps can also all take their toll on audio quality. Simply describing a camera's audio as *uncompressed PCM at 48kHz* is therefore meaningless if the recorded audio is full of static, distorted, or just plain lousy.

Figure 7.27 *Camera manufacturers typically describe audio performance in rudimentary terms such as "PCM 48kHz 16-bits stereo." More useful data related to noise, distortion, and frequency response is nowhere to be found.*

Figure 7.28 *The Canon XL2 features external controls for recording up to four channels of audio at 32kHz. In general, you should stick with the 48kHz 16-bit stereo standard. It will produce markedly better results in your final output to DVD.*

Besides 48kHz 16-bit stereo, most consumer cameras (such as the Panasonic DVX100A and Canon XL2) also permit recording FM-quality 32kHz audio in up to 4-channels. Owing to the reduced sampling, 32kHz recordings at 12-bits should generally be avoided, especially when output to DVD is contemplated. The DVD-Video format requires compressed or uncompressed audio at 48kHz.

The popular Sony HDV models present their own audio challenges. Capturing compressed MPEG 1 Layer 2 audio, the high-definition format provides substantially lower fidelity than uncompressed 48kHz PCM in standard definition DV. JVC's ProHD cameras, by comparison, including the GY-HD100U, record 48kHz PCM, so there is one advantage to JVC's HDV approach.

Shooting Double System

Owing to the dubious quality of some in-camera audio, many shooters might consider recording *double-system* just as film shooters have done for years. Portable DAT and MiniDisc recorders generally yield far better quality audio than most cameras, despite the nominal compression and lack of timecode in some consumer-grade units. The lack of timecode isn't normally a problem, as the crystal reference used in DAT and MiniDisc recorders is sufficient to maintain synchronization. When shooting double-system, be sure to record proper head and tail slates, and feed a guide track into the camera for reference and backup.

When importing MiniDisc audio into your NLE, you can expect to maintain frame accurate sync for up to ten minutes. Longer takes may experience a cumulative drift of up to six frames per hour, which is quite noticeable, so proper precautions should be taken when handling very long takes.

Shooters should take particular care when shooting double-system at 24fps. Different camera models require audio recorded at different speeds. Most specify 23.976fps—or perhaps 29.97fps. Be sure to conduct proper synchronization tests prior to the first day of shooting. No one likes surprises and there tend to be plenty with respect to synchronization of double-system recordings.

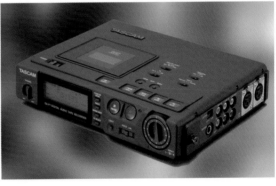

Figure 7.29a,b *Recording double system to MiniDisc or DAT is a good way to circumvent the mediocre audio sections in some cameras. Be sure to record a guide track to facilitate synchronization later in the NLE.*

Behind the DV Image 8

IT SHOULD BE REASSURING that storytelling craft can compensate for most, if not all, of small-format video's real and perceived shortcomings. After all, when audiences are engaged, they don't care if you shot your movie with a top Hollywood crew on 35mm or single-handedly on miniDV. It's your ability to tell a compelling visual story that matters, not which brand of camera you use or which manufacturer's signal-to-noise ratio is greater. The goal in this chapter is to address some of the technical issues facing you the shooter, but *only* so much as it impacts the quality of your images and the effectiveness of your storytelling.

Considering movies like *The Blair Witch Project* shot on a hodgepodge of film and video formats, including DV, it is clear that audiences will tolerate a cornucopia of technical shortcomings in stories that truly captivate. But present a story that is boring, uninvolving, or woefully self-indulgent, and you better watch out! Every poorly lit scene, bit of video noise, or compression artifact will be duly noted and mercilessly criticized.

Figure 8.1 *The success of movies like The Blair Witch Project underlies the power and potential of no-budget filmmakers with a strong sense of craft. The movie's less than pristine images contributed positively to the story , a vital lesson to the DV storyteller looking to take maximum advantage of the format's low-cost and flexibility.*

Craft Matters

We know that audiences are a forgiving lot if they're somehow being entertained, but you mustn't push these folks too far! As we've discussed, most audiences will readily accept the most horridly shot video (as in *Blair Witch*), but they will never accept unintelligible audio.

Thus we must recognize that viewers have a breaking point when it comes to technical shortcomings. We must understand that such a boundary

Figure 8.2 *Poor craft can negatively impact your audience without them ever knowing it. What's wrong with this scene? Bad lighting can undermine even the most compelling story.*

exists and then where the actual boundary might lie. This point of no return is often hard to determine as viewers have trouble describing instances of poor craft. Indeed, in most scenes, audiences cannot identify the most obvious flaws, like an actor's face illogically draped in shadow beside a clearly defined candle. (Figure 8.2)

This doesn't mean that audiences aren't negatively impacted by such defects. They certainly are! Illogical lighting, poor framing, and gratuitous camera motion all take their toll, the audience *feeling* every technical and craft-related glitch you throw at it. The issue is whether these glitches in total are enough to propel the viewer out of the storytelling experience.

The DV Imager and You

To Rembrandt, his understanding of craft almost certainly began with the brush—the texture and character of its bristles, the heft and feel of the stick. To the rest of us clambering aboard the DV and HDV bandwagon, the storytelling craft begins with an understanding of the camera's imager.

Many times as I sit in the endless snarl of L.A.'s notorious 405 freeway, I let my mind drift to ponder the nature of the ungodly world around me: is this an analog mess we live in, or a digital one? At first glance there seems to be plenty of evidence to support the analog view. After all, there I am stuck in traffic going nowhere, becoming increasingly aware of the sun rising and setting, the sky brightening and darkening in a continuous, uninterrupted manner. That sounds pretty analog to me.

But then I think, "Gee, I'm *technically* absorbing this inspiring scene in a series of snapshot 'samples' flashed on the back of my retina. The *digital signal processor* in my brain is then smoothing out the individual samples to make the world only *seem* continuous and uninterrupted. So maybe we don't live in an analog world. Maybe this is a digital mess after all—or maybe it's a combination of both?"

The CCD[1] imager is in many ways the quintessential analog device. The needle of vinyl LP grinds through a groove inducing a small current proportionate to the depth of the groove. In your camera's CCD, the number of electrons streaming from the imager is directly proportional to the intensity of light striking the sensor's surface. More light, more voltage. It's as analog as things can get.

Things haven't changed much since the earliest TV pickup tubes. In fact, your latest and greatest "digital" camera isn't that much different from the vintage Philco hi-fi you unloaded in last year's yard sale. The natural world, like the world of the video shooter, is in fact a potpourri of analog and digital technologies.[2] Always has been, always will be.

Single Chip versus 3-CCD

For many shooters starting out, the experience goes something like this. You're strolling through your local electronic superstore and the guy who sold used cars last week beckons. You're not looking for a date or to be picked up—at least not here amid the big-screens, CD-R bulk packs, and Xboxes. But the pickup line is there nonetheless: "Hey, I've got a one-chip camera from Sunny (sic) as good as any 3-CCD model on the market at a third of the price! It's winning tons of awards. You should read the raves in *Advertiser's Mouthpiece* magazine!"

For the time being, the three-chip camera is a virtual imperative for the serious shooter. Sure, 1-CCD models are cheaper to manufacture and sell for less than a comparably featured three-chip model, but there's more to the story. Single-chip cameras operate at a disadvantage since the red, green, and blue sensors must be merged into a *supersensor* on the imager surface. An overlying filter is then responsible for achieving the necessary color separation. It's an imperfect process that applies to virtually all single-chip cameras,[3] even the highest-end commercial-industry models.

Figure 8.3 *The photogenic passageways of the world exhibit a delicate interplay of light and shadow. To capture the nuances, the video shooter requires an understanding of analog and digital principles. The approximate NTSC luminance values in this scene are indicated on a scale from 7.5 to 100.*

1. The CCD (Charged-Coupled Device) is today's dominant imager type. Characterized by high-sensitivity and wide-dynamic range, the CCD after years of refinements may be finally nearing the end of its reign. Next-generation CMOS (Complementary Metal Oxide Semiconductor) chips are already appearing in some HDV cameras, including the Sony HVR-A1U.
2. In fact, one could easily argue that the only true digital technology is film. A grain of silver exposed or not exposed is akin to a bit that is either conductive or not conductive, a 0 or a 1. The binary nature of film emulsion seems plainly digital to me.
3. Analogous in design to film emulsion, the multi-layer Foveon chip does not utilize an overlying filter to achieve the required color separation. Integration of the Foveon chip into pro-level cameras is still years away.

Three-CCD or CMOS model cameras utilize a prism behind the lens to divert the red, green, and blue image components to their respective sensors. The result is discrete RGB channels that can be precisely manipulated according to the whim and vigor of the camera maker, compression engineer—or shooter's preference.

Figure 8.4 *A typical three-chip CCD or CMOS architecture.*

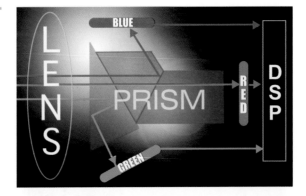

Figure 8.5 *The Arri D20 utilizes a single CMOS sensor and Bayer color-separation filter, an arrangement similar to the lowliest single chip consumer camera.*

Figure 8.6 *Three-CCD models have declined significantly in price. Panasonic GS-series cameras start at under $700.*

Figure 8.7 *16mm and 35mm film versus DV/HDV resolution. The greater the pixel density of the imager, the higher the resolution achievable in a camera system.*

Arrangement of Pixels

For shooters accustomed to working with film emulsion, it seems less than ideal that the arrangement of pixels in a CCD or CMOS imager is not continuous. These chips are thus subject to artifacts because the individual pixels are interspersed with gaps, which inhibit a camera's ability to capture uninterrupted, well-defined images.

The Spatial Offset Ruse

Engineers long ago recognized the negative impact of the discontinuous grid pattern. The pixels arranged in neat rows made the manufacturing process easier, but it also inhibited the satisfactory recording of fine detail falling *between* the rows. This relative inability to capture high-frequency detail can produce a range of objectionable artifacts, most notably a pronounced chiseled effect through sharply defined vertical lines.

To suppress these artifacts, engineers adopted a strategy of spatial offset whereby the green sensor is offset one-half pixel with respect to the

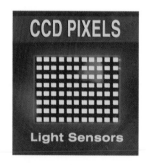

Figure 8.8 *CCD pixel arrangement in rows.*

Figure 8.9 Complex scenes like this Venice alley present a challenge to cameras whose neatly aligned imager grids cannot register the fine detail falling between the individual pixels. High resolution chipsets with increased "fill-in" significantly reduce the artifacts from such unresolved detail.

red and blue. To veteran shooters who recall not too fondly the finicky tube-type cameras of decades past, the notion of *increasing* resolution by deliberately moving the green sensor *out* of register seems illogical. But suppressing the most egregious sharpness and contrast-robbing artifacts seems to have precisely this effect.

The spatial offset ruse is not without its drawbacks. As a *National Geographic* shooter, I can recall shooting many high-detail landscapes that contained mostly green tones. Given the spatial offset approach, a large portion of such images as a grassy meadow or rainforest would *not* be offset and thus subject to substantial artifacts and loss of image quality.[4]

For years, electronic cameras integrated an optical low-pass filter to counteract precisely these types of artifacts. Placed between the lens and prism, the slight blurring afforded by the filter ironically *improves* perceived resolution and contrast in scenes where fine objects or details fall inside the CCD grid structure.

Shooters with a penchant for capturing high-detail landscapes may want to investigate the spatial offset characteristic of their camera. While the amount of offset is fixed at the time

Figure 8.10 Applying spatial offset, the green target is moved one-half pixel out of alignment with respect to the blue and red targets. The strategy is intended to capture detail that would otherwise fall between the regularly spaced sensors.

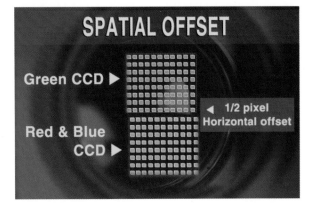

SPATIAL OFFSET

Green CCD ▶

◀ 1/2 pixel
Horizontal offset

Red & Blue
CCD ▶

4. Conversely, the same can also be said for images containing very little green, as such scenes would also not be offset and thus subject to a loss of resolution.

of chip manufacture, some mitigation of the artifacts caused by too much or too little offset may be possible by adjusting the detail level in the camera or adding a physical glass camera filter—two key strategies that should be foremost in the mind of every shooter anyway.

Analog Processing

The analog signal from a CCD or CMOS imager undergoes two distinct processes before sampling and conversion to a digital stream. In the *level shifting* stage, the black level is adjusted in accordance with shooter preference and the applicable television standard. In the United States, NTSC black level is set at 7.5 IRE. In Japan (also an NTSC country), black level is usually set at Zero IRE.

Figure 8.12 *Some cameras including the JVC GY-DV300U feature a negative gain (-3db) option to help suppress shadow noise.*

In the *gain shifting* stage, pixel sensitivity may be increased or decreased in a range of values usually from –3db to +18db. Increased gain is analogous to greater speed in conventional film stocks, and just as grain may become more apparent when using higher-speed film, so does increased noise tend to appear with an elevated gain setting in electronic cameras. For this reason, some shooters may prefer to set the camera gain *below* 0db to minimize noise in underlit shadows and thereby potentially improve the eventual MPEG-2 conversion to DVD. *(See Chapter 3 for the relative merits of employing negative gain.)*

Digital Processing

Your camera's analog-to-digital converter translates the analog brightness level of each pixel into a discrete digital value. Sampling the analog signal from the imager is a matter of assigning bits: the greater the bit depth and number of samples per second, the greater the resolution and accuracy of the digital representation. In NTSC, every imager pixel is sampled for variations in brightness thirteen and a half million times per second (13.5 MHz). In most HD implementations, owing to the greater number of pixels per frame, sampling is performed at a higher rate of 74.25 MHz. In Figure 8.13, note how increasing the number of samples per second would reduce the size of steps between individual samples, thus more closely approximating the smooth uninterrupted flow analog data streaming from the imager.

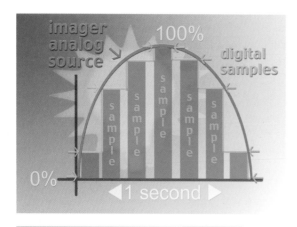

Figure 8.13a *Increasing the number of samples per second produces a digital representation (in orange) more reflective of the analog imager source (red).*

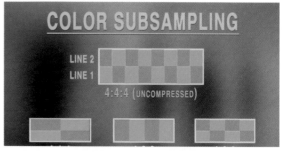

Figure 8.13b *Owing to the eye's reduced sensitivity to red and blue wavelengths and the overall imperative to reduce file size, the analog YUV signal from the imager is not usually sampled at full resolution in all three color channels. While the green or luminance (Y-component) is invariably sampled at full resolution, the blue and red channels are typically sampled at only one-half (4:2:2) or one-quarter resolution (4:1:1) as is the case in DV. The 4:2:0 color used in HDV, some DV PAL formats and DVD-Video, means that every other vertical line is skipped, i.e. not sampled for variations in the red and blue components.*

A Bit More Understanding

Any discussion of analog-to-digital conversion must begin with the silicon atom. If for some reason you slept through your general science class in high school, silicon is the most abundant element on earth and the principal component of sand. Neither clearly a metal nor a non-metal, silicon belongs to a group of elements known as *semiconductors* because they may or may not conduct electricity depending on the type of silicon and presence of a single electron bond.[5]

If this bond is present, silicon assumes the qualities of a conductor like any other metal. But if the bond is not present—i.e., the electron responsible has gone off to do some work, say, light a bulb or charge a battery— silicon is left essentially a non-metal, a nonconductor.

The two states of silicon are the basis of all computers and digital devices. Engineers assign a value of 1 to a silicon *bit* that is conductive, or 0 if it is not. The analog-to-digital converter in your favorite electronic device is able to execute complex calculations according to the conductive states of umpteen trillions of these silicon bits.

An analog-to-digital converter (ADC) comprised of a single silicon bit would be rather ineffective given that only two possible values could be assigned to each sample—black or white.

Employing a second bit to describe the brightness of a pixel greatly improves the accuracy of the sample. In this case a sampled pixel may then have one of four possible values: 0-0, 0-1, 1-0, 1-1. In 1986, Fisher-Price introduced the fabled Pixelvision camera, a children's toy utilizing a 2-bit processor that recorded to an ordinary audiocassette. Needless to say, the camera produced rather crude-looking images.

Most cameras today utilize a 10-bit, 12-bit, or even a 14-bit analog-to-digital converter. Since greater bit-depth produces greater accuracy in the sample, a camera employing a 12-bit ADC should produce markedly better, more detailed images than an older generation 8-bit model. In other words, the 12-bit ADC can assign one of 4,096 possible values to every sample compared to only one of 256 discrete values in the 8-bit version. A 14-bit model like Sony's HVR-Z1U can select from a staggering 16,384 different values! One of those values is *bound* to be a pretty close representation of reality!

Such sampling accuracy is reflective of an overall trend toward greater bit-depth processors in DV and HDV cameras.

Figure 8.14 *A silicon crystal or "bit" can assume one of two states: conductor or nonconductor yes or no, 0 or 1.*

5. Yeah, I know it's more complicated than this, and we should really be talking about N- and P-type silicon, multi-electron impurities, and covalent bonding. Suffice it to say, this book is intended for the non-physicist shooter-storytellers among us. See www.playhookey.com/semiconductors/basic_structure.html for a more in-depth discussion of semiconductor theory.

Figure 8.15 *A processor comprised of a single bit can assign one of only two possible values to each pixel: pure black or pure white. Not a very good representation of reality, is it?*

Figure 8.16 *A 2-bit processor increases to four the number of assignable values to each sample. The result is a dramatic improvement in the captured image.*

Figures 8.17 *The 8-bit processor used in NTSC, PAL, DVCPRO HD and other formats, produces a continuous gray scale represented here with color added. Twenty-years ago I tried to unearth the truth in an open-pit mine in Colombia. My search for knowledge and insight goes on.*

Figures 8.18 *The Pixelvision PXL 2000 circa 1986 featured a crude 2-bit processor and recorded to a standard audiocassette.*

Figure 8.19 *JVC GY-DV5100U. The camera's 12-bit ADC can choose from over 4,000 discrete values. Only 8 bits per channel, however, can be recorded to tape in NTSC or PAL.*

Popular DV Camcorders: ADC Sampling & CCD Configuration

Model	Quantization	Possible Values per Sample	CCD Configuration
Canon GL-2	8-bit	256	Three ¼" CCD
Canon XL1- S	8-bit	256	Three ⅓" CCD
Canon XL2	12-bit	4096	Three ⅓" CCD
Sony DCR-TRV950	8-bit	256	Three ¼" CCD
Sony DCR-VX2000	8-bit	256	Three ⅓" CCD
Sony DSR-PD100a	8-bit	256	Three ¼" CCD
Sony DSR-PD150	8-bit	256	Three ⅓" CCD
Sony DSR-370WSL	10-bit	1024	Three ½" CCD
Sony DSR-570WSL	10-bit	1024	Three ⅔" CCD
Sony HVR-FX1/1U	14-bit	16384	Three ⅓" 16:9 CCD
Ikegami HL-DV7W	10-bit	1024	Three ⅔" CCD
Panasonic AG-DVC200	10-bit	1024	Three ½" CCD
Panasonic AG-DVX100	10-bit	1024	Three ⅓" CCD
Panasonic AG-DVX100A	12-bit	4096	Three ⅓" CCD
Panasonic AJ-SDX900	12-bit	4096	Three ⅔" CCD
JVC GY-DV300U	12-bit	4096	Three ⅓" CCD
JVC GY-DV500	10-bit	1024	Three ½" CCD
JVC GY-DV5000U/5100U	12-bit	4096	Three ½" CCD
JVC GY-HD100U	12-bit	4096	Three ⅓" CCD

Figure 8.21 *Until recently, 8-bit models constituted the preponderance of DV cameras. Today, most standard and high-definition cameras feature 10-bit, 12-bit, or even 14-bit DSPs.*

Oversampling: What's the Point?

Some shooters may question the wisdom of 12-bit or 14-bit sampling if the output signal must ultimately be *squeezed* into 8-bit NTSC or PAL. In Chapter 3, we discussed how oversampling can help preserve image detail in the brightest highlights; the additional data, up to 400 percent of maximum, is folded down into the knee section of the characteristic curve. Digital VCRs limit video signals to about 108 percent of maximum so some highlight compression is inevitable in order to (partially) accommodate the huge amount of additional picture information. The highlight

Figure 8.22 *When shooting bright saturated objects, the strongest highlights may not be compressed evenly leading to a shift in hue. In some Sony models, the orange in this basket appears more like a lemon due to greater attenuation in the red channel.*

Figure 8.23 *The DV/HDV shooter may want to mitigate the factors that lead to objectionable hue shifts. In this scene, the saturated red scarf could be problematic.*

squeeze can help preserve detail in what would otherwise be blown-out areas of the frame.

Undesirable hue shifts may occur in some cameras due to uneven compression of the highlights. The problem arises in saturated scenes when one (or more) of the color channels maxes out and is then compressed in a disproportionate way. In some DV models, such as the Sony DSR-PD150, red hue shifts can be especially obvious, so some effort should be made to avoid saturated scenes containing red tones when shooting with this camera model.

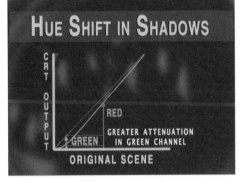

Figure 8.24 *In low light, green is attenuated more than red so shadow areas acquire a warm cast in cameras with insufficient gamma correction. Monochromatic objects with little or no color content do not display a hue shift because their RGB values are inherently equal.*

Hue Shifts in Shadows

Shooting in low light is usually a good idea in order to achieve optimal DV/HDV camera performance. But hue shifts can occur in low light as well, as insufficient gamma correction produce undesirable shifts in the shadows. These shifts tend to be more evident in Caucasian flesh tones as the green channel is substantially more attenuated than red at low light levels, leading to the excessively red skin tones.

When evaluating a new or unfamiliar camera, the DV/HDV and HD shooter should pay particular attention to the integrity of facial shadows in low light. Cameras that display a noticeable hue shift should be rejected.

Figure 8.25 *In low light a hue shift is more likely to occur in Caucasian skin due to the predominant red tones.*

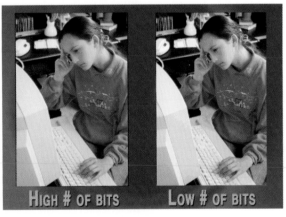

Figure 8.26 *Contour artifacts (exaggerated here) may also appear in facial shadows. Keep in mind that compression anomalies in general are more noticeable in the shadows so the shooter should look there first for trouble. (Illustrative images courtesy of JVC.)*

Limits of Perception

At some point, someone realized that the eye could be fooled into seeing thousands of colors when in fact it was only seeing three. In engineer's parlance, this is called the *tristimulous* system, the essence of which is your 3-chip camera must divide the incoming image into its red, green, and blue components. Due to differences in the energy levels of red, green, and blue light, the three wavefronts navigate the dense glass prism at different speeds. The camera's signal processor must then apply a series of complex algorithms to recombine the beams as if they had never been split. It's a major league task that is easier said than done.

Single-chip cameras, without the beam splitter behnd the lens, have one inherent advantage: the vagaries of uneven prism response need never be considered in the signal processing.

Figure 8.27 *Three-chip cameras like this Sony DSR-390 employ a beam splitter that introduces considerable complexity into the processing of images. Single chip cameras without the intervening prism are less prone to common artifacts like hue shifts.*

A CMOS Future

Three-CCD cameras exhibit many compromises by design. They utilize separate sensors for each color channel resulting in uneven compression, hue shifts, loss of resolution due to spatial offset, and reduced light transmission through a prism dividing the input image.

A single-chip system without the prism, relay optics, and compensating algorithms is far less complex and less prone to anomalies than 3-CCD systems. The major stumbling block has been the nature of single-CCD designs that propagate substantial cross-chroma artifacts and loss of resolution. Today, with the advent of advanced single-chip still cameras built on the Foveon chip, the beginning of the end may finally be approaching for the three individual sensor design. To be sure, multi-chip imagers won't disappear overnight, especially in the DV/HDV market, but the video stream is certainly on the wall.

The prospect of HDTV is propelling much of the development effort to replace the dominant 3-CCD imager in professional camcorders. A few HDV cameras have already dispensed with the CCD chipset, opting instead for a CMOS design. Originally developed for NASA and the Hubble telescope, CMOS imagers are capable of achieving extremely high resolutions at a relatively low cost.

Other key advantages of CMOS sensors: the elimination of vertical

Figure 8.28 *Sony's CMOS sensor—a harbinger of more sophisticated imagers to come.*

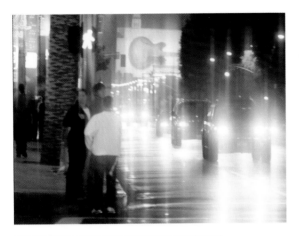

Figure 8.29 *CMOS sensors eliminate the vertical smear often seen in urban night scenes.*

Figure 8.30 *The low power draw of CMOS imagers reduces the need for shooters to cart around heavy batteries.*

Figure 8.31 *The JVC ProHD model HD7000U features three ⅔-inch CMOS chips. Despite the new imager, the camera retains much of the complexity of traditional 3-CCD systems.*

Figure 8.32 *You'll see a lot more cameras like this in the future. The Sony HVR-A1U's CMOS imager is a harbinger of things to come.*

smear from bright highlights that have been the Achilles' heel of CCD technology for years; greater range of frame rates and scanning modes; and more efficient power utilization, the typical 3-CMOS implementation requiring 80% less power than a comparable 3-CCD system.

In the near term, 3-CCD cameras will continue to offer some advantage in low light, primarily due to the strategy of line mixing. CCD imagers typically increase sensitivity in this manner at the price of somewhat lower resolution. The pixel density or fill factor is improving rapidly in the latest generation CMOS chips, but CCDs still have the edge in interlaced FIT configurations.

Relative Advantages of CMOS vs CCD Technology

Figure 8.33 *Source: Rockwell Scientific.*

Feature	CCD	CMOS	CMOS.Advantage
Size		X	Imaging architecture results in a smaller footprint than CCDs with required additional chips.
Power Consumption		X	Consumes less than 20% of the power required for a comparable HDTV CCD
Integration		X	Ideal for design into state-of-the-art cameras. CCDs require additional chips for image processing
Frame Speed		X	Many HDTV CCD sensors operate at 24 fps progressive, CMOS operates at 30 fps progressive / 60 fps interlaced at full HD resolution
Video Dynamic Range		X	Delivers >68dB at full 75MHz data rate. CCD's dynamic range is reduced as data rate increases (generally to 50-55dB)
System Noise		X	Design reduces read noise compared to CCDs traditional noise floor
Output		X	12-bit output better matches dynamic range of film compared to 10-bit CCDs
Cost		X	Is lower cost than comparable CCD imagers
Sensitivity	X	X	Comparable sensitivity to CCD if CCD's 2-line mixing not used
Anti-Blooming		X	No vertical smear in even very bright highlights
Fill Factor	X	X	Higher fill factor than progressive FIT CCD and near-comparable fill factor to interlaced FIT CCD
Sensor Dynamic Range	X	X	CCD's higher operating voltage allows larger sensor dynamic range, CMOS supplies 12 bit video at 75 MHz for 3.3V operating voltage

Finishing the DV Image

THE SAVVY DV AND HDV shooter knows the Curse well—the impenetrable blacks, the blown-out highlights, the hard plastic edges around objects. These are all shortcomings we've had to put up with in exchange for the economy and opportunity that DV and HDV offers.

With the advent of more sophisticated camera processors, greater bit-depth sampling, and higher resolution CCDs, the DV Curse has eased significantly. The latest model cameras usually require only minimal supplemental filtration, with most image tweaking more easily and appropriately performed in the camera menu settings or in the NLE post-environment.

Still, the successful storyteller understands the value of a properly *finished* image, and for most shooters a physical glass camera filter is the only way to achieve it. This is because a physical filter placed in front of the lens treats the captured image, optimizing levels of detail, contrast, and diffusion which in turn enable the highest performance and efficiency in the camera processor.

Deliberately capturing a scene with the wrong look and then hoping to fix it in post is a dubious strategy since the unwanted attributes tend to be amplified and reinforced during compression. Compensating in postproduction may not even be possible, as the dramatic countermeasures required to remedy the original shortcomings are likely in and of themselves to produce objectionable artifacts.

While the effect of some camera filters can be roughly approximated in software, the delicate interplay of light through a glass element is not a process that lends itself to generalized solutions post-camera. Consider a beam

Figure 9.1 *The complex interplay of light passing through a physical glass filter cannot be completely recreated in software.*

Figure 9.2a *Before considering a filter, be sure to reduce the camera detail to alleviate hard edges, especially in close-ups.*

of light interacting with the thousands of tiny *lenslets* inside the Tiffen Soft/FX filter. The character of the light—color, direction, and intensity—impacts the level of the diffused effect as the light passes through or around the irregularly interspersed filter elements.

Thus a filter's impact can vary substantially depending on the strength of a scene's backlight, if the backlight is striking the filter directly or obliquely, whether point sources in frame are sharply defined or more diffused, or even the degree of polarization in the sky. All of these factors influence how a fil-

Figure 9.2b *Watch those shadows! Rembrandt probably never gave it much thought, but overly dark shadows may produce objectionable noise.*

Figure 9.2c *You may need to adjust your camera gamma to better accommodate bright saturated objects.*

ter may work, and ultimately its impact on the quality of your visual storytelling.

Consider a Filter Last

The savvy shooter understands that a camera filter should be considered last, not first, with respect to controlling a story's look. It should be viewed as the icing on the cake, after the lighting has been tweaked, diffused, and appropriate camera setup options selected.

Here are a few pointers to keep in mind before reaching for your filter kit:

Most DV and HDV cameras offer only rudimentary control over gamma, detail, and knee point, so for many folks, a physical glass filter is the only way to fine-tune the captured image.

Evaluating the performance of most DV and HDV cameras, you'll likely find more than a few compromises stemming from the formats' efficiency and economy. The high compression and reduced color space virtually ensure a myriad

Figure 9.2d *When geyser gazing, watch for blown-out areas of the frame that can wreck your images.*

Figure 9.2e *Be mindful of the usual NTSC troublemakers like the moiré patterns in wardrobe and combing effects in compositions containing many vertical elements.*

FUN WITH NTSC!

MOIRÉ

ALIASING HELL

Figure 9.3 *High detail scenes like this view of my grandfather's grocery in 1937 will wreak havoc on most DV camera processors. Consider de-interlacing such scenes in your NLE or shoot 24p.*

Figure 9.4 *The right camera filter can help capture greater detail, especially in landscapes. Capturing greater detail can significantly expand expands the storyteller's options in postproduction.*

of tough decisions are performed millions of times per second. Since 80 percent (or more) of picture data must be discarded in DV cameras, some mistakes in judgment are bound to occur any way you slice it, especially in cameras costing as little as several hundred dollars.

Beyond the rough-and-tough processing, DV cameras contribute to the Curse in other ways: inferior optics, hue shifts, and overzealous error correction all play their part. But whatever the reason for lackluster images, if you're going to derive the best possible performance from your DV or HDV camera, you'll need to address the techno-aesthetic issues head-on, and that includes, almost invariably, the strategic use of an appropriate camera filter.

Practical Advantages

A physical filter offers many practical advantages. The effect of various filter types and grades can be seen easily by simply sliding them in and out of the matte box, thus obviating the need to drill down through multiple menus to change obscure camera settings. Filters can also be reviewed in combination with other filters; the combined effect being apparent on a high-resolution monitor. This interaction of multiple filters is particularly difficult to mimic in software, yet another reason to use one or more actual glass camera filters during original image capture.

Still, the shooter-storyteller as master of his craft must be familiar with a range of imaging and compositing tools, and that includes many post-camera options. With the advent of HD DVD, and Blu-ray titles, your role as a storyteller doesn't end until the DVD player sings, and that includes increasingly at least some image manipulation post-camera. Digital Intermediate[1] suites, video on demand, and exploding web opportunities only *elevate* the need for proper filtration in camera as image detail critical for effective grading and compositing operations cannot be restored later if not sampled (or digitized) in the first place.

Obviously the role of the shooter-storyteller is being transformed, and with it the nature of his tools. Some tools continue to be rather traditional, such as glass camera filters. Others are more revolutionary, representing an entire new way of working, as in the case of post-camera software. Whatever the tool, like any craftsman, today's shooter must use the right one for the job, consistent as always with his or her clear creative vision.

Designed for Small-Format Video

While camera filters of various types have been around since photography's earliest days, the advent of DV cameras' tiny chipsets has necessitated a major change in design to accommodate the more stringent demands. Not that a vintage diffusion filter or *net* can't effectively serve both film and

1. Widely used for output of digital files to film for theatrical release, the Digital Intermediate represents a powerful convergence of technologies whereby scenes, or sections of scenes, are color-corrected, isolated, and composited at a hitherto unseen level of control and sophistication.

Figure 9.5 *The tiny droplets in a black mist filter may become visible on screen due to many cameras' enormous depth of field and a confused auto-focus system. While shooting wide open (or nearly so) and avoiding back-lit scenes can help, shooters should consider an alternative diffusion filter type without an obvious pattern, such as the Tiffen Soft/FX or Schneider Digicon.*

Figure 9.6 *Modern contrast control filters like the Schneider Digicon do not contain a pattern that can inadvertently appear on screen. Such filters are much safer when shooting in uncontrolled situations, as is typically the case in documentary productions.*

small-format video. Of course it can. Storytelling with a camera is a craft, after all, and only you, the talented, gifted manipulator of light and shadow, can make the aesthetic determinations appropriate to your story.

Still, older generation filters may not be suitable for use with today's DV and HDV cameras. These filters utilized a soda lime glass that imparted a subtle green tint, a trivial amount perhaps to film shooters, but a more serious matter to digital video folks owing to the resultant inaccurate color sampling and loss of color saturation. The deleterious impact of the green

glass is exacerbated in 3-chip cameras whose green CCD or CMOS sensor is moved slightly out of register to reduce artifacts in high-detail scenes.[2]

Modern filters designed for DV and HDV applications utilize a pure "water white" glass that does not contribute to sampling inaccuracies. From the shooter's perspective, a filter should be treated like any other HD optic and must be produced in much the same way. While manufacturers today adhere to a very precise standard as fine as two-microns of optical flatness, this was not the case years ago, so older filters not nearly as flat may produce waves of distortion in today's cameras, especially evident during slow panning. Older-style laminated filters should be also avoided for the same reason; they can produce tiny focus shifts and banding patterns that may lead to pixilation in the encoded video file.

Compounding the matter of antiquated filters, the pattern frequency of some traditional nets may interfere with a camera's CCD grid pattern, and thus exacerbate certain aliasing artifacts. Old-style black mist filters can therefore be problematic, as their highly reflective droplets can confuse a camera's auto-focus system and signal processor. Some cameras simply freak, interpreting the scattered dots as a dirty lens and ratcheting up the error correction to compensate! *Quel horreur!*

Know the Look You Want

For the shooter it's all about creating compelling images. So what should the images look like? Are they soft and diffused as in a period romance? Or are they hard and unforgiving, as might be appropriate for an exposé about a toxic waste dump?

In Michael Mann's film *Ali* (2001), DV's brassiness served a legitimate storytelling purpose, providing contrast to the more polished scenes shot in HDCAM and 35mm film. Story consideration isn't the issue for most DV and HDV shooters who must make do with modest cameras in lieu of more capable (and expensive) acquisition tools.

Still, shooters of DV, HDV and small-format video in general must often produce images comparable in the viewers' minds to the most professional film and video formats. If you're shooting your first feature, you're much more likely to be working with a $3,500 Sony, Panasonic, or JVC than a $350,000 Viper. Your little wonder might offer multiple gamma settings, user-settable detail, and extreme low-light capability, but the fact remains that your modest few-thousand dollar camera was never intended to play the role of commercial-duty workhorse.

And so it happens that the DV Curse enters your life. Whether shooting a major TV spot on a soundstage or the most tasteless wedding video

2. *See Chapter 8 for a discussion of spatial offset and related aliasing issues in DV cameras.*

Figure 9.7 *Bad footage got you down? Tired of DV's brassy high contrast look? The appropriate camera filter can be an effective counter-measure.*

in Encino, your DV/HDV camera needs all the craft help you can muster if it's to do its job cleanly, efficiently, and free of wretched artifacts.

Exposure Control

Shooting with a wide aperture is always a good idea. Filter and net patterns are less likely to appear on screen; the reduced depth of field helps isolate key story elements; the large f-stop reduces diffraction, and lower light levels minimize the need for error correction in-camera.

To be able to shoot wide open (or nearly so) under bright daylight conditions, the use of an exposure control filter is imperative. Most cameras feature a built-in neutral density that provides a two-stop advantage,

Figure 9.8 *Standard ND filters are available in a range from 0.3 to 1.2, the equivalent of one to four stops. By absorbing 50 percent or more of the incoming light, the filter enables a correspondingly larger f-stop— a good thing! Neutral density filters do not affect the color or character of a scene in any way.*

Figure 9.9 *Be sure to engage your camera's internal ND filter when shooting in bright daylight. You may also need a supplemental glass ND to achieve a sufficiently large f-stop.*

Figure 9.10 *Full-size camcorders like the Panasonic AJ-SPX800 feature an external filter wheel to control exposure and color balance.*

a supplemental ND being usually required to achieve optimum exposure in bright sun. For this reason, a neutral density filter allowing an additional two to three stops' exposure compensation should be a part of every shooter's basic toolkit.

Controlling Contrast

It's your number one responsibility as a shooter and storyteller! In lifting the darkest shadows while still retaining detail in the highlights, the advantages of a contrast control filter cannot be realized in any other way. Contrast filters with smooth gradients called attenuators can expand the dynamic range of some exteriors by 2.5 stops—a boon to the shooter struggling with the eternal challenge of capturing acceptable images in bright sun.

Figure 9.11a,b *Effective sky control is critical to effective visual storytelling. At right, an ND 0.9 graduated filter darkens the sky and helps direct the viewer's eye to the compelling story inside the frame.*

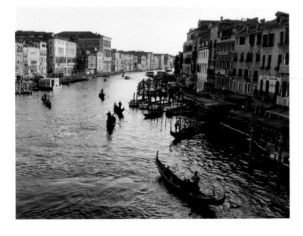

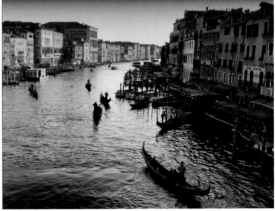

 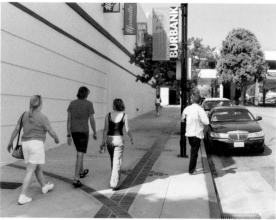

Figure 9.12a,b *Sky control filters with a smooth gradient called attenuators can reduce the risk of clipping in high-contrast exteriors. The attenuator used in the street scene at left is not intrusive; at right, the same scene without the attenuator. The filter's lack of a dividing line (and need to conceal it) is a major advantage.*

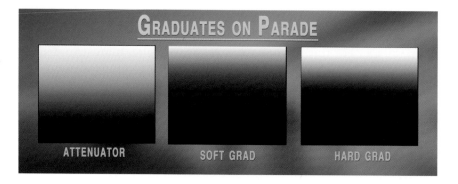

Figure 9.13 *A graduated attenuator pattern is at left. The hard edge grad (right) is used principally with telephoto lenses. The soft grad (middle) with a feathered transition is ideal for establishing shots with large areas of bright sky.*

Figure 9.14a,b *You want blue sky, I'll give you blue sky! The soft-edge of the graduated filter at right is concealed across the top third of the frame.*

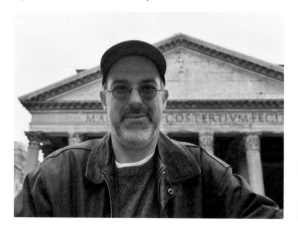

Figure 9.15 *Tiffen soft-edge blue graduated #2 filter.*

Figure 9.16 *A sunset grad can add color and interest to scenes captured late in the Magic Hour.*

Figure 9.17 *Tiffen soft-edge sunset graduated #3 filter.*

Figure 9.18 *Combination filters reduce the need to stack multiple filter types, which can reduce contrast and impair performance. Sometimes stacking is unavoidable; here, a warm diffusion filter is used to soften the harshness of the star filter behind it. Note the position of the star close to camera to reduce its visibility on screen.*

How They Stack Up

Maintaining satisfactory contrast can be a challenge to the small-format shooter. While inferior lenses and lack of a matte box are contributing factors, the stacking of multiple filters can make matters worse by increasing the number of air-to-glass surfaces and potential internal reflections that lead to contrast loss.

I try not to stack more than two filters. If a warming effect is desired with diffusion, I prefer a combination filter that merges the two functions. For example, I will commonly stack a star filter and weak Tiffen ⅛ Black Pro-Mist to soften the star's hard edges.

Figure 9.19 *The Formatt Warm Supermist combines the warming and diffusion functions in one filter.*

Figure 9.20 *The overused star filter is a favorite of sports and event shooters. A matte box with a rotating stage is essential for proper alignment of star and graduated filters.*

Figure 9.21 *The Tiffen vector star.*

A Polarized View

The polarizer is among the most heavily used filters in the shooter's arsenal and for good reason: It is the only filter that can *increase* contrast. For this reason the polarizer is indispensable for shooting land and seascapes, which tend to be low in contrast due to the many layers of atmosphere and the small f-stop typically used to record such scenes. At tiny apertures the contrast-robbing culprit is diffraction, the tendency of light to scatter as it navigates through and around a narrow lens opening. *(See Chapter 6.)*

A polarizing filter increases contrast by reducing light scatter. This is accomplished by the filter's horizontal or vertical grid blocks the off-axis waves not consistent with the polarizer's orientation. Since the northern sky (in the northern hemisphere) is partially polarized already, a suitably aligned polarizer can further darken the sky and increase the impact of clouds against it.

A polarizing filter is most effective at 90 degrees to the sun. One way to determine the area of sky subject to maximum darkening is to point

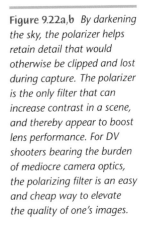

Figure 9.22a,b *By darkening the sky, the polarizer helps retain detail that would otherwise be clipped and lost during capture. The polarizer is the only filter that can increase contrast in a scene, and thereby appear to boost lens performance. For DV shooters bearing the burden of mediocre camera optics, the polarizing filter is an easy and cheap way to elevate the quality of one's images.*

Figure 9.23 *A polarizer's grid blocks off-axis rays, reducing contrast-robbing scatter. Polarizers come in linear and circular varieties. Linear polarizers are more effective but may interfere with a camera's auto-focus system. If auto-focus is important to you, go with the circular type.*

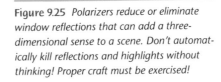

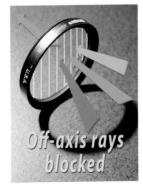

Off-axis rays blocked

Figure 9.24 *Pointing at the sun with your index finger, your thumb indicates the area of sky subject to maximum polarization. Polarizers can also help exposure, providing a 1.5 to 2 stops advantage depending on orientation. Schneider manufactures a linear polarizer with only one stop of attenuation for use in low light.*

Figure 9.25 *Polarizers reduce or eliminate window reflections that can add a three-dimensional sense to a scene. Don't automatically kill reflections and highlights without thinking! Proper craft must be exercised!*

at the sun and note the direction of your thumb pointing now at the most polarized section of the sky. The *opposite* sky at 180 degrees is also subject to maximum darkening.

When shooting exteriors under bright conditions, a polarizing filter can often improve an actor's skin tone by attenuating a portion of the sun's glare. The increased contrast may also, however, *increase* the visibility of blemishes and other defects, so a polarizer should be used with care when shooting talent close-ups.

Figure 9.26 *Low contrast filters can help prevent clipping in the brightest highlights while coaxing greater detail from the deepest shadows. A noble idea but be careful: excessively low contrast can produce washed-out images that lack sparkle.*

Figure 9.27a,b *A terrific choice for cityscapes at night, the ultra-contrast filter may eliminate the need for supplemental fill light. At right, the increased detail is apparent in the side of the hot dog stand. Scenes illuminated by practical sources such as neon stand to benefit most from the ultra-contrast or Digicon filter, which lifts underlit shadows without producing obvious flare or a pronounced diffused effect.*

The Low Contrast Dilemma

In most cases, the shooter seeks to enhance contrast, and this is where a professional matte box and polarizing filter can help. Shooting in bright sun, however, without silks, fill cards, or supplemental lighting will produce images with too much contrast, so you'll need an effective contrast reducing solution in your arsenal as well.

A low-contrast filter works by redistributing surplus values from an image's highlights into the shadows. This lightening of the shadow areas allows the overall scene to be darkened, thus pulling down the hottest highlights to prevent clipping. This can be an advantage to shooters trying to capture high-contrast exteriors with little or no additional fill light.

The increase in dynamic range comes at a price. Blacks may become murky and contribute to an overall flat lifeless image. This is because a low-contrast filter does not actually improve the *inherent* capture capabilities of the camera—that is, its ability to satisfactorily reproduce scenes with full-tonal gradations over a seven-stop range. The low-contrast filter can expand this range by two stops or more, but the washed-out look may or may not be acceptable.

The cine-like gamma option in many cameras works similarly, expanding the dynamic range and improving shadow detail while at the same time increasing the risk of creating grayer, less compelling images overall.

For the shooter-storyteller preferring a lower-contrast look, a *weak* low-con filter may work fine. Likewise for shooters looking ahead to the digital intermediate or film out; the additional shadow detail can be an advantage, assuming, that is, the murkiness in the gray tones can be ameliorated later in software.

Most diffusion filters incorporate a contrast-lowering component so few shooters will see the need to invest in a separate set of low-cons. Still, with the smooth modulated images possible in today's 14-bit cameras, a low-contrast filter and a cine-like gamma setting may be all you need to achieve a satisfactory dynamic range, particularly when shooting "run-and-gun" in daylight under full sun.

The DV/HDV Emulsion Test

One doesn't think of performing an emulsion test when evaluating a video camera, but that's what I do when working with a new or unfamiliar model. In film, shooters will often test the responsiveness of a new stock in order to determine the level of shadow detail that can be retained at various fill light levels. The same logic can apply here. By altering the black stretch and/or gamma levels in the camera while also reducing the fill light, the shooter can gain insight into the limitations of his camera and its ability to capture critical shadow detail.

Diffusion Filters: Establishing the Look

The ability to preserve shadow detail is a key responsibility of the shooter, and in this respect, the DV camera can be especially savage. To achieve the required 80 percent or more reduction in file size, engineers target what they consider to be *irrelevant* details. Understanding that human beings can't see well in deep shadow anyway, engineers tend to look there first for discardable information, the result being potentially a significant loss of shadow detail in scenes originating in DV.

Figure 9.28 *To conduct a proper emulsion test, find a cooperative subject and light her in a normal way. Then, referring to a calibrated monitor, gradually reduce the fill light and note the level of shadow detail discernible along with any hue shifts. Recognizing how your camera responds in deep shadow will improve your abilities as a visual storyteller and prepare you well for the lighting challenges ahead.*

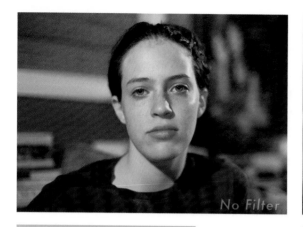

Figure 9.29 *The images from today's small-format cameras are less harsh than they once were but some on-camera diffusion is usually still desirable, especially in dramatic productions.*

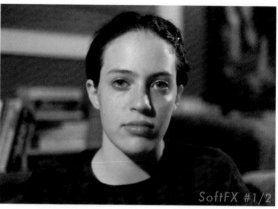

Figure 9.30 *A practical all-purpose diffuser, the soft effects filter is particularly well suited for DV and HDV exteriors. The slight loss of resolution is offset by the more pleasing look. Tiffen Soft/FX filters are available in a range of sizes, including screw-in types for consumer cameras.*

Low-contrast diffusion filters increase the relevancy of shadow detail by lifting its pixel values out of the danger zone, and making them less likely to be jettisoned during quantization.[3] As shooters, creating the appropriate mood lies at the heart of our storytelling prowess, and so we clearly need a filter strategy beyond the pointless UV type fixed to many cameras as a kind of see-through lens cap.

The one-size-fits-all diffusion filter is largely impractical. Depending on a camera's chipset, processor, and menu settings, a filter that works well on one model may work poorly on another, as manufacturers make compromises and assumptions that run contrary to a shooter's best storytelling and creative instincts.

Today's DV and HDV cameras are capable of producing remarkable images indistinguishable in many instances from their broadcast brethren. The trick is exercising the high level of craft, which includes selecting the right diffusion filter for your particular camera and setup.

Designing the Ideal Filter

Filter manufacturers look principally at three ingredients when designing their wares: refraction, diffraction, and scatter. Favoring one area over an-

3. Quantization is the process of organizing similar value pixels into groups where they can be rounded off, declared redundant, and subsequently discarded. The main purpose of quantization is to identify and retain only those image elements readily apparent to the human eye. How aggressively your camera pursues the discarding of "redundant" or "irrelevant" picture information is in part a function of its setup parameters, including black stretch, pre-knee, and other parameters.

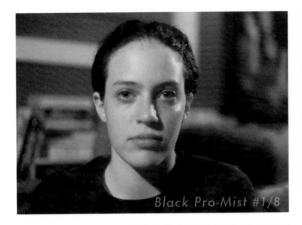

Figure 9.31 A weak black mist filter can help reduce hue shifts in the shadows, particularly in lower-end Sony camcorders. Heavier mist-type filters should generally be avoided in DV/HDV owing to a pronounced "shower curtain" effect.

Figure 9.32 The Tiffen Gold Diffusion/FX works well for stunning portraits and interviews. Its elegant finish and professional glean is seen frequently in broadcast and commercial applications.

Figure 9.33 No one talks about it anymore, but the Tiffen Softnet 1B produces a great period look suggestive of a 1930s MGM epic. The Softnet 1S ("S" for skin) creates a comparable feeling, but with enhanced flesh tones—a good choice when working with narcissistic celebrities.

Figure 9.34 Use caution when using any type of net. In high-detail scenes, the frequency of the pattern may exacerbate the grid aliasing issues associated with 3-CCD cameras.

other, notable flaws in a camera's performance can be addressed and perhaps ameliorated. This is what happened several years ago when veteran shooters discovered their time-tested Betacam filters did not translate well to DV cameras. The Tiffen Black Pro-Mist, for example, that served us so reliably for over a decade produced a much cruder effect now in the DV realm.

Schneider Optics tackled the issue of poorly performing mist filters by effecting changes in the porosity and reflectivity of the embedded black droplets. By reducing the droplet size, the company's latest generation filters achieved the desired level of diffusion without the halation and loss of

Figure 9.35a *By enhancing skin tones, a warming filter can help draw the viewer into your story. Warming filters are often applied in combination with diffusion to reduce the need for stacking of multiple filter types.*

Figure 9.35b *No warming filter.*

resolution that had formerly been the case. For the DV shooter, the reduced droplet size also eliminated the risk of seeing the filter pattern on-screen—a significant advantage when shooting under conditions that can change quickly and unpredictably.

Of course, no one filter can magically transform a mediocre-performing camera into a $350,000 acquisition tool, just as no one filter can magically transform a clueless shooter into Sven Nykvist. Still, in most situations, the small-format video storyteller needs a diffusion filter of some sort, and that means facing a bewildering array of choices. In the Tiffen line alone, there's the Pro-Mist, Black Pro-Mist, Soft/FX, Black Diffusion FX, Gold Diffusion FX, Fogs, Double Fogs, and Softnets, in addition to the many contrast-control filters. Schneider has its own lineup of diffusion filters, including the Classic Soft, Warm Classic Soft, Black Frost, White Frost, Soft Centric, and Digicon.

How can anyone keep track?

Warming Up

A warming filter or *skin enhancer* can help build credibility with an audience by making talent appear more human and alive. Inasmuch as the shooter-storyteller usually seeks to foster as much intimacy as possible with the viewer, a warming filter can play a key role in that effort by helping convey a person's humanity and caring nature. Just be sure to remove the filter prior to white-balancing the camera in order to preserve the warm effect.

Recommendations by Camera Model

The following recommendations apply to various DV and HDV camera models under *average* interior and exterior conditions. Admittedly there

is a hand-waving component here as what constitutes "average" can be very subjective, as does what looks "good" ultimately on screen. You are therefore warned that my recommendations are not to be construed as gospel. They simply reflect what has worked and continues to work for me on a variety of projects.

Sony HVR-FX1/Z1U/A1U

Sony's HDV cameras represent a quantum leap forward in small-format video imaging. With their 14-bit processing and true 16 × 9 imagers, the Sony HVR-FX1, Z1U and A1U are fluid head and shoulders above the popular models of only a few years ago. Despite the cameras' long-GOP MPEG-2 compression[4] and lack of 24p capability, the HDV shooter can realize astounding images right out of the box, a remarkable feat given the cameras' relatively modest price tag.

When shooting HDV for standard definition DVD, the additional fineness afforded by the cameras' 1440 × 1080 chipset makes for terrific, even startling, images at the lower resolution. Some noise, however, due to the format's high compression, may appear in some scenes, especially those containing broad unfilled shadow areas.

To reduce or eliminate this noise, a tightening filter should be used, not to alter the character of the image, but to soften its hard edges and pull together the underlying integrity of the frame. The reduced noise will pay dividends down the line as the HDV streams are decompressed and recompressed in and out of the NLE. In the Sony HVR and other recent generation cameras, a very light Black Frost or Black Pro-Mist can quiet noisy DV shadows considerably.

JVC ProHD GY-HD100U

Compared to the Sony models, the JVC HD100U appears somewhat noisier overall and thus may benefit even more from a black mist-type tightening filter. To be sure, the camera's mediocre (interchangeable) lens is partly to blame, as no filter can be expected to compensate for the loss of contrast and sharpness in the camera's primary optics. Still, a shooter can help the camera's stock lens considerably especially in exterior scenes by employing a professional matte box and polarizing filter wherever possible.

The detail level in the JVC should also not be set too low. There's a trade-off here between the sharpness you want and the unnatural edging around objects you don't, so many shooters will want to determine the

4. *See Chapter 3 for a discussion of issues related to HDV and long-GOP compression.*

Black Level Intrigue

Like the Holocaust and man walking on the moon, some folks deny the DV Curse really exists. They claim what appears to be DV's extra dark shadows are actually the product of a misunderstanding over proper black level. We explored this issue in Chapter 3, but it's worth reiterating here. Many DV cameras, still output analog video incorrectly with the black level set at 0 IRE. Not surprisingly, this produces images with noticeably crushed blacks when displayed on an NTSC monitor expecting a black level of 7.5 IRE.

When evaluating shadow detail on a field monitor, always verify correct black level before tweaking the set lighting or adding camera filtration. If necessary, the monitor can be adjusted to reflect the depressed black level output from the camera. (See Chapter 3.)

camera's sweet spot. Small f-stops should be scrupulously avoided in the JVC HD100U, as this will also further contribute to the loss of contrast and performance.

Canon XL2/XL1-S/XL1

The XL2 benefits handsomely from the enhanced 12-bit sampling (compared to only 8-bit in previous models), yielding much improved shadow detail along with resistance to clipping in the highlights. The XL2's more sophisticated processor is particularly evident when black stretch and the low knee settings are enabled.

The previous Canon XL models continue to be among the most widely used DV cameras in the world. The XL1, introduced in October 1997, produced excellent images that in retrospect seem crude and in desperate need of a professional makeover. The XL1's grating look contributed to the camera's *hyper-real* reputation—a negative attribute in my view, but one some shooters embraced with gusto. Go figure.

Shooters still working with the XL1 or XL1-S can realize improved performance with the appropriate camera filter. While the standard black mist filter produces a murky and confused image even in the weakest ¼ and ⅛ grades, the camera responds much better to Tiffen's Black Diffusion/FX. The resultant image is much improved with a pleasing hint of diffusion that is

Figure 9.36 *The Canon XL2 features much improved optics with better tracking and mechanical functions. The camera's 12-bit processor and latest generation CCD has diminished the need for significant supplemental diffusion. Its latest generation 3-CCD design has diminished the need for significant diffusion in-camera.*

not at all obvious or brassy. This filter in the ½ grade should be used primarily for interior scenes when shooting with the aperture at or nearly wide open. This is because the Black DFX contains a large etched pattern that may appear on screen under backlit conditions at full wide-angle and/or at small apertures. Alternatively, the Schneider Classic Soft without a visible pattern may be more practical (and safer) for some shooters.

The updated XL2 camera does not display the harshness of the earlier models, and so your filter treatment should reflect the new reality. The Schneider ½ Classic Soft works well on the XL2 for general noise reduction and tightening. The Tiffen ½ Soft/FX also finishes nicely with this camera, and is readily available in screw-in sizes for use without a matte box.

Sony DSR-PD170/150/100A/PDX10

Compared to the early Canon XL and GL models, the entry-level DVCAM cameras are far gentler beasts, reproducing more pleasing images even without supplemental camera diffusion. Nevertheless, some Sony prosumer cameras do exhibit a noticeable hue shift in brightly saturated objects. An orange, for example, may appear more like a lemon under high-key conditions.[5]

Your choice of diffusion filter can help suppress these objectionable hue shifts. For DSR-PD170 (and earlier DSR-PD150) shooters, the ⅛ Black Pro-Mist offers a pleasing professional finish and thus can be considered an excellent default filter for most fiction and nonfiction projects. The slight diffusion and flare introduced by the ⅛ BPM adds a distinctly refined look to images captured in the PD170 and earlier Sony models.

Figure 9.37 *In Sony prosumer camcorders like the DSR-PD170, the Tiffen ⅛ Black Pro-Mist is may improve shadow detail and help reduce noise. If you prefer a more sophisticated look, the Tiffen ½ Soft/FX and ⅛ Schneider Classic Soft are solid performers, producing only slight image softening along with improved contrast. A warming filter is not recommended for Sony models including the PD100A/PD150/170 and PDX10 series.*

5. *See Chapter 8 for a discussion of hue shifts in highlights and shadows*

Sony VX-2100/2000

The imager in the VX-2100 is identical in the DSR-PD170 so one would expect the same filters to work just as well in both models. Yet for reasons that are not entirely clear, I've experienced some variability in the look of images captured in the VX, the default settings leaning toward more edging and deeper shadows.

The VX-2100/2000 models seem to benefit from slightly more diffusion. You may have to put up with less solid blacks in the "opened-up" shadows, but consider this the price for a bit more life in your images overall.

If you're seeking a more polished look for dramatic titles, Tiffen's #½ Black Diffusion/FX and Schneider #⅛ Classic Soft are excellent choices, adding a pleasing overall finish without the potential murkiness of a black mist-type filter. For exteriors, the #1 Soft/FX works particularly well for most applications. As a starting point, you might select one grade up from the DSR-PD170.

JVC GY-DV5100/DV5000

When the JVC GY-DV500 camera was introduced several years ago, it was hailed by shooters as a breakthrough in affordable DV technology. With its 3-CCD ½-inch chipset, the camera offered advanced features hitherto unavailable in the $5000 price range.

Figure 9.38 *The JVC DV5000U may produce images that appear unruly and harsh in the deeper shadows. The Schneider #⅛Classic Soft or #¼ Digicon can help suppress the noise in underlit areas.*

The newer GY-DV5100U model performs well with either a #½ Black Diffusion/FX or #1 Schneider Digicon, a solution that many 5100/5000 owners should consider *de rigueur* for dramatic presentations. For a tasteful look on documentaries and business films, shooters might opt for the Schneider #½ Digicon, this slightly lower grade adding a nice finish without being intrusive. For exteriors, the #1 Soft/FX is a pleasing way to go, with the warm version providing enhanced skin tones—a substantial improvement over the camera's generally cool presentation.

JVC GY-DV300U

With its 12-bit processor and 410,000-pixel CCD, the JVC GY-DV300U offers excellent performance for a modestly priced DV camcorder. Its detail level can be adjusted in the camera setup menus, as can the critical knee setting useful to attenuate the hottest picture areas to prevent clipping. Inside or out, the Schneider #½ Classic Soft or Tiffen #1 Soft/FX will add a nice professional panache to your images.

Figure 9.39 *A weak Soft/FX or Classic Soft diffusion filter will help produce well-tuned images in the JVC DV300U.*

Panasonic AG-DVX100B/DVX100A/DVX100

With all the hype that accompanied the introduction of the Panasonic DVX100 camera in 2002, it was difficult for shooters to separate fact from fiction. Shadow detail was clearly better than anything we had seen previously in competing models, and like the JVC DV300U, some of the improvement could be directly attributed to the new generation higher-density CCD. Other factors: the increased resolution afforded by the 24p format and the better-than-average primary camera optics.

Figure 9.40 *The Panasonic DVX100B incorporated key improvements including a more robust overall construction, stronger LCD screen hinge, more reliable tape loading, and less noise in image shadow areas. Filter recommendations remain the same for the updated DVX model.*

Figure 9.41 *Cross-reference of diffusion and warming type filters by manufacturer.*

Type	Tiffen	Schneider	Formatt	Remarks
Black Mist	**Black Pro-Mist** ⅛, ¼, ½, 1, 2, 3, 4, 5	**Black Frost** ⅛, ¼, ½, 1, 2	**Black Supermist** ⅛, ¼, ½, 1, 2, 3, 4, 5	Lowers resolution with moderate flare. Good for Betacam analog cameras. Black Frost creates more pastel, glamorous look and has less effect on blacks than Black Pro-Mist. Can be used for general tightening in weak grades. Higher grades not recommended for DV and HDV shooters.
White Mist	**Pro-Mist** ⅛, ¼, ½, 1, 2, 3, 4, 5	**White Frost** ⅛, ¼, ½, 1, 2	**Supermist** ⅛, ¼, ½, 1, 2, 3, 4, 5	Lowers contrast by lowering white exposure. Gently flares highlights without reducing resolution. Often used in tandem with soft effects-type filter for romantic look.
Ultra Contrast	**Ultra Con** ⅛, ¼, ½, 1, 2, 3, 4, 5	**Digicon** ¼, ½, 1, 2		Effectively raises black levels while lowering highlights. No loss of resolution or softening. Minimal halation and flare. Combined with in-camera gamma settings, a higher dynamic range can be recorded.
Lenslet	**Soft/FX** ½, 1, 2, 3, 4, 5	**Classic Soft** ⅛, ¼, ½, 1, 2	**Soft Effects** 1, 2, 3	Lowers contrast with no little loss of resolution. Keeps sparkle in eyes sharp. Causes highlights to glow softly in heavier grades. Good choice for DV exteriors.
Circular Diffusion	**Diffusion/FX** ¼, ½, 1, 2, 3, 4, 5	**Soft Centric** ¼, ⅓, ½, 1, 2		Subtly reduces contrast without flare or loss of sharpness. Reduces visibility of blemishes and wrinkles in close-ups. Adds subtle edge-diffraction effects. Etched pattern may become visible in backlit scenes and/or when shooting at full wide-angle.
Warming	**812**	**81 Series**	**Warm Skintone Enhancer**	Used primarily to augment skin tones. Warm effect is commonly merged with diffusion in single filter.

Figure 9.42 *Recommended filters by camera model. Your results may vary, but here is what works for me: (Tiffen references shown)*

Camera	Interior	Exterior	Remarks
Sony HVR-FX1/Z1U/A1U	½ Black Diffusion/FX[2,3] ½ Gold Diffusion/FX[2,3]	#1 Soft/FX	Use ⅛ Black Pro-Mist for general tightening Dramatic presentations generally require a more diffused look. Z1U model has advanced menu setup options including gamma for better control of shadow detail.
Sony VX2100/2000	¼ Warm Pro Mist[1]	#1 Warm Soft/FX[1]	Pro-Mist filters can introduce substantial flare even in weaker grades. Do not use unless an obvious diffused look is desired.
Sony DSR-PD100a	⅛ Black Pro-Mist ¼ Black Diffusion/FX[2,3]	½ Soft/FX	Camera tends to run 'warm'. Warming filter not recommended.
Sony DSR-PD170/150	⅛ Black Pro-Mist ¼ Black Diffusion/FX[2,3]	½ Soft/FX	Camera tends to run 'warm'. Warming filter not recommended.
Canon XL2	⅛ Warm Pro-Mist[1] ¼ Black Diffusion/FX[2,3] ¼ Gold Diffusion/FX[2,3]	½ Soft/FX #1 Warm Soft/FX[1]	Much quieter than previous XL1-S model. Also quieter in the shadows than Panasonic DVX100A. No HDV capability. Routine use of black stretch and LOW knee setting recommended.
Canon XL1-S/XL1	¼ Black Diffusion/FX[2,3] ½ Soft/FX	#1 Soft/FX	Camera has harsh brassy look. Mist-type filters e.g. Black Pro-Mist not recommended.
JVC ProHD100U	⅛ Black Pro-Mist ½ Black Diffusion/FX[2,3]	½ or #1 Warm Soft/FX[1]	Use of tightening filter e.g. ⅛ Black Pro-Mist strongly recommended at all times. Polarizer advisable for most exteriors to help contrast.
JVC DV5100U/5000U	¼ Black Pro Mist[1] ½ Black Diffusion/FX[2,3]	#1 Soft/FX[1]	Tightening filter recommended at all times. Soft/FX works well in most setups. Warm version helps skin tones.
JVC DV500	¼ Warm Pro Mist[1]	#1 Warm Soft/FX[1]	Unruly presentation. Tightening filter recommended at all times. Warming filter helps skin tones.
JVC DV300U	#1 Warm Soft/FX[1]	#1 Warm Soft/FX[1]	Filters containing large etched or embedded image patterns not recommended. Use of polarizer for bright exteriors strongly suggested. Warming filter helps in most scenes. This camera runs cool.
Panasonic DVX100B/A	¼ Black Diffusion/FX[2,3] ¼ Gold Diffusion/FX[2,3] 1B Softnet (period look)	½ Soft/FX (non-fiction) ⅛ Double Fog (dramatic)	Improved DVX100B model is less noisy than previous 100A version. Applied diffusion produces smoother, better textured images.
Panasonic DVX100	½ Black Diffusion/FX[2,3] ½ Gold Diffusion/FX[2,3] 1B Softnet (period look)	#1 Soft/FX (non-fiction) ⅛ Double Fog (dramatic)	Use of tightening filter e.g. ⅛ Black Pro-Mist strongly recommended to reduce shadow noise. ½ Gold Diffusion/FX looks fabulous for talent close-ups. Soft/FX helps ease high-contrast exteriors.

1. Combines warming filter #812. To prevent negating its effect, be sure to white balance camera with the filter *off*.
2. Not all grades available in screw-in sizes.
3. Always use caution when using *any* filter with a large etched or embedded pattern, as it may appear on screen when shooting in backlit conditions, stopped down and/or at full wide-angle.

Borrowing heavily from its high-end brethren, Panasonic endowed the DVX with a range of specialized features like a cine-like gamma that allowed DV shooters for the first time to mimic the look and feel of images captured with a top acquisition tool. It was this level of control in tandem with the camera's 24p capability that transformed the DVX100 into a true phenomenon.

The improved DVX100A/B models feature a 12-bit processor that enables more precise sampling than the original 10-bit camera. Of course only 8-bits can *actually* be recorded to tape in NTSC and PAL, so opinions vary regarding the wisdom or usefulness of such oversampling. Nevertheless, the improved performance is readily apparent on-screen; the B-model exhibiting significantly less noise in the shadows than its predecessor.

Compared to the original DVX, the later-generation models require less supplemental diffusion to achieve a highly polished look. If you liked the Tiffen #1 Soft/FX or Schneider #¼ Classic Soft for exterior shooting in the original model, you might consider a slightly weaker grade in the DVX100A/B. The retention of detail is simply that much better in the updated cameras.

Incidentally, the Tiffen Black Diffusion/FX and Gold Diffusion/FX filters perform particularly well in the DVX models, adding a bit of glamour and pizzazz to images at full or nearly full aperture. My own favorite is the #½ Gold DFX, which applies a well-modeled three-dimensional finish to interior scenes and portraits.

Out of the Fog

Cinematographers have long used fog filters to add atmosphere to otherwise sterile or lackluster exteriors. For DV shooters, these filters had never been a real option due to their heavy and unnatural effect.

Now owing to the improved performance of today's cameras and higher density CCDs, traditional fog and double-fog filters again offer shooters a multitude of storytelling possibilities. Whether you're looking to add a touch of atmosphere or a full-blown marine layer inversion, there's likely a strength and type of fog filter out there that can make it happen.

The merit of utilizing a physical filter to accomplish the fog effect is a matter of debate. Some shooters simply find it easier and more practical to apply the effect in post, and this is certainly understandable. The approach has the advantage of being able to tweak the fog in a thousand different ways without permanently altering the background scene.

A post-camera strategy makes the most sense for simple color effects or for adding a touch of warmth or coolness to a scene. It makes much less sense when attempting to add or manipulate diffusion and fog, since the dynamics in front of the lens with respect to light and a physical glass cam-

Figure 9.43a,b *With the advent of higher performance DV and HDV cameras, traditional fog filters can again find practical use. In this Venice scene, the double fog introduces a natural-looking effect with minimal flare as evidenced in the foreground string lights. At right is the same scene sans filter.*

era filter cannot be fully recreated in the post environment. In general, therefore, the shooter should strive to integrate the desired fog or diffusion effect into the original image capture.

Compared to a standard fog filter, the double fog produces a greater sense of *actual* fog. Close-ups retain their sharpness despite the lower contrast and blooming of highlights. Of course, such effects should always be tastefully applied in keeping with your overall storytelling goals.

Silk Stockings: Christian Dior to the Rescue

Some shooters don't care for the look of a glass diffusion filter, preferring instead the increased flare from a real silk stocking. On cameras with interchangeable lenses, a small section of stocking can be stretched across the back element and secured with ¼-inch double-sided tape or a rubber O-ring. The rear-mounted stocking produces extreme blooming in the highlights, so you should consider the appropriateness in the context of your story.

Since the stocking color is infused into the highlight glow, I usually prefer a black net as it imparts an overall neutral cast. On the other hand, a flesh-color stocking offers the extra benefit of enhanced skin tones, a potential advantage when working with aged celebrity types.

My current stocking of choice is the Christian Dior Diorissimo No. 4443, generally available in Europe's high-end boutiques. (I acquired my stash several years ago in Paris at the Bon Marché on Rue de Sèvres.) If you do go the stocking route you should resist the temptation to use

Figure 9.44 A silk stocking behind the lens produces dramatic blooming of highlights, as seen in this factory scene in China.

Figure 9.45 A swatch cut from a silk stocking can be affixed to the back of the lens with a rubber band or O-ring. Always check the camera's back-focus after mounting behind-the-lens diffusion. A suitable back-focus chart is included free with the DVD that accompanies this book.

Figure 9.46 The sheerest fabric invariably produces the best results. I've been evaluating women's lingerie for years in various contexts. My favorite: Christian Dior Diorissimo No. 4443.

lower-quality hosiery, as the effect on screen will invariably appear crude and heavy-handed.

The Post-Camera Finish

This discussion of silk stockings is intriguing, but the temptation remains: why *not* apply such finishing touches in the NLE or compositing tool? We've noted the complex interplay of light as it scatters, halates, and otherwise refracts through a physical glass filter, and how these parameters are difficult to reproduce accurately or convincingly in postproduction software. Yet, one must admit that image tweaking post-camera has become a fact of life, the shooter coming now under intense economic and practical pressures to delay many image-finishing decisions as long as possible.

Over the years I can recall one or two crusty engineers taking me aside to lambaste me: because small-format video offers less resolution than "real" professional formats, they'd say, the shooter should refrain from using on-camera filters as they can only complicate in their view the (likely) up-conversion later to high (or higher) definition video or film.

The talented shooter should reject this notion. Aside from the aesthetic considerations and the need for shooters to control their own images and destiny, a modern diffusion filter does *not* necessarily reduce resolution. On the contrary, the DV/HDV shooter can take ample advantage of a new generation of filters (like the Schneider Digicon) that impart a pleasing diffused finish with no apparent or actual softening of the image.

Of course, there are times when appropriate diffusion *must* be applied post-camera. On some shows, as in the case of many live concerts, produc-

Figure 9.47 *My overstuffed filter case contains more than 125 individual filters, some of which—like the color effect types—I no longer use much.*

Figure 9.48 *One of my old favorites had been the tobacco filter, which worked well for historical re-enactments. The effect now is more easily applied in software.*

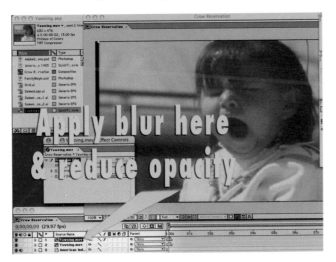

Figure 9.49 *While the look of a physical diffusion filter cannot be recreated entirely in software, we can roughly approximate the look in compositing tools such as Adobe After Effects. Here the original unfiltered scene is duplicated and placed in a second track. A blur is added to the second layer and its opacity is adjusted to achieve the desired diffusion. The Unsharp Mask in Photoshop works in a similar fashion.*

ers may opt to economize by not investing in multiple diffusion filters for various cameras. Utilizing software, the shooter can precisely tweak the level and nature of the diffusion for each camera. Final Cut Pro users even have the option of writing their *own* diffusion FX scripts for a truly custom look.

Roll Your Own

For the shooter investigating post-camera solutions, there are a variety of plug-ins on the market. Plug-ins extend the capabilities of the host NLE or compositing tool, and can offer shooters an almost limitless range of image finishing options. The 55mm plug-in from Digital Film Tools is particularly inspired, featuring a long list of presets intended to mimic the look of popular camera filters, including the color graduated and infrared types.

The Magic Bullet Suite from Red Giant software is a *tour de force* in software design. Beyond the ability to dial in any desired level of diffusion, Magic Bullet integrates a host of distinct and recognizable looks. If you want a warm and fuzzy look like *Jerry Maguire*, there's a preset for it. If you want a heavy diffused look like *Eyes Wide Shut*, you just dial it in.

Magic Bullet offers a range of capabilities well suited to the DV/HDV and HD craftsman. From "look" development and adding film damage, to letterboxing and preparing for film output, this suite of tools complements beautifully the visual storyteller's workflow, building on the shooter's sense of craft and adding tons of finishing options on top of it.

Figure 9.50 *Digital Film Tools' 55mm plug-in offers shooters a familiar list of diffusion and other type camera filters. Such software approximations do not eliminate most shooters' need for physical on-camera diffusion and exposure control.*

Addressing Excessive Depth of Field

We've lamented how excessive depth of field can be an ongoing challenge for small-format video shooters. Basic physics is the culprit, as the DV/HDV camera's tiny chipset produces a too-wide range of focus, impairing the shooter's ability to place objects in clearly defined focal planes. This relative

Figure 9.51 *The Magic Bullet from Red Giant Software is available for Adobe After Effects and most popular NLEs, including Adobe Premiere Pro and Apple Final Cut Pro. The Magic Bullet toolset is as essential to creating compelling images as a matte box, tripod and a case full of conventional filters.*

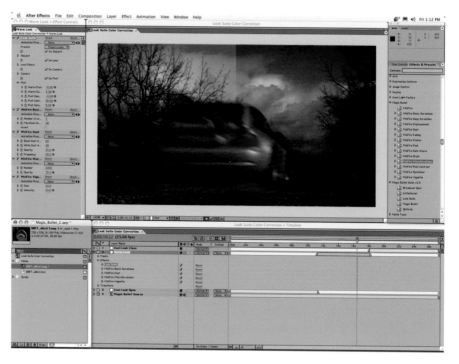

Figure 9.52 *Bear Lake, Idaho (as shown in Figure 9.2) seen here through 55mm's Day For Night filter.*

inability to focus viewer's attention on what's important in the frame negatively impacts the effectiveness of our visual storytelling.

While excessive depth of field can only really be addressed in-camera, some *pseudo* reduction in DOF may be possible in postproduction utilizing the Lenscare plug-in from Frischluft. The effect is less than photographically

Figure 9.53a,b *The shooter-storyteller can select from a range of presets in the Magic Bullet Look Suite. The Warm and Fuzzy Jerry Maguire look is seen in Figure 9.53a. The untreated frames appear in Figure 9.53b.*

Figure 9.54 *Selective focus helps direct viewer's attention inside the frame. Note how in this scene the fall-off of focus appears natural from near to far.*

Figure 9.55 *Frischluft's Lenscare plug-in can help address DV's excessive depth of field dilemma. Utilizing keyframes to track a subject, the shooter can even add follow-focus to a scene!*

Figure 9.56a,b *Adjusting depth of field in software produces a highly stylized look that is quite different from addressing the issue in-camera.*

salient, so (as always) good judgment and taste should be your guide. For best results, the original image should be prepared with the appropriate perspective in order to take advantage of the plug-in's capabilities.

Shooters, Take Charge!

The practice of finishing one's images in post is a process that fills many shooters with dread. On the one hand, the shooter-storyteller is smart to embrace the latest software tools for the creative freedom and possibilities they offer. On the other hand, the prospect of leaving unfinished images lying around a control room or media library is a threat to the shooter's reputation and livelihood. The shooter knows that despite the assurances of producers, clients, and stock library custodians, his or her untreated (or poorly treated) work will always one way or the other find its way in front of the public.

This crazy digital world is evolving so quickly that it no longer makes much sense to be dogmatic about filters and how and where they should be applied. Times have changed, but the smart shooter still assumes responsibility for finishing the image, a process that only *begins* with capture into the camera but really isn't complete until considerably later.

In the end, the shooter-storyteller ideally needs a combination of in-camera and post-camera image finishing strategies. Remember, you are the artist, the painter of light, the Vermeer of this digital age. It's up to you to decide by what standard you wish to be judged. Do you really want a blurry-eyed editor or compositing artist facing the deadline of his life applying finishing touches to your work? *Do you really think he'll bother?*

So, take charge of your images! Coddle them, diffuse them, and tell stories with them. But most of all—*finish* them. However you do it—whether it's in-camera or post-camera—it is your *image* that is at stake.

The DV-to-DVD Storyteller 10

NEEDLESS TO SAY, DVD retail sales have been phenomenal, recently exceeding $25 billion[1] per year, so chances are good as a successful shooter-storyteller that you owe your livelihood in whole or in part to the five-inch disc. Whether you're a shooter of feature films, music videos or high school plays, DVD is keeping many of us solvent, and that's going to continue to be the case as we look ahead to the high-definition DVD market.

Because so much craft and discipline go into creating a commercial DVD, from audio and video to menu graphics and extra value content, it makes sense as shooter-storytellers that we adjust our thinking to accommodate the format's unique requirements. After all, we're not outputting to VHS tape anymore, and indeed, Christmas 2005 will likely mark the unofficial end of commercial VHS, as we know it. When major retail chains like Target and Wal-Mart declare they will no longer sell VHS tapes, one can safely assume the venerable 25-year-old format has finally reached the end of its cassette.

Of course, this has huge implications for the video shooter. Today it matters less that your DV and HDV images look great in the camera or NLE. What *really* matters is how those images look at the end of the DVD rainbow, which is after all what the public is most likely to see and how our work is ultimately judged.

While other distribution vehicles exist for the DV/HDV storyteller—cable TV, reality programming, web videos, to name a few—the DVD behemoth offers by far the most lucrative opportunities in the current

1. Variety DVD Exclusive 'Research' March 2005.

marketplace. *Video on demand* is coming and when it does, the DV storyteller will face many of the same issues all over again, especially with respect to high compression and the need for proper camera craft. For most of us, however, for the foreseeable future, our destiny is inextricably linked to the sliver of plastic inside an Amaray case.

DV to DVD: A Good Match

DV and DVD have a lot in common: They share the same frame dimensions in standard definition—720 × 480 NTSC and 720 × 576 PAL. They share the same audio standard: 48kHz 16-bit stereo PCM. They also share the same fundamental approach to video compression. One look at HDV and we can see a similar progression occurring as high-definition DVD, whether HD-DVD or Blu-ray-based, will support 1080i and 720p configurations.

As we look to the future, it's clear that standard definition DVD will be around for years to come, and will in fact coexist with whatever high definition DVD format ultimately carries the day. It makes sense then to look at the shooter-storyteller's workflow today, with an eye to optimizing it for current and future generation DVD output.

Shooting for DVD

The shooter can use various strategies to improve the quality of his DVD storytelling. Shooting 24p makes sense since every DVD player is in truth a native 24p playback device. From the time DVD titles first became available in late 1996, movie studios originating on 24fps film have logically encoded their movies to disc at 24fps. Relying on the player to perform the conversion to 29.97fps NTSC, the DV-to-DVD storyteller can shoot, capture, edit, and encode an entire production at 24fps (actually 23.976fps), and thereby reduce the file size of the finished program by 20 percent. This is not an insignificant savings given the pressure these days to jam everything *and* the kitchen sink on a DVD.

Shooting 24p improves resolution and detail by eliminating the $\frac{1}{60}$ second temporal artifacts that can occur between odd and even fields. The suppression of aliasing defects associated with NTSC is a major factor in improving the look of DVD-encoded programs captured, finished, and encoded at 24p.[2]

The Old Master painters of the Renaissance recognized the seductive power of the widescreen canvas, and you should too with respect to DVD.

2. *See Chapter 3 for more insights into the relative advantages of progressive versus interlaced images.*

Figure 10.1 *Outputting 24p files to an NTSC display, the DVD player must perform the required conversion to 29.97fps. You might consider the complexity of this task when investing in your next DVD player. The $13 model at your local Walgreen's may not be the wisest choice.*

a

b

c

Figure 10.2a,b,c *Modern transcoders like Canopus ProCoder and Apple Compressor correctly tag 24p encoded files for interlaced playback at 29.97fps NTSC. Note the actual frame rate of 23.98 indicated in the updated version of Compressor.*

Storytelling in 16:9 simply makes good visual sense with the advent of widescreen cameras like the Sony HVR-Z1U and DVD players that invariably exhibit widescreen material correctly, according to the viewer's preference for letterbox, 16:9, or 4:3 pan-and-scan display.

The DVD format and its inherent high compression underlie the need to appropriately reduce the detail level in camera, as this more than any other internal setting can impact the look of your DVD encoded images. Raising or lowering camera detail directly affects the thickness and appearance of the hard edging around objects, and with it potential blocking artifacts during decoding of the MPEG-2 stream in the DVD player.

HD acquisition for standard definition DVD release is fundamentally a good idea. In Chapter 3 we cited the advantages of HD and HDV origination; the additional fineness of the high-resolution format being retained to some degree in DVD's standard definition 8-bit image. The effect is similar

to shooting 35mm film for release on lowly 240-line VHS. By any measure, the film original looks a *lot* better than originating on VHS in the first place.

Make It Sound Good

It matters more than ever now. The DVD shooter can significantly enhance the visual impact of his work by adopting a better audio compression standard and utilizing multichannel surround sound. Supported inside Apple DVD Studio Pro and other DVD authoring software, Digital Theatre Sound (DTS) offers far better quality audio (albeit at a higher bit rate) than the decades-old Dolby Digital AC-3.

Figure 10.3 *The DTS encoder enables integration of high-quality audio in even modest DVD titles. Top-quality sound invariably improves the audience's perception of your images!*

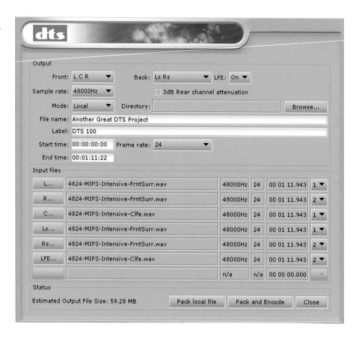

Figure 10.4 *Dolby AC-3's lower bitrate leaves more bits for video, but the quality of AC-3 audio can be mediocre, especially for music and entertainment titles.*

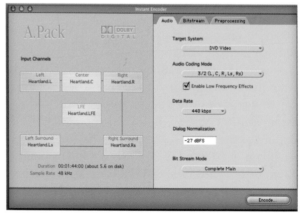

For the DVD shooter and storyteller, however, care should be exercised to avoid a potential loss of picture quality as the larger DTS file size may significantly reduce the bits available for satisfactory video encoding. This is less of an issue with respect to dual-layer projects where the increased capacity (8.54GB) allows for greater leeway in the bit budget. Virtually all DVD players these days support DTS.

DVD Means More Shooting Gigs

As a shooter-turned-DVD-storyteller, perhaps this is your *real* agenda, and it's only logical. Being proficient in the ways of DVD means interfacing with the directors and producers who make shooting gigs happen. Could there be a better way to gain credibility and network with industry honchos? From my experience I can say that ample knowledge of DVD is better than any agent, and your DVD prowess doesn't take 10 percent!

The increased opportunities for shooters can be attributed in part to a disc's extra value content. According to a survey conducted for the Los

Figure 10.5 *DVD has fostered a strong demand for extra content that presents a bountiful source of fresh opportunities for shooters. This rear panel is from the Lost in Space Platinum Edition DVD.*

Figure 10.6 *To remain prosperous, the DV/HDV shooter must adjust to today's market, which is increasingly DVD-centric.*

Angeles *Daily News*, deleted scenes are *the* single most popular "extra value" feature on a DVD.[3] This contrasts with less-demanded features like director's commentary, behind-the-scenes, and web interactivity. The latter option has proven particularly unpopular with the public, as it inconveniently requires the insertion of the DVD into a properly configured computer.

The inclusion of deleted footage on the disc presents a bit of a quandary for the seasoned shooter. For one thing, everything we record, no matter how poorly framed or executed, is potentially in play. Some of our worst takes, indeed our *worst* work, may wind up in the finished DVD seen by millions of people. As shooters, we are often powerless to stop it, as producers seem ever more eager to feed the public's appetite for outtakes and screw-ups of every kind.

Figure 10.7 *DVD's still and motion menus have evolved into high art as each menu and button overlay must be individually handcrafted. Creating compelling menus is a key responsibility of the DV-to-DVD storyteller. This menu was created by a former student, John Rheaume, who exemplifies this new breed of image creator.*

3. A *transcoder* converts one type compressed file to another; a hardware-based *encoder* converts to MPEG or other format from analog or digital videotape. In practice, "encoder" is used generically to describe either tool, hardware or software-based.

Figure 10.8 *Pre-rendered After Effects project files facilitate the creation of customized menus without necessitating starting from a blank canvas. Digital Anarchy's Chaos provides just such a good starting point for creating compelling menus.*

The Money Is in the Menus

It seems illogical that a proficient shooter should find increased opportunities in creating DVD menus. On a typical feature film DVD, over two-thirds of the total budget is allocated to preparation of assets, including menu design. The DV and HDV shooter who can transfer his visual acumen into this exploding new realm can do very well indeed.

A Concept Tool for the DVD Storyteller

Clearly, the shooter's role as an image creator has expanded far beyond the familiar world of cameras, lenses, and tripods. To prosper in today's converged world, the competent shooter must embrace an ever-widening palette of tools in order to maintain proper control of his images. Compositing tools like Adobe After Effects have become a natural extension of the shooter's craft, and Apple Motion is certainly a reflection of this notion.

Motion is not just a compositor but an effective *previsualization* tool. Many of us are familiar already with After Effects, the industry workhorse offering capabilities far beyond what most of us can really fathom or imagine. But AE for all its power and features is not a realtime compositing tool;

Figure 10.9 *Apple Motion as a previsualization tool provides shooters with a realtime canvas. To realize Motion's full potential, a Power Mac G5 with abundant RAM and a pro-level graphics card are essential.*

Figure 10.10 *From a shooter's perspective Motion's imaging power is best applied subtly, as in the headlight reflection, smoke rising from the bike, and a radiant glow emanating from my daughter's skin.*

some time-consuming rendering is almost always required to implement its prodigious capabilities.

The high-end Discreet Inferno has been a traditional favorite of commercial television and film production for years, its capabilities perhaps not as deep as After Effects, but it is fast, rendering essentially in realtime.

Apple Motion does not (yet) pretend to replace the Inferno or AE's specialized tools, but it does function in realtime or nearly so, which is of great value to the shooter who wishes to brainstorm images on a digital canvas. As shooters, it is after all how we are generally accustomed to working—with instant feedback.

Finding Your Storytelling Niche

In the DVD marketplace, opportunities abound to earn a good living, and not just in the entertainment field. In the legal profession, DV shooters are capturing and encoding to DVD an entire day's worth of depositions and testimony. In the medical field, shooters are providing video support and consolidating doctor/patient records into a searchable DVD archive. Many potential applications in real estate, games, and employee training portend the exploding demand for effective storytellers who recognize the potential of the digital versatile disc.

Figure 10.11a *Car and motorcycle DVDs are always big sellers. Go ahead. Push start your career.*

Figure 10.11b *A kissing DVD might have a lot of appeal to romantics.*

Figure 10.11c *Take the controls! DVD raises your "craft" to new heights!*

As we've discussed, it's no longer the creative tools and who owns them that determine which shooter-storytellers are going to prosper in the marketplace. A modest camera and basic editing software are well within the financial means of nearly everyone. What really matters now is who owns *content,* or more precisely, who owns content that anyone wants to see. For these DV and HDV storytellers who have ready access to such material, DVD is truly a gift from the gods.

So who are these lucky content owners? It's anyone with the ability to tell a visually compelling story with a DV camera. And that could mean *anyone.*

Why? Because there's bound to be an audience for a subject no matter how specialized or esoteric. If you're a 1960s VW fanatic like I am, you could produce a DVD on this heady subject and almost certainly realize a healthy return. Given the low or no cost of shooting and editing DV or HDV, you don't have to sell a 100,000 units to break even. You don't even have to sell 10,000. A mere 500 DVDs sold at $20 dollars apiece will still yield a not so shabby $10,000. And what husband or wife *wouldn't* invest $20 in a DVD at Christmas time that so precisely targets a spouse's passion?

Virtually anything can be the subject of your next DVD.

The Quality of the Image

The shooter is of course foremost concerned with the integrity of his images, and in that regard, the advent of DVD has profoundly transformed how others see and judge our work. Whether we like it or not, our meticulously lit, doted-over images will be highly compressed on the order of 40:1 and that compression better be done right and with due respect.

This means the DV-to-DVD storyteller must take control of the encoding process as well. It's only logical, as in years past, film shooters diligently learned the nuances of every new stock and laboratory process. This was considered essential for the director of photography to maintain control of his craft. In the current environment, the shooter faces a more daunting challenge, including mastery of the principal video codecs,[4] especially MPEG-2.

4. Hundreds of compression-decompression schemes (called codecs) exist, including more than 20 different flavors of MPEG. MPEG-2 continues to be supported in high-definition DVD, along with MPEG-4, H.264 and VC-1.

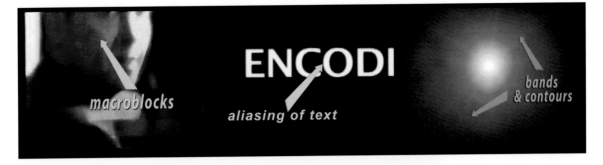

macroblocks

ENCODI

aliasing of text

bands & contours

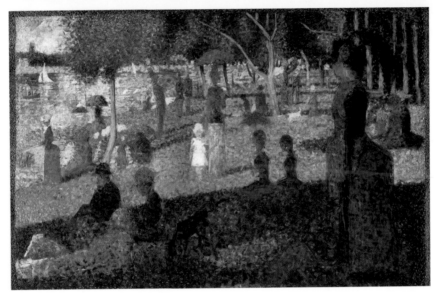

Figure 10.12 *The DVD storyteller ignores serious compression artifacts at his own peril.*

Figure 10.13 *Compression artifacts are not art! This is Seurat's "A Sunday Afternoon on the Island of La Grande Jatte," painted in 1884.*

The Codec of Our Age

One look around at its many implementations and we can see that MPEG-2 has become the compression technology of our age. In cell phones, video games, satellite TV, and DVD, it's everywhere you want to be in all its glory—and ugly artifacts.

All other factors impacting the shooter's craft—lens performance, camera setup, and filter nuances—pale in comparison to this one inescapable reality: that those responsible for compressing our programs for the Web, satellite, or DVD can make any show we produce, no matter how well crafted, look like a Seurat painting.

Many common artifacts like *macroblocking*, *vertical aliasing*, and *banding* can be highly disconcerting to even unsophisticated viewers. Your job as a new breed DV-to-DVD storyteller is to minimize such image defects at every stage, up to and including the encoding of the finished program to DVD. In other words, your job as a shooter and professional image creator isn't over until the MPEG encoder satisfactorily fulfills its task.

Know Your Codec, Know Your Encoder

DVD holds enormous promise for the DV shooter, but there is also peril in them thar bits. Like DV, MPEG-2 is a DCT-based[5] codec that seeks to identify redundant pixel values inside the frame. In the case of MPEG-2 for DVD, the codec also looks for redundant values *interframe*. If you look closely at an arm's length of movie film, you'd notice little difference from one frame to the next. The engineers associated with the Moving Picture Experts Group (MPEG) recognized that the variation in color and motion over any given group of frames is usually slight.

Anatomy of a GOP

The high compression achievable in DVD-compliant MPEG-2 is derived from the group of pictures (GOP) containing only one *complete* frame, the "missing" frames in the GOP being mathematically derived from the initial intraframe or I-frame. Those fields, frames, and fragments of frames deemed to be redundant or irrelevant are discarded and no data is written. In the frame's place, a message is left at the head of each GOP instructing the player on how to resurrect the missing frames based on the embedded cues.

Bidirectional B and predictive P frames enable long-form GOP MPEG-2 to *anticipate* action inside the group of pictures. The scheme seeks to identify and fill in *completed* action inside the GOP, referencing the previous I-frame—the only complete frame (albeit compressed) retained from the original (typical) 15 frames of video.

Figure 10.14 *In this strip of 35mm film, one frame appears hardly different from the next or previous frames. In other words, there seems to be a high degree of redundancy from frame to frame.*

Figure 10.15 *While the frame is the minimum decodable unit in DV, the group of pictures is the basic decodable unit in DVD. Ranging in size from 4 to 18 frames, the typical GOP length for NTSC titles is 15 frames. HDV utilizes a similar GOP structure to achieve a reduced file size.*

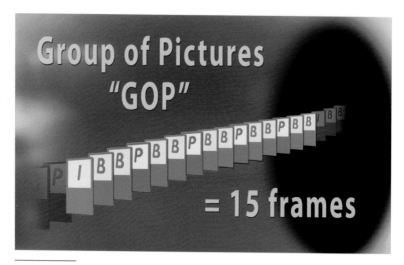

5. Discrete Cosine Transform (DCT) provides a means of sorting data to make it easier to discard picture elements not particularly visible or relevant. DCT is applied to 8 × 8 pixel blocks in standard definition.

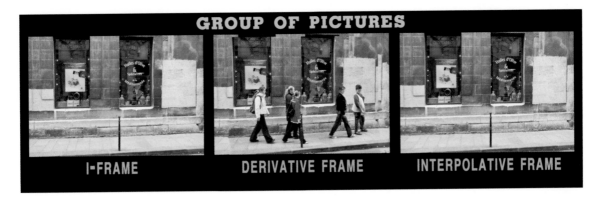

GROUP OF PICTURES

I-FRAME | DERIVATIVE FRAME | INTERPOLATIVE FRAME

High-definition codec H.264, also known as MPEG-4 Part 10 or AVC (Advanced Video Codec), utilizes a DCT-like compression scheme applied to blocks as fine as 4 × 4 pixels. Unlike MPEG-2, H.264's predictive frames look ahead or back in a video stream without limitation for optimal results. For this reason and others, H.264 achieves radically better quality images than MPEG-2 at half the bitrate.

GOP Structure and Your Storytelling Goals

GOP size and structure may impact the look and feel of your visual story in subtle but meaningful ways. Just as a film lab might skip a bleach bath to achieve a certain look, so can the DV-to-DVD storyteller alter the encoder GOP settings in order to influence the mood and character of a program. Most often, the effect of a nonstandard GOP structure (such as IPPP) is barely noticeable, but this can vary substantially depending on the scene and the amount and nature of the motion contained in it.

While a GOP size of 4 to 18 frames is legal in NTSC, a too short GOP is not usually desirable as MPEG-2 encoders work more efficiently with sufficient breathing space between I-frames. The rapid drawing and redrawing of complete I-frames seems to stress the encoder and impair performance. Of course, the stressed look may be exactly right for your story, so the savvy shooter-storyteller should take notice of this as a potential tool. Traditional cell or CG animation, on the other hand, with a limited range of color and motion can often benefit from a short GOP. The same GOP size when applied to high-intensity sports would likely lead to unacceptable results.

Thus, the shooter who understands the nuances of compression and the MPEG-2 encoder enjoys a crucial advantage when outputting a finished program to DVD. The encoder has become just one more tool in the ever-expanding shooter-storyteller's toolbox.

Figure 10.16 *In the frames above as several pedestrians enter and leave the GOP, the background of the building is revealed by the departing persons and must be interpolated. Clues recorded during compression enable the DVD player to recon-struct the missing portions of the discarded frames by referencing the initial I-frame—the only complete frame in the (usual) 15-frame GOP.*

Figure 10.17 *GOP size and structure can have a subtle but significant impact on a story's visual tone. While IBBP construction produces the most natural representation of motion and color, other GOP structures can sometimes be useful as they may impart a slightly surreal look to your story.*

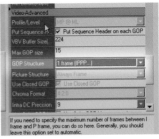

The Tale of the Tape (in order of estimated overall quality)

Encoder/ Transcoder[6]	Perfor- mance	(points earned)	UI/ Workflow	MSRP (USD)	Judges' Comments
Cinema Craft CCE-SP 2.70 (PC)	94	833	83	$1,995	Best of show. Multi-pass VBR up to 9 passes. Performance comparable to best hardware-based encoders. Recently improved user interface.
Canopus Procoder 2 (PC)	86	756	62	$499	Awkward UI but superb, very smooth performance. Field-based encoding is possible.
Innobits Bitvice (MAC)	83	734	74	$297	Advanced noise reduction. Inverse telecine & other advanced features missing in current version. Simple UI.
Apple Compressor 2 (MAC)	82	728	87	N/A	Extremely versatile, excellent speed & improved performance in general-purpose encoder. Seamlessly integrates SD & HD, PAL & NTSC.
MainConcept/ Adobe Premiere (PC)	78	701	70	$149	Stand-alone PC version tested. Also available for Mac ($249).
Discreet Cleaner XL (PC)	75	695	66	$499	Solid performer. Significantly better performance than Cleaner 6 for Mac but UI/workflow is not as good.
Discreet Cleaner 6 (MAC)	60	512	72	$499	Disappointing in the current release, especially compared to earlier Cleaner versions.

All versions available as of Aug 2005

Figure 10.18 *This table ranks the performance of several popular MPEG-2 transcoders based on a series of blind tests conducted by my DVD students in 2005. Your results may vary depending on noise reduction applied and relative complexity of the original footage. Software engineers working within narrow constraints must often juggle good color and contrast with adequate motion estimation.*

Encoders Have Personalities

The DVD storyteller understands that encoders from different manufacturers invariably favor one compression parameter over another. One encoder may work well with high-action sports such as rodeos, but perform less robustly when confronted with a Christmas parade at night featuring complex colors and costumes. To the adept shooter and image creator, the brave new world of MPEG-2, H.264, Windows Media, VC-1, and all the rest, means understanding a *range* of encoding tools based on their individual strengths and weaknesses. No single tool can be expected to do it all, even hardware-based encoders costing tens of thousands of dollars.

6. Los Angeles *Daily News*, Business section, July 17, 2002.

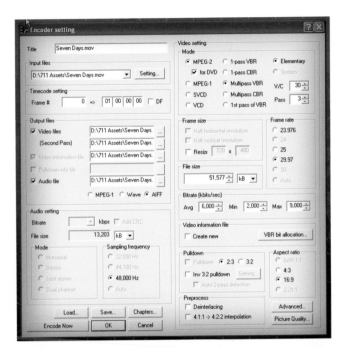

Figure 10.19 *Its excellent sharpness and contrast make the CinemaCraft CCE-SP encoder well suited for feature film.*

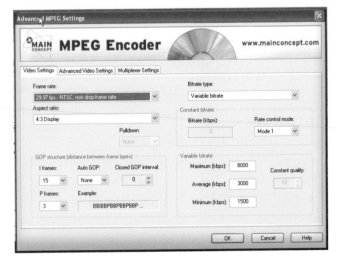

Figure 10.20 *Apple Compressor has recently improved significantly with better contrast and less image softening. For Mac users working in both standard and high definition, the intricacies of frame dimensions and pixel geometry are completely transparent. When encoding H.264, Compressor looks very good by any professional measure.*

Figure 10.21 *MainConcept is a mid-level transcoder featuring an impressive array of options. Some folks know it as the MPEG-2 encoder inside Adobe Premiere Pro.*

The DV-to-DVD Storyteller

Figure 10.22 *The MainConcept advanced video settings.*

Scenes that Spell Trouble

In the land of MPEG-2, high bitrates eliminate or reduce most objectionable artifacts. The more bits used to describe a scene, the more likely that scene will be represented free of obvious defects. Practically speaking, maintaining a high bitrate of 7 or 8 Mbps reduces the need for a more sophisticated encoder as modern encoders invariably perform well at such levels. Of course, high bitrates also reduce the available run-time on a DVD, which may be problematic if your total program exceeds fifty minutes.

The shooter should also be aware of certain type scenes that present a high degree of difficulty to MPEG-2 encoders. Fades and dissolves, especially to and from high-contrast static frames, can be challenging and therefore require close scrutiny during the QC process. Scenes containing wafting smoke, expanses of water, rustling leaves, and falling snow are also inherently tricky. The smart DV/ HDV shooter recognizes these potential troublemakers during capture and stays on top of them throughout the postproduction and DVD-encoding process.

Figure 10.23 *Fast moving objects like this London taxi racing through a static frame can be especially problematic for the MPEG-2 encoder.*

Figure 10.24 *Expanses of water with gently shifting waves are notoriously difficult to compress. Be sure to scrutinize such potential problem areas during your quality review.*

Figure 10.25 *Large monochromatic areas like the blue sky in this scene may exhibit significant noise in the encoded file. Adding clouds or other texture in postproduction may help produce quieter, more professional results on DVD.*

Figure 10.26 *The Innobits BitVice offers sophisticated noise reduction in an inexpensive transcoder.*

The Noise Reduction Imperative

Besides dialing down detail and applying appropriate camera diffusion, the shooter should take care to reduce or eliminate noise as much as feasible. Single-pixel noise is Public Enemy No. 1 when it comes to competent compression, and while suppressing such artifacts should be a top priority, it

Figure 10.27 *When using Apple Compressor, mild noise reduction (Iteration = 1) is usually advisable to help performance. Applying noise reduction of any kind significantly extends processing time.*

Figure 10.28 *Discreet Cleaner's adaptive noise reduction can substantially improve image quality when encoding from VHS or other noisy analog sources.*

can be difficult for encoders to discern the fine image detail you do want from the single-pixel noise you don't. The de facto use of a tightening filter such as the Tiffen #⅛ Black Pro-Mist or Schneider ⅛ Digicon can help suppress the noise in the deepest shadows, and thus help improve the look of your DVD images.

When shopping for an encoder, look for one with sophisticated pre-processing and noise reduction capabilities. While some noise reduction is almost always advisable prior to compressing to MPEG-2, appropriate restraint must be exercised to avoid excessive loss of fine detail.

Know Your Encoding Mode

Since minimizing artifacts is our goal, it would seem to make sense to use as high a bitrate as possible. This notion is constrained, however, by two factors: DVD's maximum 9.8Mbps bitrate for the multiplexed program (including audio and subpictures[7]), and the overall capacity of the disc.

In most satellite TV systems, many MPEG-2 streams must move simultaneously through the satellite's finite "pipe." The program packages or GOPs move on what might be regarded as a huge conveyor belt. To efficiently move as many streams as possible, the individual belts should travel move at a constant speed with each package being of equal size, as packages of varying girths could coincide at any moment and clog the pipe. Thus moving identical-size packages at a constant rate is the most efficient use of this type of delivery system. The DVD player is a much different animal

7. Subpictures are the menu overlays and subtitles that comprise DVD's third data stream.

Video Shooter

Figure 10.29 At a constant bitrate (CBR), exploding battleships and talking heads receive the same allocation of bits regardless of the scene's complexity. While CBR is effectively required for multi-angle titles, variable bitrate (VBR) encoding produces overall better results for DVD projects in excess of 50 minutes total running time.

Figure 10.30 Variable bitrate, represented by different size packages on the conveyor belt, is more efficient as bits scavenged from static scenes like a reporter's standup are reassigned to action scenes like a barroom brawl. Such adjustments in the video stream take place at the GOP level in as few as four frames in NTSC!

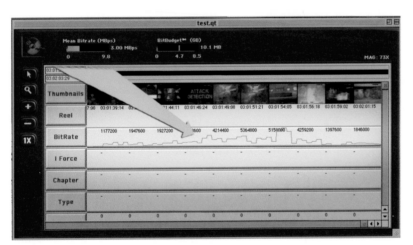

Figure 10.31 In this screenshot from Sonic DVD Creator, we see the variation in bitrate over the length of the encoded program. While VBR allocates bits as needed within a prescribed minimum and maximum, the desired target is maintained so as not to exceed the maximum file size determined by the project bit budget.

as it must decode only a single program stream. Constant Bit Rate (CBR) encoding like that found in satellite systems can still be used, the encoder assigning a fixed number of bits to scenes regardless of their complexity. If the source video contains a great deal of motion or is color-complex, the encoder applies greater relative compression, reducing picture quality in order to maintain the constant (specified) target rate.

In Variable Bit Rate (VBR) mode, the available bits are assigned with much greater efficiency. Scenes with greater motion or color nuances receive more bits; scenes with low-complexity like talking heads, receive fewer bits. VBR encoding thus produces much better results than CBR (in most cases) at the same target bitrate.

Approximate Video Run-Times at Various Bitrates (in minutes)

Video Bitrate	DVD-5	DVD-9 (DL)
1.0Mbps	530	910
3.0Mbps	170	300
4.0Mbps	130	225
5.0Mbps	100	180
7.0Mbps	75	130
9.0Mbps	55	100

Figure 10.32 Approximate running time for single angle DVD titles recorded on single and dual-layer media. Times indicated assume a single Dolby stereo track at 224 Kbps plus a reserve of 5–8 percent. Most Hollywood feature films are encoded VBR at 4.5–5.5Mbps. Encoding CBR at under 3Mbps will seldom produce acceptable results regardless of encoder.

Figure 10.34 DVD players display MPEG-1 programs full-screen despite the reduced 352 × 240 frame size. The lower resolution results in a softer displayed image, although the absence of macroblocking and other interlacing artifacts may compensate for the loss of sharpness. High definition DVD does not support playback of MPEG-1 video.

Figure 10.33 The frame dimension of DVD-compliant MPEG-2 streams is 720 × 480 regardless of aspect ratio or display mode: 4:3, 16:9, or letterbox.

Consider MPEG-1... Maybe

While MPEG-2 is associated generally with DVD-Video titles, the MPEG-1 standard may also be used. In fact, MPEG-1 may actually produce better results at *very* low bitrates around 1.5Mbps. For corporate, legal, or medical applications, the use of MPEG-1 greatly expands the storytelling possibilities, as a single-layer DVD-R (or +R) can hold over four hours of VHS-quality video.

Shooting Multiple Camera Angles

The DVD-Video specification allows for up to nine camera angles, and with the growing acceptance of DVD in corporate and industrial circles, a greater implementation of multi-angle in training and educational titles is a near-certainty.

This may represent a new opportunity for the DV-to-DVD shooter, but it also poses some challenges. For one thing, lighting for multi-cameras is

inherently compromised, as most scenes cannot be optimally lit from multiple vantage points at the same time. For this reason, shooters often resort to a flat and uninteresting "sitcom look."

DVD shooters looking ahead to a multi-angle DVD title should ideally shoot each angle sequentially—with a single camera—so the lighting may be tweaked appropriately for each vantage point. Due to time and money constraints, however, such resetting of the lighting is seldom done for low priority "extra value" content. Instead, producers will typically opt for a second or third camera to cover the same action, the optimal lighting required for each angle being the least of the filmmakers' concerns.

The notion of total running time on a DVD is less clear now in the face of multi-angle DVD titles. Toss in an additional *white rabbit*[8] feature and other bifurcations, and suddenly your two-hour movie could easily contain 50 percent more "story" than is immediately apparent in the principal program.

Clearly with this increased content, the DV-to-DVD storyteller must develop an efficient *modus operandi*. Good shooting craft is now more imperative than ever, as the penalty for overshooting or indecision can be career killing given the greater productivity required.

Multi-Angle Bitrate Constraints

Number of Angles	Practical Maximum Bitrates
1	9.0Mbps
2–5	7.0Mbps
6–8	6.5Mbps
9	6.0Mbps

Figure 10.35 *The maximum bitrate of multiplexed video, audio, and subpicture streams for standard definition DVD is 9.8Mbps. When employing a single video angle, a maximum rate of 9.0Mbps ensures adequate headroom for the accompanying Dolby AC-3 audio. When encoding for multi-angle, each video stream must be encoded at a reduced rate, resulting (possibly) in a loss of image quality. The figures indicate the maximum bitrates for multi-angle content. Video for multi-angle use should always be encoded CBR.*

Figure 10.36 *When shooting multi-angle with Panasonic DVX cameras, the syncing of time-code is facilitated via FireWire. This capability was added in the Panasonic DVX100B.*

8. The "white rabbit" feature introduced in the original *The Matrix* ushered in a new era of extra value DVD content. A clickable rabbit icon appeared on screen from time to time in the course of a movie, allowing the viewer to access additional story material.

Figure 10.37 *Beware the*
evil among us! The cheap
DVD player can sink your
career lest you take some
common sense precautions.

Now Meet the Villain of Our Story

The $13 DVD player is more than a nuisance. It's a public scourge, as un-suspecting folks attracted by the low price eagerly snap up the poorly per-forming machines. Since impaired playback can reflect negatively on us as gifted craftsmen, it is in our interest to know the enemy and know him well.

The hallmark of an el cheapo unit is out-of-sync playback, which the public invariably attributes to a defective disc. If a disc is authored and encoded to the DVD specification and the player is designed and manu-factured to the same standard, all should be fine in the promised land of DVD. But when player manufacturers cut corners, as they are inclined to do in the bargain boxes, we DVDers start to shake in our jewel cases. After all, there's only so much we can do to ensure our images are prop-erly reproduced on shoddily constructed, substandard players.

The DVD-R (+R) Morass

According to the standard, DVD-Video discs must be replicated in a man-ufacturing plant, each disc being the product of stamping millions of micro-scopic pits into a thin plastic substrate. DVD-R (+R) media that is *burned* is not therefore a *true* DVD-Video disc as the pit shadows are simulated by tiny drops of dye that change color in response to the DVD burner's laser. Some players (as we all know) don't buy this phony pit ruse and react errat-ically. The low reflectivity of the simulated pits leads to tracking errors, and is thought to be a major contributor to the incompatibility of DVD record-able media.

The incompatibility of DVD-R (+R) media can be the subject of a long discussion. According to one respected study[9] conducted several years ago,

9. *DV Magazine,* July 2002, "DVD Compatibility Test," by Ralph LaBarge

Figure 10.39 *Only replicated discs (prepared in a manufacturing plant) can legally bear this logo. Pressed DVD-Video discs exhibit few playback anomalies.*

Figure 10.40 *While player compatibility has improved in recent years, satisfactory playback of DVD-R (+R) media in an unknown player should never be assumed. This excerpt from a professional testing service report lists the player models tested for compatibility.*

Figure 10.38 *The DVD's multiplexed data stream is read in a continuous spiral from the center of the disc. Inferior DVD-R (+R) media may be slightly warped, leading to tracking and related compatibility issues on some players.*

90 percent of DVD players exhibit *some* incompatibility with recordable media. The situation may have improved since then but bear in mind that "compatibility" is seldom an all-or-nothing thing. A disc will often load and play flawlessly for a while before turning erratic. This may take the form of weird navigation, poor decoding of audio, video, or both, or occasionally the refusal to play a disc at all. Erratic playback is most likely to occur late in the DVD presentation, as the player's laser tracks outward from the center of the disc, encountering greater *wobble* and warping of the disc that can produce tracking errors.

In critical applications utilizing DVD-R (+R) media, a variety of players should be tested to assess compatibility. You can hire a professional company to do this for you—there are a number of them around—or you can simply venture into your local electronics megastore and do your own impromptu evaluation (with the store's permission, of course). Again keep in mind that initial loading and reading of the disc is not an adequate measure of compatibility; a proper review can only be accomplished by observing the entire disc, including the extra features.

For critical client presentations, you should always verify satisfactory playback of DVD-R (+R) media on the actual player to be used. I often bring my own and proven set-top player (or use my Apple PowerBook laptop) to forestall calamities. But beware of a common ambush: after a successful screening, many clients will ask for the disc to show the boss or significant other. You should resist this potentially lethal scenario. A few years ago, I lost a major assignment worth potentially hundreds of thousands of dollars when my DVD-R demo did not run smoothly on a CEO's brand new laptop!

DVD-R versus DVD+R: What's the Difference?

Both formats are comparable in design, and compatibility. The major difference is: DVD+R allows recording in sessions; DVD-R does not. This means that DVD-R recordings must be finalized after a single session. DVD+R media can be recorded over multiple sessions and thus may be more suitable for home use.

Improving Your Chances

With respect to standard definition DVD players, here are a few tips to help your DVD-R (or DVD+R) discs play more reliably:

• *Encode video no higher than 7.5Mbps maximum bitrate.* Due to the low reflectivity of recordable media, high encode bitrates over 7.5Mbps may impede some players' ability to satisfactorily decode multiplexed audio and video streams in realtime.

Figure 10.41

Figure 10.42 *Playback of uncompressed (PCM) audio from DVD-R (+R) media can be problematic, especially in conjunction with high video bitrates. Dolby Digital AC-3 is therefore advisable for most titles. Dolby recommends a default value of -27db for dialog normalization.*

WATCH MAXIMUM RATE!

• *Use Dolby Digital AC-3.* To facilitate playback of video at moderate to high bitrates, the use of compressed audio (i.e., Dolby AC-3) is imperative to avoid player stutter or freezes. While AC-3 compression entails some compromise in audio quality, the smaller file size and concomitant gain in player compatibility are usually worth it.

• *Avoid burning to the outside edge of the disc.* Compatibility problems increase as a player's laser tracks outward from the hub of the disc. Maintaining 5 to 10 percent of free space on a DVD-R (+R) may reduce read-errors in this vulnerable edge region.

• *Use high-quality media.* Cheap media is responsible for more incompatibility problems than any other factor. Spending a bit more per disc is worth it if your clients are able to view your work with fewer hassles and hiccups.

• *Consider replication instead of duplication.* If you require more than 50 discs of a title, it may simply make sense to replicate your DVD. A typical price for a minimum 1,000-unit run is now well under $1 per disc with

Figure 10.43 *Compatibility on some players is enhanced by not utilizing the full capacity of the disc. Note that a minimum burn area is required. If the program is short, your burning application will lay down the required minimum as lead out.*

Figure 10.44 *Replication may not be practical for DVD-R titles requiring regular updates, such as this digital media archive.*

a multicolor label and storage box. Shorter runs don't usually offer much savings owing to the expense of preparing a glass master or stamper.

• *Use DLT tape for submission to replication facility.* Owing to the low cost and convenience of DVD-R (+R) media, many shooters will be tempted to submit a DVD recordable disc to the replication plant. While many facilities will accept such discs as a mastering source, it is not recommended as errors burned into the disc may be multiplied in the DVD master, possibly impairing playback of the manufactured discs.

Figure 10.45 *Digital Linear Tape (DLT) is still preferred for submission of a DVD title to a replicator. As a read-after-write format, DLT continuously compares the cloned file to the original and makes necessary corrections, thus assuring an error-free transfer . Older model DLT drives such as this DLT7000 work well for DVD premastering purposes.*

Figure 10.46 *DVD-R authoring media (left) offers maximum compatibility with DVD players but can only be burned in a Pioneer DVR-S201. For practical reasons, most folks utilize DVD-R general media like the type shown at right.*

The New Shooter-Storyteller

It doesn't take a lot of processing power to realize that videotape is nearing the end of its cassette. In nearly every market and niche, from home entertainment to education, oxide-impregnated mylar is rapidly passing from the scene.

It's not just videotape that is disappearing, but the linear brand of storytelling that went with it. Thanks to random-access and the interactive component, the multifeatured DVD is giving viewers increased control of the playback experience. Deleted scenes, secret endings, white rabbit features, all contribute to a customized storytelling environment that directly impacts how the image creator ultimately applies his craft.

For the accomplished shooter, this means exploiting the aesthetic sensibilities honed from years behind the camera. Whether constructing a scene for multi-angle use, recording 24p instead of 60i, or shooting compositional elements for a motion menu, the skills that served us all so well in the past now portend even greater opportunities, especially for those DV and HDV shooters willing and eager to grasp DVD's lustrous gold ring.

Today's shooter no longer has the luxury of living and dying by his or her camera prowess alone. The world we live in and the work we love *and* need is much more complex as shooters and editors, compositors and directors, all have access to the same tools and imaging landscape.

It's a dog-eat-digital-bits world out there, and some of us will always be more talented than others in framing and lighting it. For those folks able to tell compelling visual stories with their cameras, there will always be a demand for first-class image capture specialists. But for everyone else and for the vast majority of shooters today, the economics of digital media are such that merely possessing the ability to capture moving pictures is not enough. To stay relevant and prosperous, the new shooter-storyteller must understand and embrace the digital odyssey from start to finish, long after his doted-over images are captured and leave the warmth and security of the camera's womb. The image creator's role is now a long and extended process, and the shooter who intrinsically understands the opportunities and perils of the journey will continue to do well in DVD, video on demand, or wherever the journey may take us.

Figure 10.47 *The shooter-storyteller is in for quite a ride. Make sure you enjoy it!*

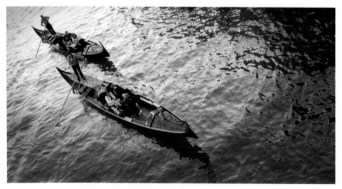

Video Shooter Resource List

Barry Braverman Website
www.barrybraverman.com
Hopefully you'll always find something useful here. Tips on cameras, lighting, lenses, and accessories plus craft tips. Always jaded. Always with an attitude.

16x9, Inc.
www.16x9inc.com
Professional high-quality camera accessories including Alfred Chrosziel matte boxes and follow-focus rigs.

Abel Cine Tech
www.abelcine.com
Film and video rentals for professionals. New York and Los Angeles.

Adobe
www.adobe.com
Inspired creators of Photoshop and After Effects—the workhorses of our industry. Need we say more? Lots of tips and tutorials are available on and through the Adobe website.

Band Pro Film & Video
www.bandpro.com
The U.S.A's leading reseller of high-end Sony high-definition cameras, including the latest HDV models. Strong emphasis on service and education.

Boris FX
www.borisfx.com
Sophisticated plug-in offers a mind-boggling range of digital effects from page turns and mapping images on spheres to professional blurs and 3D. The interface is daunting with lots of tiny icons. Luckily Boris offers free online tutorials to ease the learning curve.

Canopus
www.canopus.com
The Canopus ProCoder is the most versatile software of its kind, allowing transcoding to and from virtually any type of digital media file. The quality of encoding MPEG-2 for DVD is exceptional.

Century Optics
www.centuryoptics.com
Suppliers of wide and ultra lens adapters for popular DV and HDV cameras. Century also manufactures excellent lens gear rings for integration with the Chrosziel follow-focus.

Cinemacraft
www.cinemacraft.com
The CCE-SP is the best DVD-compliant MPEG-2 encoder on the market. The latest version has a greatly improved GUI, eliminating the wretched engineer's interface of previous versions. PC-adverse Mac users lament that CCE-SP is for Windows only.

Datavideo-Tek
www.datavideo-tek.com
Manufactures robust DV-enabled LCD monitors suitable for on-board applications. This is serious gear at a reasonable price.

Digital Anarchy
www.digitalanarchy.com
Developer of *Chaos* and other inspired plug-ins for Adobe After Effects. Project files are customizable allowing for an almost unlimited range of visual patterns and motifs.

Digital Film Tools

www.digitalfilmtools.com

The company's *55mm* plug-in closely mimics the effect of many popular camera filters. For shooters, it plays a vital role in one's post-camera imaging strategy.

DTS

www.dtsonline.com

If superior DVD sound is your goal, a DTS encoder is indispensable. DTS is supported in current versions of Apple DVD Studio Pro.

Evatone

www.evatone.com

Full-service CD/DVD replicator. Reliable and efficient.

Formatt

www.formatt.co.uk

British manufacturer of camera filters noted for high light transmission and low weight. Each filter ships with a graphical printout attesting to its optical performance.

Foveon

www.foveon.com

Developer of advanced single-chip imagers utilizing multiple color response layers analogous to film emulsion. The future is here.

Frischluft

www.frischluft.com

Lenscare is one of the few post-camera solutions around that addresses the DV camera's excessive depth of field. The software produces a stylized effect, that is not at all like reducing actual depth of field during capture.

Industry Advanced Technologies

www.industryadvanced.com

California manufacturer of the Intel-A-Jib, the best-designed small crane on the market.

Extremely rugged and stable with no backlash. Setup and tear down is fast in about two minutes.

K-Tec

www.mklemme.com

Designer and manufacturer of versatile microphone boom poles. Lots of thoughtful features make the K-Tec boom an indispensable part of your basic audio package.

Lectrosonics

www.lectrosonics.com

Makers of state-of-the-art wireless mic transmitters. Shooters would do well to include one or two of this company's basic units in their working kits.

LitePanels

www.litepanels.com

Innovative designers and makers of efficient LED lighting. The camera-mounted Litepanel Mini is the most useful light you can own.

MediaStar

www.mediastarLLC.com

Southern California-based replicator specializing in short runs and fast turnaround. Very reliable. An excellent resource for the corporate producer and independent filmmaker.

Microdolly

www.microdolly.com

Makers of a lightweight yet robust camera support system including dolly, track and jib arm. One of the few portable support solutions that actually works.

P+S Technik

www.pstechnik.de

Manufacturer of the Mini35 and Pro35 lens adapters permitting use of high-quality 35mm cine optics on DV camera models. The P+S

Technik adapters are the only real solution to the depth of field quandary posed by most DV cameras' tiny imagers.

Reflecmedia

www.reflecmedia.com

The Reflecmedia system features a special screen and ring light that greatly facilitates shooting green screen sequences. The system works best for simple setups since the green or blue spill from the ring light can easily contaminate foreground set elements.

Sachtler

www.sachler.com

World's foremost manufacturer of high-quality fluid head tripod systems.

Sennheiser

www.sennheiser.com/sennheiser/icm_eng.nsf

Legendary makers of the world's most rugged microphones. My Sennheiser 416 has been going strong for two and half decades.

Sim Video

www.simvideo.com

Spirited Toronto-based rental house specializing in Sony high-definition gear. Offices also in Vancouver and Los Angeles.

Sorenson

www.sorenson.com

Sorenson Squeeze is the best all-around encoding tool for encoding audio and video for the web and CD-ROM. Its interface is simple and its performance is top-notch—except when converting to DVD-compliant MPEG-2. Available for Mac and PC.

Sound Devices

www.sounddevices.com

Manufacturer of high-quality portable analog and digital audio mixers for radio, television, film, and music recording. First-class machines worth every penny.

Red Giant Software

www.redgiantsoftware.com

The inspired Magic Bullet software is a tour de force of design and simplicity. A lower cost version for popular NLE platforms has recently been introduced.

Schneider Optics

www.schneideroptics.com

Bob Zupka can talk your ear off about filters so it's a good thing Schneider manufactures a first-class product. The company primarily produces filters like the Black Frost and Digicon for the professional market so round-type screw-in filters are not standard issue.

Tiffen

www.tiffen.com

Ira Tiffen is no longer with the company but his remarkable filters including the Soft/FX and Diffusion/FX continue to be effective with current generation cameras.

Total Training

www.totaltraining.com

Producers of the best digital training DVDs on the market covering a wide-range of A/V applications including Photoshop and After Effects. Extremely well produced series covering many hours of in-depth training. Often humorous, always effective.

Index

What's on the DVD?

The companion DVD contains tutorials and demo footage of storytelling techniques and technical matter, including a comparative filter study.

Updates

Want to receive e-mail updates for *Video Shooter*? You can visit our Web site: www.cmpbooks.com/maillist and select from the desired categories. You'll automatically be added to our preferred customer list for new product announcements, special offers, and related news.

Your e-mail address will not be shared without your permission, so sign up today!